Cuba Represent!

Cuba Represent!

Cuban Arts, State Power, and the
Making of New Revolutionary Cultures

Sujatha Fernandes

DUKE UNIVERSITY PRESS DURHAM AND LONDON 2006

Printed in the United States of America on acid-free paper ∞

Designed by Heather Hensley

Typeset in Quadraat by Tseng Information Systems, Inc.

Library of Congress Cataloging-in-Publication Data appear on
the last printed page of this book.

Permissions/Subventions:
Earlier versions of Chapter 3 appeared as "Fear of a Black
Nation" in the Anthropological Quarterly 76, no.4 (2003): 575–
608, and as "Island Paradise, Revolutionary Utopia or Hustler's
Haven" in the Journal of Latin American Cultural Studies 12
(2003): 359–375; Web site <www.tandf.co.uk>.

For my parents, Sylvie and Joe Fernandes

Contents

Illustrations

Preface

Every time I approach the immigration counter at Havana's José Martí International Airport, the same scenario plays itself out. "Are you Latina?" I am asked cautiously. "No." "So why do you speak Spanish?" "Because I learned Spanish when I first came to Cuba." "Then why is your last name Fernandes?" "My parents are from the part of India in the south that was colonized by the Portuguese," I repeat, almost by rote. "But you have an Australian passport." The official is getting a little agitated now. "Yes, my parents moved to Australia, and I was born there." "But you live in the United States." "Yes, I went there to do my PhD." "So why are you studying Cuba?"

Over and over I am called upon to justify and explain my choice of research locale. Such constant probing can be unsettling, but it has forced me to confront and articulate the reasons why I chose to dedicate several years to a study of the arts in Cuba, and what this study can illuminate about contemporary Cuban politics. From the start, I saw the arts as a window into an extremely complex and contradictory moment of transition in Cuban society. I felt that I could learn so much more about how ordinary Cubans were understanding and living the crisis by watching a film or listening to a rap song than by reading an article or listening to a news report. Yet as I continued with the project, I found that the arts were not simply a reflection of what was going on in Cuban society. In some ways, artistic activities were constitutive of that society and the changes taking place within it. The more I investigated, the more aware I became of the interconnections between Cuban socialist ideology, forms of popular culture such as rap and film, and the resilience of the Cuban state. I began to see the role played by artists in the gradual emergence of the Cuban system from the worst of the crisis. Besides a fascination with the peculiarities of the Cuban situation,

this study was motivated by an academic interest in what the Cuban case could reveal about larger questions of power, hegemony, and culture, and how these articulate in the context of late socialism.

But my research also addresses questions of a more personal nature; it reflects my concern with the political nature of art not just from an academic point of view but from the perspective of an artist and an activist. I was involved with campus activism for all of my undergraduate years at the University of Sydney, but I found myself increasingly frustrated by my inability to make people care about politics. While we would stand on a street corner with a petition against nuclear testing or protesting the increase in Aboriginal deaths in police custody, the young people whom we were trying to involve were standing in circles breakdancing or lining up outside movie theaters. I later became involved with the growing hip-hop movement in Australia. I worked with a company called Death Defying Theatre, which carried out workshops with young Aboriginal and immigrant rappers in Sydney's western suburbs. I was inspired by the three young militant Palestinian women who entered the stage in fatigues, rapping about the plight of their families in the West Bank, and the Aboriginal men who sent a video they had made of their rap group in a jail cell. A few years later, I formed a rap group with Waiata Telfer, an Aboriginal woman, and Alec Heli, an Islander man, in order to address what we felt were the important issues facing indigenous and immigrant communities, such as police brutality, lack of media representation, racial discrimination, and the growing influence of white supremacists. I found that up there on the stage, I could finally command people's attention. They would stop and listen to what we had to say when we couched it as a story. These personal experiences keyed me in to the role of culture as an important mode of communication, as well as a crucial terrain of political struggle and contestation.

This study unites my academic, activist, and artistic concerns. As an insider and an outsider, I see all three of these realms as intimately bound up with one another, and possibly enriched by one another. The mixing of activism, art, and scholarship is not always encouraged within academia, as shown by reprimands issued by Harvard's president, Lawrence Summers, to the African American studies professor Cornel West in October 2001. Summers questioned West's nonscholarly pursuits, including his role as a consultant to the politicians Bill Bradley and Al Sharpton and his recording

of a rap album, *Sketches of My Culture*. This attempt to preserve the purity of academia from incursions by the outside world was misplaced, and West's threats to leave Harvard quickly drew apologies from the president. But Summers's lack of judgment was perhaps also a lack of foresight regarding the changing nature of academia, particularly as scholars of diverse perspectives, backgrounds, and orientations enter into dialogue with the establishment. I locate myself among those scholars who seek to create space for alternative epistemologies and for the unorthodox blending of creative, political, intellectual, and personal pursuits.

Acknowledgments

Part of this volume deals with the value of collectivism and how it is experienced and realized within Cuban society as the island becomes increasingly caught up in the globalization process. My experience in researching and writing this book has also been a highly collective and transnational experience, due to the support, encouragement, and crucial contributions of numerous people across the globe. To my friends in Cuba who inspired this project and helped me realize it I owe immense gratitude. My friend Norma embraced the project from the moment I first mentioned it to her, and she worked with me the entire time I was in Cuba as though the project were her own. Her lively sense of humor has always kept me going. Hilda, Carlos, and *abuela* warmly welcomed me into their home and their lives. Through our long discussions, often extending late into the night, Hilda and I discovered together many of the crucial theoretical issues that were framing my study. Lily and her son Randy painstakingly helped me to transcribe sections of interviews and rap lyrics. Lily was also a dedicated and committed contributor to this project, organizing focus group sessions and turning up even in torrential thunderstorms, when nobody else would venture out. I shared home-cooked meals, the occasional Cuban cigar, and many passionate discussions about hip hop music with Magia and Alexei. Natacha was my constant companion, and our salsa dancing and beach excursions helped me occasionally divert my attention from my work.

I am indebted to those Cubans who facilitated my access to the film archives, including Dunia Rodríguez, Elvida Rosell, and Pedro; and music archives, including Grizel Hernández Baguer. I am grateful to Ambrosio Fornet for his generosity in providing contacts for my research, to Desiderio Navarro and Clinton Adlum for

our stimulating intellectual exchanges, to Catherine Murphy for sharing her thoughts and ideas, and to Gustavo Alcoz Fernández for his open and frank discussions about Cuban cultural politics. I owe thanks to Désirée Díaz and Lillebit Fadruga, who kindly lent me their MA theses on Cuban film and visual arts, as well as other materials, and especially to Lillebit, who provided crucial information by email at the last stages of the book. Hilda Torres and Kenya Dworkin also helped me translate many of the Cuban rap songs into English.

Field research can often be a transformative experience, and my many field trips to Cuba have put me in touch with some incredibly talented and inspiring musicians and artists, too numerous to list here, who taught me a great deal about art, improvisation, and politics. To perform at the jazz club La Zorra y el Cuervo with the percussionists Emilio Valdez and Changuito, to sing with Decemer Bueno, to record with the producer Pablo Herrera, and to perform with the rap musicians Magia and Alexei are experiences that can happen only in Cuba, and they have been some of the most profound experiences of my field research and my life. I thank them and Agustín Drake, Mercedes Cortés, Mateo, Ariel Fernández, and Juaniquiqui, all artists who have had important influence on the project by showing me new ways of seeing Cuban politics and conceptualizing art.

This book comes out of my doctoral dissertation, and I was lucky to have an enthusiastic and dedicated dissertation committee, who gave substantial time, energy, and creative inspiration to my project in ways that have driven me to expand my own horizons and abilities. I am profoundly grateful to my co-chairs, Susanne Rudolph and Lisa Wedeen, for they have influenced me and the project in ways I cannot begin to express. Susanne Rudolph is an exemplar of the kind of academic I aspire to be and the kind of person I hope to be within academia. Her generosity of spirit, her unwavering support for my project, and her continual faith in my abilities to meet the tasks I set myself have helped me to sustain my vision of what I hoped to achieve. Lisa Wedeen has been part of the project since before it was even conceived: her dynamic lectures on interpretive methods convinced me that such a study was possible within political science, and she continued to push, probe, and lend her creative insights and critical red marks to everything I wrote. Susan Stokes showed me ways of looking at my own material that helped me to begin the task of theorizing and organizing the dense matter I had collected. I was fortunate to have Bill Sewell's

interventions and critical readings, which kept me close to the ethnography and the fieldwork experiences that have animated my research. John Beverley provided many vital contacts in Cuba, and my interactions with him, as well as his classes on Latin American film and popular culture, have helped me to engage with a broad range of cultural studies literature that has proved important for my work.

Many others gave crucial feedback and criticism on various versions of the manuscript. Patchen Markell gave generously of his time to help me work through theoretical knots at an early stage. Two close friends from graduate school, Jen Rubenstein and Yasmin A. Dawood, read over several drafts of chapters and offered wise and caring counsel every step of the way. Various chapters benefited from critical readings by Robin Moore, Tony Kapcia, Ariana Hernández-Reguant, Diane Soles, Kate Gordy, Luis Duno, Eric Hershberg, Iraida López, and Ted Henken. My students Jessie Weber and Katie Brennan read over the entire manuscript at a late stage and gave me detailed feedback. Other students, Rocío Rosales and Margaux Joffe, have been important interlocutors about Cuban cultural politics and gender. Earlier versions of chapter 3 were published in *Anthropological Quarterly* and the *Journal of Latin American Cultural Studies*. I thank the editors and reviewers of these journals for criticism that shaped the book in important ways.

I received a good deal of critical feedback and useful advice on various drafts of chapters from my presentations at the University of Chicago's Social Theory Workshop, Caribbean Studies Workshop, Anthropology of Latin America Workshop, Comparative Politics Workshop, and Political Communication and Society Workshop. I have also had opportunities to present my work at the Literary Studies Colloquium at Fordham University, the Latin American Studies Seminar Series at Princeton University, the Bildner Center for Western Hemispheric Studies Cuba Seminar series at the CUNY Graduate Center, the Comparative Politics Faculty Seminar at Princeton University, the Northeastern Political Science Association (NPSA) Conference in Philadelphia, the "Locations of Africa in the Black Atlantic" Conference in the Anthropology Department at the University of Chicago, and the Hip-Hop Festival Colloquium at the Union of Cuban Writers and Artists (UNEAC) in Havana. I thank the organizers and audiences of those events for their helpful criticisms and comments.

The Society of Fellows in the Liberal Arts at Princeton University has

been a wonderful interdisciplinary home in which to revise my dissertation into a book. I am very grateful to Mary Harper, who ensured that my time at Princeton was as rewarding as it could be. My exchanges with Yan Hairong proved crucial to developing many of my ideas, and together we explored much new ground in Marxist theory and practice. I have been lucky to have a supportive group of mentors and colleagues at Princeton. Miguel Centeno made time to explain the publishing game to me, and he opened doors, read drafts, and extended his infectious enthusiasm to my work and my book. Jim Clark undertook the task of guiding me through the whole process, from reading and commenting on my entire dissertation to providing advice about publishing and facilitating contacts at every stage. I enjoyed sharing my home-cooked Indian meals with Jim and his wife, Isabel Clark-Deces, although I know that I can never repay them for everything they have done for me. Carol Greenhouse saw the shape of my book before I did and helped me work through theoretical and practical problems during each phase of review. Her pioneering work in political anthropology has been very stimulating to my own research. Deborah Yashar, Atul Kohli, Val Smith, Stan Katz, Mitch Dunier, Jeremy Adelman, and Michael Stone also gave feedback on various sections of the book and/or provided advice and guidance, for which I am grateful. I was lucky to have access to the wonderful folks at the Bildner Center for Western Hemispheric Studies at the CUNY Graduate Center, especially Mauricio Font, Margaret Crahan, and Jerry Carlson, who warmly encouraged my endeavors and helped me whenever they could.

This work would not have been possible without generous grants for field research and writing. I thank the Center for Latin American Studies (CLAS) at the University of Chicago for providing a summer grant for an early field trip to Cuba. I am grateful for a Social Sciences Research Council (SSRC) Dissertation on the Arts Fellowship, which allowed me to carry out my major stint of field research in Cuba, as well as giving me some time for write-up soon after I returned. I also had a Mellon Foundation–University of Chicago Dissertation-Year Fellowship for my final year of write-up. I was fortunate to have two skilled and committed editors at Duke University Press, Raphael Allen, who had a vision for the book, and Miriam Angress, who carried that vision through to the end. I am also thankful to five anonymous reviewers and a very skilled copyeditor who made crucial contribu-

tions to the final form of the book. At the Woodrow Wilson School of Public and International Affairs, where I have been based while at Princeton, my secretarial assistants, Janet Thompson and Bridgette Coleman, provided a great deal of administrative support for the project. Fernando Acosta-Rodríguez, an endlessly resourceful Latin American Studies librarian and colleague at Firestone Library, provided me with many materials, as well as being an interlocutor on contemporary Cuban politics. Thanks also to my research assistants, Paula Cortés-Rocca, Jessie Weber, and Rebecca Wolpin, for archival and transcribing work.

I am grateful to those friends and family who oversaw the technical side of my book. My dear friend Armin Moehrle was my twenty-four-hour computer service hotline technician. My auntie and uncle, Daphne and Dominic Gonzalvez, took on the tedious task of storing and archiving the material that I sent them regularly from Cuba over the three years that I made field research trips. I am grateful to them for their guidance over the years: they have always supported me in my academic endeavors.

This book is dedicated to my parents, Joe and Sylvie Fernandes, whose influence on me is apparent in this book in more than one way. They encouraged my love of political debate, my appreciation of music, and my desire to travel, explore, and question the world from a young age. They have taught me to follow my heart above all else, and for this I am deeply grateful. My sister Deepa has always inspired me with her constantly innovative activism and ideas, and my association with Cuba has been mediated through her own incursions into Cuba and the paths that she opened up for me. She has been my co-conspirator, collaborator, and soundboard for as long as I can remember. Priya Srinivasan was my long-distance savior; her unfailing optimism and continued faith in me have been the driving force that kept my goals in sight and my failures in perspective. My *compañero*, Mike Walsh, has lived this project since the start, and he has kept me on track and helped me get off track when I needed to. Mike's exuberant personality, love of life, and sense of outrage over social injustice always ground me, and I consider myself lucky to have him as my life partner.

Introduction

Artistic Public Spheres and the State

I am looking out from my rooftop apartment in Central Havana in the evening. In every house, television sets project the evening's news: "More Cuban doctors sent to El Salvador and Guatemala, young Cubans have the highest level of literacy among the young of all Latin American countries, Cuban athletes sent to Sydney to represent the glory of the nation." A few old men sit nodding off in front of their TV screens. A housewife, taking a rest from cooking the evening meal, pauses momentarily in front of the screen and then returns to her work. But the television is merely background noise for most of the residents of this barrio. Women stand in the center of the street, children on their hips, talking loudly. Men play checkers with old bottle caps on the sidewalks, kids push each other down the street in makeshift wooden carts, and old women sit in doorways, holding their skirts to their knees. After the news comes the movie of the evening, a Cuban film. Gradually the streets become deserted and for two hours the whole neighborhood laughs together, cries together, and offers advice to the characters on the screen. As the sun sets over the Malecón, the city is engrossed in the trials, tragedies, and triumphs of its screen heroes. Once the film ends and a matronly woman comes on the screen to talk about the high level of public health enjoyed by Cubans, the streets fill up again. Men lean on balconies smoking cigars and arguing animatedly, women shout across the balconies to each other as they hang up sheets, even the dogs engage each other in mock fights.

In Cuba, as in most other parts of the world, ordinary citizens find that the rhetoric and slogans that issue from official media and political speeches do not always speak to them in a compell-

ing way. Issues that were earlier relegated to political organizations and mass rallies are increasingly being addressed in the spheres of culture and consumption. Within the arts and popular culture, Cubans debate questions of socialism and democracy, legality and illegality, tourism, emigration, and issues of racial and sexual discrimination. On buses, in food queues, and in the market, Cubans engage in lively informal discussions about the latest Cuban films. Young black Cubans on the corner rhyme about racism, police harassment, and survival. Members of troupes and ordinary Cubans participate in impromptu theater in the streets. Artists hold private exhibitions in their homes. Students shoot videos about controversial political issues. Tattoo artists inscribe flags and other cultural icons on the bodies of their clients. In many ways, Cubans live through the arts. Particularly during the 1990s and the early twenty-first century, the arts have taken on a vital role in formulating, articulating, and making sense of everyday life.

These images of vibrant and engaged public spheres that have developed through the arts sit oddly with most accounts of Cuban politics. Scholars have tended to portray the Cuban socialist state as a highly repressive regime that stifles individual freedom and exiles or imprisons its critics. Most scholars of Cuban politics have not addressed culture and the arts, and when they do, it is generally to point to the damage done to the arts by an ideologically driven cultural bureaucracy. Cuban literature marketed outside of Cuba, such as Reinaldo Arena's autobiography, *Before Night Falls*, does show problems of exile and censorship in the arts. However, the revolutionary period has simultaneously produced and nurtured a prolific and internationally recognized national cinema, Cuban musical geniuses such as Chucho Valdés and Frank Fernández, and a flourishing national ballet, among other artistic accomplishments. How can the production of this rich body of artistic production be reconciled with the standard representations of an inflexible, authoritarian, and repressive cultural apparatus? Moreover, highly critical forms of art and popular culture have emerged to address issues such as bureaucracy, racial and gender discrimination, and alienation in Cuban society. Why does the Cuban state permit these vibrant and critical artistic practices?

The crisis that followed the collapse of the Soviet Union gave rise to a plethora of agents seeking to negotiate with the state for varied and com-

peting social demands. In a moment of growing contradictions, greater repression of formal political activities by the state, and the emergence of new social bases for action, the arts have become an important forum in which ordinary Cubans evaluate competing political alternatives, rethink the basic values of the revolution, and reformulate visions for the future. It is through these discussions and debates about art that new alliances and realms of agreement are consolidated between artists, ordinary Cubans, and the state. Artists and publics collaborate with government actors to re-incorporate critical expressions into official discourses, often strategically and self-consciously. In contrast to standard accounts of Cuban politics and authoritarian states in general, I see the state not as a repressive centralized apparatus that enforces its dictates on citizens from the top down but as a permeable entity that both shapes and is constituted by the activities of various social actors. Moreover, incorporation entails some degree of dialogue, which gives a public profile to the critical issues raised by artists.

I term these critical spaces within the arts "artistic public spheres." I define artistic public spheres as sites of interaction and discussion among ordinary citizens generated through the media of art and popular culture. Theorists have not generally used the concept of the public sphere to talk about socialist societies, because of the widely held principle that critical debate and discourse should be independent of the state. For Jürgen Habermas (1996:369), it is not possible for public spheres of civil society to exist in authoritarian or bureaucratic socialist societies; he claims that administrative intrusions of the socialist state corrode local networks, paralyze independent engagement, crush social groups, and dissolve cultural identities. Yet in Cuba under late socialism,[1] we find critical and lively discussions about politics even in cinema, an art form that is highly dependent on the state. The dynamics of the Cuban case provide a challenge to conventional notions of public spheres, which have tended to emphasize their conceptual distinction from state and economy. In contrast, I see artistic public spheres as spaces of interaction which are both critical of and shaped by state institutions, local relations of production, and global market forces.

By focusing on public spheres, and not on the Cuban state or the charismatic figure of Fidel Castro, I seek to foreground the perspectives of ordinary people. This book presents a window into the lives of Cubans during a time of extraordinary social change and contradiction, and it records

the poignant voices of these Cubans, desperate to hold on to meaningful and deeply held values from the past. This story is partly an account of the Cuban tragedy, as consecutive superpowers have squandered the aspirations of Cubans for a new and better society, only to leave them at the mercy of a unipolar world. But even in the despairing circumstances of the present, many Cubans continue to believe that the revolution was important and that elements of its values and institutions can be salvaged. As an ethnographer, I have been privileged to enter the lives of Cubans during this unique and unprecedented moment in history, to record their hopes, dreams, and continuing faith in a future. As a social scientist, I show how the Cuban experience can shed light on broader theoretical debates about state power, public spheres, culture, and hegemony.

Explosions of citizen unrest in the 1990s in places such as Los Angeles, Palestine, Chiapas, South Korea, Argentina, and Bolivia show that Cubans may not be alone in their vision of an alternative social order. Some political scientists argue that the twentieth century saw a universal commitment to market reforms and multiparty democracy.[2] However, this tendency toward liberal democracy and free market capitalism may not be universal, as evidenced by the popularity of communist successor parties in East Central Europe; the coming to power of populist and workers' parties in Venezuela, Uruguay, Bolivia, and Brazil; and the continued survival of Cuban socialism and Chinese market socialism despite predictions to the contrary. In a moment of weakening national sovereignty and increasing inequalities generated by free trade agreements and the decline of redistributive welfare states, the ideologies of egalitarianism and local autonomy promoted by revolutionary and developmentalist governments remain attractive, particularly to poor and working-class people of underdeveloped countries. The Cuban story provides a useful way of analyzing the factors that sustain state-led developmental alternatives despite declarations of the "end of history" and the global appeal of liberal democracy as a system of governance.

Cuba is a particularly interesting case because its crisis replicates those of many developing countries in Latin America, Eastern Europe, and Asia while also differing from them in significant ways. In the late 1950s, a guerrilla movement led by Fidel Castro gathered popular support around the country, culminating in the overthrow of Fulgencio Batista's regime in 1959. Once in government, Castro and other prominent leaders of the movement such as Ernesto "Che" Guevara and Camilo Cienfuegos set about

the task of nationalizing major U.S.-owned corporations, sugar mills, and large farm properties in order to begin a process of national redistribution, similar to that which occurred in Nicaragua in the 1980s under the Sandinistas. However, the severing of all trade and diplomatic relations with the United States and the consequent economic embargo imposed on Cuba led Castro to seek support from the Soviet Union in the early 1960s, beginning a three-decade-long economic and political relationship that ended abruptly with the collapse of the Soviet Union. Since the onset of the so-called special period[3] in the early 1990s, the Cuban government has been forced to make concessions to the international market, allowing some degree of foreign investment and privatization. The adoption of neoliberal-style reforms has been much slower in Cuba than in Latin America and Eastern Europe, but Cuba has been undergoing a process of controlled transition that is undermining the socialist project of centralized planning and gradually reintegrating Cuba into global markets.

The Art of Politics

In recent decades there has been a resurgence of interest in the concepts of state and civil society, initially in response to changes in post–World War II international political economy and later as political scientists attempted to theorize the resurgence of popular sectors in collective movements that brought down long-standing authoritarian regimes in Latin America, Eastern Europe, and Africa. Renewed attention to the state in the 1980s was spearheaded by Peter Evans, Dietrich Rueschemeyer, and Theda Skocpol's *Bringing the State Back In* (1985), a work that sought to define an autonomous and active role for the state against both the society-centered explanations coming from pluralist and structuralist frameworks in political science and sociology and reductive Marxist perspectives that saw the state as an instrument of class rule. This volume contributed to a developing literature in political science that saw the state as an independent variable, referring to its institutional weight, internal structural coherence, and capacity for autonomous action.[4] Although the recent popularity of the civil society concept has been premised on a reduced role for the state, given its associations with bureaucracy, authoritarianism, and welfarism, state-centered perspectives nevertheless provided the theoretical scaffolding for civil society theorists by insisting on the separateness of state and society.

Beginning with an analysis of the Polish opposition movements in the

early 1980s (Arato 1981), political scientists invoked the concept of civil society to explain the transitions from authoritarian rule to civilian government in a variety of contexts. These scholars argued that civil society, as a broad set of activities consisting of public communication, associations, and social movements, was instrumental in the development of political alternatives that could oppose and ultimately replace authoritarian regimes.[5] Most of the civil society literature in political science extols the value of a "lively and independent civil society" (Linz and Stepan 1996:9), "autonomous organization in civil society" (Przeworski 1991:58), and the normative requirement of an institutional division between the two spheres of state and society (Keane 1998, Cohen and Arato 1992). These approaches have helped to broaden the scope of what we mean by politics and have opened new possibilities for theorizing the relationship between spheres of public action and state power. But the emphasis on state and civil society as bounded and often opposed entities limits their analytical scope in contexts such as Cuba, where governance is not confined to the formal political apparatus and critical activity is often developed within or in collaboration with official institutions and actors.

Another approach to the study of state and society sees modern forms of power as actually operating through the diverse networks and relations of civil society. Following an alternative theoretical trajectory through the work of Antonio Gramsci, Louis Althusser, and Michel Foucault, various political scientists and sociologists have sought to demonstrate the illusion of a state-society distinction. These works exist along a continuum, from those of radical culturalists such as Nikolas Rose and Peter Miller (1992), who tend to dissolve the state into the elaborate networks and relations of civil society, to those of such analysts as Timothy Mitchell (1991, 1999), who seek to retain the distinction between state and society insofar as it is an effect produced by power. Unlike analysts who take the mainstream approaches, these scholars are more sensitive to Gramsci's (1971:261) expanded concept of the state as not just "the apparatus of government" but also "the 'private' apparatus of 'hegemony' or civil society." These approaches offer a way to conceptualize transformations in governance and the extension of modern power into social and political life. But these theorists converge in their understanding of the state as a discursive field. Various poststructuralist and postcolonialist theorists have also seen the state

in this way, as a "mythicized abstraction" (Foucault 1991:103), "the façade of an entity" (Mbembe 1992:6), and a fetishized idea (Taussig 1997). These perspectives obscure the role of the state in the creation and regulation of institutions. Moreover, collapsing the two spheres into one discursive field makes it impossible to track the penetrations between state and society in an empirical sense.

In contrast, Gramsci saw civil society as both distinct from and coterminous with the state. At times he refers to state and civil society as two separate levels: civil society as "the ensemble of organisms commonly called 'private'" and the state as "political society" (Gramsci 1971:12). At other times Gramsci (1971:244) presents the state as consisting of an "entire complex of practical and theoretical activities" that enable it to maintain its dominance. Although these two usages may seem contradictory, in fact, as some theorists have noted, Gramsci holds them in fruitful tension with one another (Neocleous 1996, Crehan 2002). In his analysis of the free trade movement in early-twentieth-century Italy, Gramsci (1971:159–160) shows how the proponents of economic doctrines of free trade presented distinctions between state and civil society as "organic," when in fact these distinctions are "merely methodological." Gramsci retains the methodological distinction between state and civil society, which, as Kate Crehan (2002: 103–104) notes, exist not as inherent bounded categories but as a set of power relations that make sense only when they are situated in a specific historical and ethnographic problem.

This kind of approach to the study of state and civil society is found in the work of some Cuban and Chinese scholars. Cuban scholars have pointed to what they call a "redimensionalizing" of the state–society relationship in Cuba in the early 1990s, whereby the state withdrew from various channels of civil society, giving the latter greater space to function (Dilla 1999, Acanda 1997, Limia 1999). Theorists accord this greater role of civil society to a number of factors, including the opening up of Cuba to a global market economy; the scarcity of resources, which reduced the economic power held by state institutions over their members; and the political crisis of the special period, which forced the Cuban government to concede space to other social actors. But the Cuban scholar Haroldo Dilla (1999:164) also describes the ways in which the state has penetrated the new roles and representative organizations of civil society. Similarly, schol-

ars of post-Mao China have shown that cultural contestation came to be situated within the socialist state apparatus rather than in opposition to it. Wang Hui (1998:32) argues that the opposition between market reformers and the state that developed in countries such as Poland is unlikely to occur in China because "market reforms in China were initiated by a strong state from the very beginning." Cuban and Chinese scholars show how the state operates through civil society, but by retaining a methodological distinction between the two levels they are also able to trace historical shifts in state power as the state withdraws from an omnipotent role in civil society but brings emerging critical movements and activities under its purview.

Scholars in fields such as comparative politics, political theory, and political anthropology have also noted the greater collaboration of state institutions with the organizations, agencies, and actors of civil society.[6] Atul Kohli and Vivienne Shue (1994:323) suggest that we look at "mutual empowerments of state and society; tactical disengagements between elements of state and society; and alliances of domination." Moreover, as Shue (1994:82) goes on to elaborate in her insightful study of associational life in China, the renegotiation of state–society relations in contemporary China has created the conditions for both empowering new social forces and enhancing state power. These analyses of state power reveal the inadequacy of theories such as state corporatism, which developed in the 1970s as a way of explaining how authoritarian states co-opted critical movements by recognizing or licensing them.[7] The state has maintained and extended its power not by expanding bureaucracies but by decentralizing tasks and strategies of governance. The "state" encompasses the formal institutions and apparatus of government, but I use the term "state power" to refer more broadly to the arts of governance that have emerged as states eschew highly centralized forms of rule for accommodation, negotiation, and collaboration with a range of actors.

While the concept of the state is more intelligible across a range of contexts, some theorists question the notion of civil society as a transhistorical empirical category (Chatterjee 1990, Comaroff and Comaroff 1999). According to John and Jean Comaroff (1999:23), the liberal concepts at the core of civil society, including "the nation-state, the individual, civil rights, contract, 'the' law, private property, democracy," presume a series of exclusions and separations that rule out the participation of certain sectors.

Interactions between public and private are culturally specific; non-European societies produce their own forms of accountability, public spheres, and associations that may not be reducible to the Euro-specific concept of civil society (Comaroff and Comaroff 1999:27). The analytical possibilities of civil society are also weakened by its ideological associations with "civility" and "civilization," its moorings in the European Enlightenment, and its historical implication in processes of colonialism and imperialism. Given these objections, what possibilities exist for reclaiming civil society, particularly in non-European contexts such as contemporary Cuba?

If we are to move beyond Eurocentric theoretical paradigms, we need to locate the changing state–society relationship in a broader reconfiguration of culture and the culture industries in contemporary Cuba and Latin America. According to Latin American scholars such as Néstor García Canclini (2001:22), in the contemporary era of globalization, public spheres have been reconstituted via the market through consumption of the mass media. In Cuba, the strict official control over television and radio and the repression of formal political activities that began in the mid-1990s has meant that it is rather the arts that became a privileged site for the exercise of cultural citizenship, particularly given their growing importance as an export sector for the Cuban state and in the tourist sector. But while the arts may help to generate new public spaces for debate and dialogue, these spaces also constitute an important means by which the Cuban state redraws the parameters of its hegemonic project.

The Politics of Art

Sociology and communications approaches to culture and the culture industry have made important contributions to our understanding of the new cultural conditions under which citizens and states interact in an age of information technology and mass communications. The concept of the "culture industry" comes from the critical theorists of the Frankfurt School in Germany. Theodor Adorno (1984) offered an extensive analysis of the ways in which the mass culture of late modernity replaces critical, engaged political art with a conformist, commercially manufactured popular culture. For French sociologists of culture such as Pierre Bourdieu (1984), social reproduction is linked specifically to differentiated and specialized fields of consumption. While mass or popular culture is governed by the require-

ments of capital, the emergence of autonomous artistic fields with their own criteria of knowledge, rules, and conventions legitimates the distinction and power of the elite.

The cultural studies theorists Néstor García Canclini, Jesús Martín-Barbero, and Carlos Monsiváis[8] have sought to broaden Bourdieu's notion of consumption, particularly given the specific constitution of modernity in Latin America. These theorists suggest that in Latin America there is less evidence of the distinction between a functional mass culture and an autonomous elite art. In the 1920s and 1930s, García Canclini (1995:96) argues, the subordination of popular traditions in Latin America to the imperatives of a national culture often led to the mixing of the cultured and the popular. In the course of global modernization, this tendency has been manifested in such diverse ways as the marketing of gallery art to a wide public, the mass production of avant-garde literature, and the conversion of art film to video for popular consumption (García Canclini 1995:17). Martín-Barbero (1993:77) in particular seeks to restore a Gramscian notion of hegemony as cultural struggle to an analysis of the culture industry. Martín-Barbero analyzes how fields of contestation can be created within mass culture.

Other scholars suggest that the dominance of neoliberal policies of privatization and trade liberalization has led to a shift from the ideological functions of culture to the expediency of culture (Yúdice 2003, Ramírez 1996, Dávila 2004). George Yúdice (2003:12) argues that in the United States, culture has increasingly been conceptualized as a "resource" that can solve the crime problem, promote education, build capital, and bridge racial divides. Mari Carmen Ramírez (1996:25) suggests that the integration of Third World countries into global markets has necessitated the exchange of cultural capital for access to economic and financial privileges. Culture becomes an important export commodity for governments and local elites on the periphery, especially given the decline in traditional export markets. This analysis is particularly relevant to Cuba, whose culture industries have undergone significant changes since the start of the special period as a result of their reinsertion into global networks of production, distribution, and consumption (Hernández-Reguant 2004). Cuban arts and popular culture were partly commercialized as a way of enticing foreign investment into Cuba. Through foreign licensing of Cuban records, overseas

contracts for musicians, joint film productions with overseas companies, and foreign sales of Cuban art, the Cuban government was able to attract badly needed revenue. International projections of a vibrant Cuban culture have been a cornerstone of the tourist industry. As Esther Whitfield (2002) argues, the pan-cultural transatlantic *nuevo boom cubano* (new Cuban boom) triggered by the success of the Cuban ensemble Buena Vista Social Club has been linked to the Cuban government's attempts to attract hard currency through tourism and investment. The international prominence and marketability of the arts has reduced the importance of ideological considerations for the Cuban government.

But at the same time, the insertion of the Cuban culture industries into global markets of entertainment and consumption has opened up the site of culture to new contradictions. According to Lisa Lowe and David Lloyd (1997), the operation of transnational capital through multiple segmented spheres produces a new "politics of difference" that reifies the exotic features of non-Western cultures for market consumption and provides the basis for the emergence of new kinds of identities. For instance, Afro-Cuban themes, previously marginalized in cultural discourse, have become more visible as a result of the global market's appetite for everything it sees as "different." Afro-Cuban culture is being packaged for sale to tourists and commodified for global audiences. The resurrection of stereotypical images of a tropical 1950s tourist haven and images of the crumbling majesty of Havana has aroused nostalgia in metropolitan consumers. Representations of life in the Cuban gulags and sordid accounts of deprivation and contradictions during the special period in art forms such as literature were also partly responses to the appetites of European and American audiences eager for contact with the forbidden island. This reification of difference has produced the conditions for alternative practices at the local level (Lowe and Lloyd 1997:24). Discussions about homosexuality in Cuban films, the emergence of blackness as a political identity in Cuban rap, and art exhibitions that feature race are attempts to bolster ever-present critiques and new concerns amidst the contradictions of Cuba's insertion into regimes of global capital.

Moreover, the Cuban state continues to monitor and shape domestic cultural production and reception. As the market makes new and limited kinds of agency available to Cubans, the Cuban state has turned critical cultural

expressions to its advantage by partially incorporating them into visions of a revised revolutionary project. Central to this task of reincorporation are cultural intermediaries, who have emerged as the brokers between state institutions and transnational agencies on the one hand and Cuban cultural producers and consumers on the other. Cultural intermediaries encompass a variety of actors and have their own agendas. Filmmakers, rap producers, and art teachers seek to broaden the scope of public discourse by raising the profile of previously taboo or marginalized issues within state institutions. These brokers are integrated into the dominant culture to varying degrees, and they seek to incorporate the more radical or alternative elements of cultural movements in official frameworks. But these domestic brokers operate at the intersection of local institutions and market forces, negotiating paths between distinct and often contradictory agendas. The agency of these intermediaries lies in their potential to translate and not simply transmit state directives, ideologies, and messages (Wilson 2001:317). Foreign curators of art open up spaces for Cuban artists to exhibit and travel overseas while shaping the production of art within Cuba. The international curator is based primarily in global markets, but moves through local markets with ease (Ramírez 1996:23). Like the local brokers, the international curators shape the possibilities of artistic expression as they break down older borders and expand the public visibility of artists.

The ability of cultural intermediaries to identify, appropriate, and absorb critical discourses and practices in dominant frameworks is part of the ongoing construction of hegemony in a moment of crisis. The Cuban state tolerates counterhegemonic cultural practices such as critical art because they can be reincorporated in official institutions, traditions, and discourses in ways that bolster the state's popularity, delineate the boundaries and limits of contestation, and promote national unity in the face of increasing ideological polarization and growing racial and economic disparities in Cuban society during the special period. But new modes of incorporation are incomplete and partial, as critical art can also give rise to ideas, strategies, and agendas that do not coincide with those of the Cuban state.

A Theory of Artistic Public Spheres

The relocation of the state–society relationship in new schemas of cultural production and consumption requires an analytical framework of the public sphere that goes beyond ideal-typical notions of the public, such

as that proposed by Habermas. Habermas sees the literary-cultural public sphere as a space where eighteenth-century European property owners, through intimate discussions and reflections on questions of humanity and identity, gained a sense of themselves as a bourgeoisie. Habermas (1989:50) shows how the development of a bourgeois consciousness in the literary-cultural public sphere was facilitated by literary forms such as the psychological novel, which "fashioned for the first time the kind of realism that allowed anyone to enter into the literary action as a substitute for his own." The medium of publicity made meditations by privatized individuals a process of collective self-discovery. This intimate sphere of personal reflection anchored the entry of bourgeois citizens into the external realm of politics, known as the public sphere. Some critics of Habermas have challenged the public/private distinction, arguing that one cannot exclude questions of identity formation, subjectivity, and difference from the activities of the public sphere by locating them in a private sphere (Ryan 1992; Calhoun 1992, 1993; Fraser 1992). Joan Landes (1988) contests the masculinist emphasis on discourse as speech acts and as rational. Nancy Fraser (1992:123) argues that the exclusions exercised by the mainstream public sphere have led to the development of oppositional or "subaltern counterpublics." Critical theorists have provided important qualifications to Habermas's concept, but they retain a notion of the public sphere as limited to voluntary forums in liberal democratic contexts, which are independent of both the state and market relations.

Can public spheres exist in one-party systems and within the state apparatus? The vibrant debate found in spheres of Cuban cultural life, including highly institutionalized forms such as film, would suggest so. Given the state's control over most areas of Cuban cultural life, conflict has historically been transferred to state institutions. The nationalization of film companies in May 1961 empowered the political leadership to set priorities for cinema and to control the production and distribution of film. But the establishment of cultural institutions in Cuba was a process that involved struggle between political leaders, who were more interested in the propaganda uses of art, and artists and cultural directors, who wanted to define an independent but collaborative role for art within the revolutionary process. During his famous speech "Words to the Intellectuals" on 30 June 1961 at the National Library, Fidel Castro (1961) emphasized the propaganda value of cinema and television as important for the "ideological in-

struction of the people." By comparison, artists and directors of cultural institutions promoted critical art and the concept of the active spectator.[9] Creative expression was fought for and defended against the intrusions of state bureaucrats. As in socialist Eastern Europe, confrontations between artists and the state often took place within cultural institutions, both sides using common points of reference such as the nation (Verdery 1996). In Cuba during the 1990s, public spaces of criticism also emerged within state institutions and state-sponsored cultural forms such as film, showing the ongoing importance of the state as a site of conflict and negotiation.

The role played by commercial forces in sustaining and promoting certain kinds of criticism in Cuba suggests that public spheres are not always distinct from the market, either. García Canclini (2001:159) suggests a notion of an "interpretive communities of consumers" as "ensembles of people who share tastes and interpretive pacts in relation to certain commodities (e.g., gastronomy, sports, music) that provide the basis for shared identities." Art forms such as film are bound up with the marketplace; there is a distinction between the ideal public sphere as envisioned by Habermas and the realities of commercial production and global distribution of art. But Cuban cultural producers such as filmmakers, rap musicians, and art collectives do retain a sense of themselves as interlocutors within a public sphere. These artists make a conscious attempt to create a space of dialogue and debate within the arts in Cuba. Following Jacqueline Urla (1997:288), I show how critical cultural forms envision members of the public as producers or participants, in contrast to mass-mediated forms of publicity, which construct the public as spectators or consumers.

I propose the notion of artistic public spheres as a way of capturing the dynamics of contemporary cultural production in Cuban society, which represent new kinds of negotiation within and against the limits of state power and cultural markets. The specific interaction of these forces is dependent on the shifting coordinates of cultural policies, markets, and alliances between artists and the state. The state may shield cultural producers from the global market, just as it plays an important role in the external promotion and internal commodification of culture and artists. Likewise, commercialization provides opportunities and alternative strategies for artists as it submits them to new criteria of marketability and profit. It is in these contested and contradictory fields that cultural producers such as

filmmakers, rap musicians, and visual artists have been able to carve out semi-autonomous spaces for expression.

As spaces of cultural struggle and critique, artistic public spheres in Cuba are generally linked to forces, discursive spheres, and forms of cultural expression beyond the nation.[10] Transnational cultural exchange existed in Cuba before the 1990s, but the collapse of the Soviet Union made possible new kinds of transnational linkages that facilitated closer contact with the nonsocialist world. Scholars argue that in a moment of growing contact with the outside world, interpretive communities are increasingly detached from national referents (García Canclini 2001, Beverley 2001). Solidarities and exchanges based on race, style, and other markers of cultural identity replace national belonging in the formation of "international communities of consumers" (García Canclini 2001:44). Hip-hop has created transnational communities of young black people who share experiences of race and marginality, expressed in clothing styles, greetings and handshakes, slang expressions, and the tropes of the ghetto or barrio. Many Cuban visual artists who still live in Cuba exhibit their work overseas, creating new hybrid cultural expressions in transnational spaces as a way of renegotiating local concerns. But while the creation of transnational cultural communities has been an important result of globalization, these communities do not always emerge in opposition to or to the detriment of national frames of belonging. Transnational exchanges and actors may act to reinforce the new modes of incorporation that emerged in the late 1990s.

The historical relationship with state institutions, access and exposure to various kinds of transnational networks, and the degree of participation in mainstream cultural life are all factors that influence the nature of artistic public spheres and their potential for critical debate and intervention. Filmmakers have increasingly been required to cater to the demands of international markets to secure co-productions. This requirement has created new constraints but also openings for their work, as it allows them to bring in themes not previously addressed in Cuban cinema, such as homosexuality and race. But as they continue to work within a mainstream state institution, filmmakers generally seek to incorporate more critical ideas through allegories of reconciliation. The marginal status and transnational alliances of rap musicians allow these artists to express more radical demands of racial egalitarianism and fashion new strategies for survival based on hus-

tling and consumerism. Young art students working in collectives have also aimed to make space for alternative cultures, as when they organized a transvestite show at their college. But while appeals to cultural identity in the form of racial and queer pride are a challenge to the race-blindness and homophobia of the Cuban political leadership and society, identity-based demands are also more easily incorporated in a vision of a diversi-fied and more tolerant revolution. As the censorship of certain Cuban films and exhibitions and the rocky relationship between the 1980s generation of visual artists and the state show, other oppositional ideas cannot be easily incorporated.

Methods

Patricia and Ricardo's home was in the rear section of a sprawling man-sion just off La Rampa, the main commercial district of Havana. To reach the house I had to pass by several Cubans on the front porch engaged in a game of dominoes and then make my way the length of a long corridor, in-vading the homes of two or three other families, all living together in what would have been the residence of one upper-class family before the revolu-tion. When I turned up at the house with my videocassettes, ready to show a film to the family and have a discussion, Ricardo apologized profusely, saying that they had received a call from an uncle who needed their help and they would have to cancel the session. I told them that I had one short film, only fifty minutes, and they agreed to watch that one before leaving for the uncle's house. As we began to watch the video, fumigators knocked on the door: under Ministry of Health regulations they needed to fumi-gate the house. The task would take about half an hour, and then we could not enter for another half hour. Patricia suggested that we take the video out to the street and watch it there while the fumigators did their work, so we carried out the video and television, passed an extension cord through someone's front window, and then carried out chairs to sit on. Meanwhile, the neighbors, interested in what was happening, asked if they could join us, and the game of dominoes ceased while the men from the front porch also came to see what was going on. Pretty soon a small crowd had gathered in the street to watch the film, and the discussion afterward was as close as one could get to replicating street-corner conversations in an experimen-tal setting.

This sort of thing happened so frequently when I attempted to organize film debates in Cuba that I came to think of the participants as ethnographic focus groups. I attempted to organize discrete groups of individuals to view films and discuss them in their homes, but often friends and other visitors would pop by and join in the discussion, or we would move en masse somewhere else. These spontaneous, improvised sessions greatly benefited the study, as casual, informal discussion was the phenomenon I was actually trying to observe. The term "ethnographic focus group" was coined by Andrea Press and Elizabeth Cole, who showed television programs to groups of women in order to explore the ways in which they discussed feminism and abortion. Press and Cole (1999:149) use the term to refer to their own alterations to the traditional focus group methodology: groups are smaller, they usually consist of friends or acquaintances, and discussions take place in homes rather than institutional settings.

Press and Cole (1999), following William Gamson (1992) in his qualitative study of how ordinary people discuss politics, suggest focus group methodology as a supplement or even alternative to public opinion research in fields such as political science. Press and Cole and Gamson question the ability of survey research alone to provide adequate answers to Americans' beliefs about complex issues such as abortion, the Arab-Israeli conflict, and nuclear power, suggesting that qualitative research that uses in-depth interview techniques can show how people actually construct and negotiate shared meaning. Press and Cole's and Gamson's insights bear strongly on this process in respect to the arts, for which survey data are available. For many years the Instituto Cubano de Arte e Industria Cinematográficas (Cuban Institute of Cinema Arts, or ICAIC), has carried out audience research surveys, administering questionnaires to audiences after each film and generating tables and maps of the results. However, these results alone shed little light on my concerns. Besides basic data of sex, age, race, religious belief, and occupation, the questionnaires ask people to evaluate the film's music, photography, and script; they ask about identification with particular characters and what the principal idea of the film was. Most questions are answered yes or no or by other one-word responses.[11] Tables and charts indicating that 32 percent of the audience identified with the main character or 77 percent liked the ending the best do not shed light on why they identified with the main character, what the ending signified for them,

or how people are using films to formulate and reformulate values and political ideologies.

I focus less on people's answers to standard questions in relation to particular media than on the ways in which they engage each other in debate in response to selected media. For this reason I rarely intervened, rather allowing participants to structure their own discussions. I attempted to use the techniques of ethnographic focus groups to study the film public sphere, a construct that so far has been elaborated only theoretically or textually, not ethnographically. I am concerned with how people argue with each other, the ways in which differences come up in conversations, and the means by which people negotiate those differences to come up with a shared perspective, or at least to justify their differences. This approach draws from work by various feminist interpreters of Habermas such as Susan Bickford and Georgia Warnke. Bickford (1996:2) emphasizes the importance of listening in processes of communicative interaction, and the ways in which listening can lead to changes in consciousness and can enable actors to clarify the nature of conflicts and how to act in the face of those conflicts. How does listening to the views of others enable people to enrich and develop their own understandings of their world? As Warnke (1995:256) suggests, more important than Habermas's "force of the better argument" are the insights that can be gained from listening and sharing. For Warnke, the aesthetic domain is a model in the sense that discussions can reflect an interpretative pluralism rather than necessarily leading to assessments of right and wrong.

However, critical debate and discussion take place within the context of particular relations of power, and even listening and sharing can function to reproduce those relations. As Shane O'Neill (1997:93) argues, patriarchal power is one form of power that can work to distort discussion. In my study of film in particular I sought to explore the effects of power on critical debate and discussion, analyzing the ways in which gender, race, age, and status affect how people relate to one another and their willingness to be influenced or their attempt to dominate. While Warnke and Bickford argue that interpretive pluralisms can do away with the need for moral consensus, I have found that people do come to agreement about particular ideas and values, and that interpersonal dynamics can often influence which norms or values are collectively accepted by the group. Broader power relations are

also at play in critical debates. As William Roseberry (1994a:361) suggests, material, social, and economic processes of domination are evident in the use of certain kinds of language: hegemony itself constructs "the central terms around which and in terms of which contestation and struggle can occur." I seek to explore the areas of agreement that may underlie critical debates, as these factors can give us an indication of the kinds of frameworks that are being reproduced through discussion.

I did not use ethnographic focus groups in the study of the public spheres of rap music and the visual arts because discussion of these cultural forms, unlike talk about films, is not an organized activity. Various forums in Cuba have popularized discussion and criticism of films. Cuban movie theaters regularly organize film showings followed by discussions, known as *cine debates*. When I was organizing ethnographic focus group discussions, people referred to them as cine debates. This term was widely accepted and the cine debate was seen as a normal activity. In comparison, while rap music and visual arts do elicit debate and people engage in discussions at concerts and in galleries, people are not accustomed to organized discussions about these forms, and hence an ethnographic focus group would be a much more artificial means to capture this debate.

In order to evoke the public spheres of music and visual arts, I used a combination of participant-observation techniques and ethnographic fieldwork.[12] My participation in artistic communities as a musician deepened my understanding of how artists work in Cuban society and strengthened my relationship with artistic communities. Prior to my field research, I spent three months in Cuba in 1998 as a singer and percussionist, performing with jazz and rap groups in clubs such as the Jazz Club of Havana, at local rap concerts, and for official events such as the Electro-Acoustic Music festival. During subsequent research trips I performed with Cuban jazz, rap, and funk musicians. In August 2000 I was part of a panel of judges at the auditions for the annual rap festival, an experience that gave me insight into how institutions intervene in artistic practices. I regularly visited galleries, attended exhibition openings, and was present at public performances. While these methods may be more partial than the ethnographic focus groups I gathered to study the film public sphere, I feel that they allow for a more organic and contextualized representation of these other public spheres.

In addition to the ethnographic focus groups, which involved seventy-five ordinary Cubans, I conducted open-ended interviews with over fifty cultural directors, state officials, filmmakers, rap musicians, music producers, workers in cultural organizations, visual artists, and art critics.[13] I used a semiotic approach as a means of gaining access to the conceptual world of artists (Geertz 1973), who may use either symbols or metaphors to articulate sentiments that they may not express explicitly. I spent several months in ICAIC's archives, watching and analyzing films from the early years of the revolution until the present. I collected and transcribed over eighty songs from twenty-five rap groups and analyzed their lyrics. I visited galleries and the homes of artists and I consulted art books in order to analyze works of visual art. In order to explore the transnational extensions of Cuban visual arts, in August and September 2004 I conducted interviews with curators and directors of art programs in New York City; in April 2005 I visited a Cuban art exhibition in Pittsburgh; and in October 2004 I traveled to Brazil to carry out some comparative research on hip-hop movements in São Paulo.

Other political scientists and anthropologists have used ethnographic methods to give vivid, illustrative evidence of political processes (Paley 2001, Wedeen 1999, Apter 1999, Comaroff and Comaroff 1997, Hansen and Stepputat 2001, Nugent 1997). Until the 1990s, with a very few exceptions —William Hinton's 1966 monograph on a Chinese village, José Yglesias's 1968 work on a Cuban country town, and Oscar Lewis's three volumes on Cuban men, women, and families living under the revolution (Lewis et al. 1977a, 1977b, 1978)—little ethnographic work was carried out on the socialist world. Since the collapse of the Soviet Union more work has been done on the dynamics of postsocialist societies (Verdery 1991, 1996; Burawoy and Lukács 1992; Berdahl 1999; Humphrey 2002; Wanner 1998; and Gal and Kligman 2000). In contrast to accounts of contemporary Cuba written outside Cuba, ethnographic fieldwork can bring out the complexities that make Cuba a lively place to study art and politics, particularly in the contemporary moment of crisis and change.

Until the 1990s, Cuban studies in the United States has been highly polemical. On one side, the Cold War discourses of anticommunism, typical of much Sovietology, shaped the development of so-called Cubanology and reduced the possibility of unbiased critical accounts of Cuban politics and

society during the revolution. On the other side, pro-Castro scholars have tended to have an idealistic, romanticized view of the Cuban revolution, ignoring problems such as the lack of democracy and state repression. Both sides have suffered greatly from an inability to carry out research in Cuba due to the United States' ongoing travel restrictions and the defensiveness of the Cuban state.

The openings in the 1990s made it possible for foreign scholars to do research in Cuba, and a younger generation of scholars, mainly anthropologists, have begun doing empirically informed research on Cuba that addresses some of the weaknesses of traditional Cubanology. The end of the Cold War has also eased tensions among Cuba scholars and led to some rethinking and reformulation. Nevertheless, the history and nature of polemical research in Cuban studies makes it a difficult subject to approach without raising hackles on either side of the ideological divide. As a political scientist dealing with questions of cultural politics, state power, and hegemony, I have had to confront these controversies. I have tried to ensure the accuracy of my work, and I have taken particular care not to fall into the ideological parameters constructed by either side. My scholarly exchanges with academics in Cuba have greatly enriched my work, and in this book I also make use of the research being carried out by these scholars, a body of work that has been ignored by most mainstream Cubanologists.

Organization of the Book

The principal argument of this book is that the ability of political regimes to associate themselves with alternative and oppositional images, values, and ideas matters for their legitimacy. I am using the Cuban case to clarify the ways in which alternative ideologies and visions emerge in societies, and how they become linked to particular political and social institutions. How do people bridge the gap between their ideals and their lived reality? What are the specific ways in which people's values are related to political regimes? Do ideas have to be tied to political movements in order to be significant? Why do people transfer their visions of revolution to the state rather than to the market or dissident political organizations? These questions frame my inquiry and suggest the many layers of contestation and negotiation that exist within transitional societies such as Cuba.

Chapter 1 provides an account of the evolution of ideologies and politi-

cal ideals in Cuba, showing how the Cuban revolutionary leadership sought to craft a new political project and suggesting why revolutionary values are now coming under scrutiny by a variety of social actors. The next three chapters explore the ways in which socialist ideologies are being contested, reframed, and reincorporated within multiple worlds of cultural engagement in Cuba. In each chapter I describe the distinct forms of cultural contestation and I trace the emergence of social agents who seek to reincorporate critical discourses into hegemonic frameworks. Chapter 2 shows the potential of a dominant public sphere such as film to assimilate new and emerging values into a political vision, primarily through allegories of reconciliation. In Chapter 3 I show the greater leverage available in a form such as rap music for asserting demands such as racial egalitarianism while bolstering the power of the socialist state around a new conception of a Black nation. In Chapter 4 I discuss the visual arts, a conglomeration of fields in which a younger generation of artists have used public performances and negotiation with state institutions to raise new issues and expose the contradictions between rhetoric and reality. In this chapter I also address the emergence of transnational visual artists who build a broader critique of global capitalism, highlighting the collusion of the Cuban state with foreign multinationals. The Conclusion discusses the implications of the Cuba case for theorizing about power, ideology, and hegemony.

1 Remaking Conceptual Worlds

Changing Ideologies in Socialist Cuba

Ordinary people share certain languages, symbols, and discursive frameworks for describing and perceiving change in their realities and for making sense of the world and their place in it. Discursive frameworks are shaped by the broader political and economic orders under which people live, but these frameworks can also be undermined, reworked, and overcome by counterhegemonic movements and orders. A radical ideological vision gave people the tools to analyze their existing realities and at the same time retained the power to reincorporate their alternative and oppositional ideas. The values and beliefs coded in that vision now shape people's efforts to come to grips with a tragic dismantling of the world as they knew it.

The revolutionary movements of the 1950s and 1960s in Cuba popularized such values and ideas as collectivism, work, and egalitarianism. These values had been implicit in the activities of certain groups and had some historical resonance within sectors of Cuban society as a result of nationalist and anticolonial struggles dating back to the nineteenth century. The revolutionary leaders used these new values as they attempted to remake the political, economic, and social worlds of ordinary Cubans and to win over large sectors of the population to their project of social reconstruction. The increasing gap between the rhetoric of socialism and the reality of everyday life produced an ideological crisis for the Cuban state of the kind that proved detrimental to the socialist regimes in the former Soviet Union and Eastern Europe. But the emergence of new modes of incorporation in Cuban society has allowed the state to manage the crisis as it attempts to rebuild its cultural legitimacy.

Hegemony as Partial Reincorporation

The concept of hegemony as it has developed within the social sciences and humanities has tended to focus on the cultural and discursive elements of power and domination. Drawing on Gramsci, cultural studies theorists and anthropologists such as Stuart Hall and Jean and John Comaroff argue that culture constitutes a crucial terrain in the war of ideas, as dominant groups attempt to gain popular support for their particular ideology or worldview. According to Hall, the ideology of a historic bloc becomes hegemonic when it becomes the "horizon of the taken-for-granted" (1988:44), when it "shapes our ordinary, practical, everyday calculation and appears as natural as the air we breathe" (1985:8). However, dominant values in contemporary Cuba are not "taken-for-granted" in the sense of constituting a set of shared values or a naturalized social order. The collapse of the Soviet Union and the ensuing economic crisis have revealed the contradictions between lived reality and dominant socialist values such as collectivism or the communal solidarity of the Cuban people, egalitarianism as the ideal of a community undivided by class or social distinction, and work as the voluntary labor necessary to overcome the nation's dependency. Individualism has become more marked, the introduction of a dollar economy has given rise to growing inequalities in Cuban society, and work is no longer remunerative.

A range of theoretical interventions in the social sciences have sought to challenge the account of hegemony as ideological incorporation or shared values. The political scientist James Scott (1990) claims that the subversive jokes, folktales, and other forms of hidden resistance that have always been a part of popular subaltern life prove that most subordinates have never been invested in the ideas of ruling elites to the extent claimed by Gramscian-inspired theories of hegemony. In contrast to the idealist interpretation of hegemony prevalent in cultural studies and anthropology, Derek Sayer (1994:375) also argues that domination is less about inculcating beliefs or securing consent than about inducing compliance by means of bureaucratic regulations and routines, such as licenses, censuses, and registers. Scholars have extended these insights to socialist and authoritarian systems, suggesting that citizens do not believe the claims of official ideology; rather they pretend to uphold official slogans and ideologies

while privately maintaining a cynical distance (Žižek 1989, Wedeen 1999). People's cynicism toward dominant values of work and collectivism does not matter; what is important to the maintenance of domination is that citizens participate in rituals that give the appearance of public consent. This interpretation does have some applicability in the Cuban context. Citizens see the contradictions between official ideology and lived reality, but they continue to participate in what Michael Burawoy and János Lukács (1992:20) have called "ritual activities," such as production conferences and brigade competitions, which give official ideology a structuring reality of its own. Cubans use the term *doble moral*, or duplicity, to refer to this upholding of official rhetoric while privately holding other views.

But even if dominant values are not "taken-for-granted" by ordinary Cubans, in my field research I found that many people are invested in and recognize certain meanings, images, ways of understanding their world, and articulating their concerns. This is not, as Roseberry (1994a) notes, a "shared ideology," but rather "a common material and meaningful framework for living through, talking about, and acting upon social orders characterized by domination." On the one hand, the material realities of power shape and constrict the kinds of frameworks and languages that are available, as Gramsci (1971:184) himself noted: material conditions such as economic crises can "create a terrain more favorable to the dissemination of certain modes of thought, and certain ways of posing and resolving questions." Consciousness is shaped by broader, often contradictory, material forces such as a socialist political economy, a growing tourist sector, and foreign investment, as well as by more local processes such as state censorship and systems of production. But on the other hand, people retain some agency to interpret, challenge, and reinvent the ideas and values that inhabit the public sphere; ideological struggle remains an important part of the way hegemony works.

I propose a notion of hegemony as both the cultural elements of values, images, and ideas that are broadly disseminated in a given social order and material practices such as regulation, censorship, and institutional control that may serve to inscribe meanings in everyday life. This concept of hegemony can help us to map the shifts in power that Cuban scholars identify as important in a moment of crisis and transformation, particularly as the Cuban state yields space to a range of actors and modes of governance be-

come more dispersed. In the contemporary period, in areas such as the arts, Cubans question the values and meanings that have motivated the Cuban revolution since 1959. However, beliefs are often reconciled or resolved in ways that bolster the power of the Cuban socialist state: this is how hegemony operates in Cuba. Instead of accepting the idea that an ideology achieves hegemony when it is taken-for-granted, I suggest we conceive of hegemony as a process of partial reincorporation, or the efforts of actors at various levels to assimilate counter-dominant expressions and practices into official discourses and institutions. Hegemony is always being made and remade, but in a moment of crisis when the system faces challenges from a variety of groups, we can see the process of reincorporation much more clearly.

By bringing a revised notion of hegemony back into our analysis of power and change, we can begin to theorize the complexity of ideological fields and their development over time. How are dominant discourses formed? How do ordinary people reimagine and reinterpret discourses in ways that are important for them at moments of crisis and change? How do diffuse and newly emerging values influence the ways in which official discourses are constructed?

Social Values in Prerevolutionary Cuba

There is a tendency within Cuban studies to see socialism as a set of foreign values that were attached to Cuban nationalism. For example, Tzvi Medin (1990:53) claims that Cubans were far removed from the conceptual world of Marxism-Leninism: "Cuban revolutionary leaders introduced Marxism-Leninism into the Cuban revolutionary message by grafting it onto the images, symbols, values, and concepts of Cuban nationalism." Antoni Kapcia (2000:6) sees the Cuban socialist values of collectivism, egalitarianism, and work as part of an ideology of *cubanía*, or Cubanness, that had been the basis of nationalist movements from the late nineteenth century to the 1950s. The values of collectivism, egalitarianism, and voluntary effort that were to become the basis of state ideology in the socialist period were embedded in prerevolutionary Cuban society through the experiences of the Cuban nationalist movements, religious and other forms of social organization, and even paradoxically as a result of the contradictory impact of such North American cultural influences as baseball, Protestantism, and

consumer culture. According to Louis A. Pérez (1999), such agents as missionaries, conservative politicians, revolutionaries, and North American capitalists competed to appropriate alternative values for their own particular projects of transformation. But by the 1960s, the revolutionary leadership had gained considerable ideological ground as the force capable of restoring the utopian vision of Cuban nationalism.

Collectivism was linked to the desire for equality in the experiences of the Cuban nationalist movements during the nineteenth century. Ada Ferrer (1999:4) argues that the joint political action of armed white, black, and mulatto men in Cuba's anticolonial war created a tangible basis for cross-racial alliance and national unity, in contrast to the spatial segregation of North America and the promotion of miscegenation in such countries as Mexico, Brazil, and Venezuela. In the struggle against Spain, nationalist ideology produced the vision of a free, equal, and inclusive republic (De la Fuente 2001:12). The notion of a unified community that was forged across racial and social lines, as envisioned by the Cuban nationalist leader José Martí, helped to foster strong traditions of collectivism and egalitarianism in Cuban popular consciousness (Kapcia 2000:86). On the one hand, as Ferrer (1999:135) notes, unity implied silence in regard to race; to speak of race was seen as compromising the nationalist project. But on the other hand, black and mulatto activists and intellectuals such as Juan Gualberto Gómez and Rafael Serra were central to the construction of an ideology of racial unity along with the white independence leaders José Martí and Manuel Sanguily (Ferrer 1999:133). Notions of a raceless Cuban community and collective national belonging were present in the writings and speeches of black Cuban intellectuals, insurgents, and journalists during the struggle for independence.

The emphasis on voluntary labor was also established during the nationalist movements of the prerevolutionary period. Matilde Molina Cintra and Rosa Rodriguez Lauzurique (1998:71) argue that the work ethic had specific roots in an ideology promoted by Martí. According to Martí, "Man grows with the work that comes from his hands. Creating the habit of an intelligent force emancipates the personality and disciplines the character" (quoted in Molina Cintra and Rodriguez Lauzurique 1998:71). The level of voluntary effort required by the anticolonial movements during the wars of independence gave further impetus to an ethic of work discipline.

The values that were nurtured by the anticolonial movements of the nineteenth century both conflicted with and found curious expression in various strands of North American culture that spread in postindependence Cuban society, as Cuba was increasingly drawn into the United States' orbit. Pérez (1999) argues that the growth of North American Protestantism after independence was partly a reaction against the Catholic church and its association with the Spanish colonizers. Protestant missionaries attempted to integrate Cubans into a new culture that emphasized the market as a means of well-being. Protestantism and the new market culture, represented also by the influx of North American motion pictures, advertising, fashion, and consumer goods, introduced values such as free will, individual responsibility, hierarchy, and consumerism, which stood in contrast to the notions of cooperation, collectivism, equality, and work that had been developed through the experiences of anticolonial organizing. But in other ways, Protestantism and market culture themselves promoted and reinforced the anticolonial values: the evangelical churches' ethic of hard work and helpfulness to others encouraged perseverance and cooperation. Quakers and Methodists organized programs to teach schoolchildren a "cooperative spirit" and promote crafts and cottage industries. Even baseball, popularized by an expanding North American presence, served in some ways to foster solidarity and an ethic of work and discipline among Cubans (Pérez 1999:250–259). But during the mid-twentieth-century years of revolutionary activism, new cultural visions led to a reconfiguration of ideological fields as they had developed in the nineteenth and early twentieth centuries.

Many factors led to increasing disillusionment with the North American cultural presence and the promises of the market in the 1950s. Washington's support for Fulgencia Batista's military coup of 1952 estranged Cubans from North Americans (Benjamin 1990:121). The decline in profits from sugar and broader structural adjustments produced unemployment and uncertainty, and the cost of living rose sharply (Pérez 1999:449–451). The promises of access for all and material well-being based on a prosperous market economy derived from U.S. models were giving way to a reality of privilege, hierarchy, and indifference to inequality (Pérez 1999:467). In this context, the unrequited aspirations and consumerism originally fostered by the market were transferred to the growing revolutionary movements that sought to challenge the authoritarian government of Batista.

The movement that toppled Batista's regime on 8 January 1959 joined guerrilla rebels, politicians, activists, supporters of the Cuban Socialist Party, students, workers, and intellectuals. As Kapcia (2000:99) states, this movement had a "visibly broad base of active and passive support" that crossed regional and social boundaries, including Havana's middle classes and elites, as well as the poorest peasants in the Sierra. The euphoria generated by the triumphant entry of Fidel and his forces into Havana in January 1959 and the participation of large sectors of the population in subsequent activities carried out by the revolutionary leadership—the literacy campaign, the Committees for the Defense of the Revolution (CDRs), cooperatives, brigades—produced a sense of solidarity that had a profound influence on Cuban social consciousness.

The campaign against illiteracy that began in 1961 mobilized one and a quarter million Cubans as teachers or students. Richard Fagen (1969:57, 75, 92) describes how the revolutionary leadership sought to encourage participation and keep the public involved by all means possible, including "auto races, tree-planting expeditions, athletic contests, beauty pageants, dances, songfests, literary events, inspirational talks, radio programs, televisions shows, symbolic displays, and even Coca-Cola advertisements." Castro launched CDRs on 28 September 1960 as systems of collective vigilance and popular participation, and by 1961 their membership was said to be over one million. The CDRs set out to promote urban reform, education, and public health programs by organizing neighborhood meetings, distributing printed materials, and ringing doorbells. The large scope of the mobilization and the sense of popular participation in pursuit of a common goal led to a dynamic of collective empowerment that had a strong impact on the lives of many Cubans. At the same time, the solidarity generated among those Cubans who supported and worked for the revolution turned them against anyone who was ambivalent about the revolutionary project; Cubans who had left the country or openly expressed dissent were scorned as *gusanos* (worms).

The Consolidation of Socialist State Ideology

After the initial euphoria of the 1960s, the political leadership set about institutionalizing the spontaneous and ad hoc revolutionary movement that had overthrown the Batista dictatorship. In the process of creating a hegemonic bloc, Fidel Castro and the other leaders of the Cuban revolution

sought to associate their new system with values and ideals that had long been incubating within Cuban society. They consolidated newfound values that had emerged through the activities of collective organizing over the past decade. In their task of establishing a socialist system of economic production based on state ownership of the means of production, the Cuban leadership drew on values of collectivism, egalitarianism, and work to justify and regularize new practices and productive relations. As Susan Eckstein (2003:12) argues, while policy initiatives may have been consistent with socialist ideology, the government often had economic reasons for advocating such policies, and used socialist principles to legitimate those policies.

In socialist Cuba, work was no longer necessary to cover living expenses, as rent, food on the ration, clothes, health care, and education were all provided free by the state. However, this suspension of the obligation to work created major problems for production, and absenteeism reached 29 percent in 1970 (Kapcia 2000:139). To deal with these problems, the state introduced the *ley de vagancia* (vagrancy law) in 1971 and enforced the criminalization of absenteeism through workers' councils (Pérez-Stable 1993: 130). In a society no longer subject to a capitalist logic of labor productivity, the moral value of work began to take on increased importance. Revolutionary leaders drew on ideological precedents in Cuban culture to reinforce the work ethic among ordinary citizens. The work ethic, with origins in the prerevolutionary nationalist movements, became crucial in a new system of socialized economic production.

In contrast to the Soviet line, which stressed material incentives for hard work, the political leadership initially sought to replace material incentives with moral incentives (Bunck 1994:127). Fidel Castro argued that while Cubans, heirs to a colonial past, clung to the notion of labor as degrading, in the new revolutionary society these attitudes must be replaced by a labor *conciencia*, or consciousness of the value of work (Bunck 1994:129). In particular, the political leadership emphasized the notion of voluntarism: all Cubans should work more than their scheduled hours in order to meet collective targets, increase production, and resolve problems. The emphasis placed on work varied with the projected goals of the Cuban government. At times when resources were scarce and the state needed to increase labor productivity, the political leadership adopted a militaristic language

to describe labor efforts as "heroic battalions," "doing battle" in the cane fields (Bunck 1994:144). Katherine Verdery (1996:64) explains that socialist regimes, lacking the inputs generated by the profit motive, emphasize industrialization programs that are "labor-intensive and capital-poor," seeking to increase production by maximizing labor power. Part of the ideological project of the Cuban government was to redefine work as a means to progress and change; it was no longer to be seen as dehumanizing and menial.

Egalitarianism was also a part of the new revolutionary socialist discourse being promoted by the political leaders, although they interpreted it mainly as economic equality. State ownership of industry meant that most Cubans became paid workers of the state, and the relative equivalence of public-sector wages kept wealth differentials from increasing markedly. The political leadership took a largely economic approach even to discrimination against blacks and women. Fidel Castro (1966:52) claimed that the institutional changes brought about by the revolution had eradicated the basis for such discrimination: "In a class society, which is to say, a society of exploiters and exploited, there was no way of eliminating discrimination for reasons of race or sex. Now the problem of such discrimination has disappeared from our country, because the basis for these two types of discrimination, which is, quite simply, the exploitation of man by man, has disappeared." The political leadership assumed that by addressing what they perceived to be the material bases of exploitation, they could eliminate discrimination by sex and race from Cuban society.

Drawing on traditional Engelsian arguments about the causes of sexual oppression as linked to women's confinement to reproductive tasks in the patriarchal family, the Cuban political leadership had maintained that liberation from sexual oppression was to be found through women's participation in the workplace (Bengelsdorf 1997:238). The Cuban state set up a mass organization, the Federación de Mujeres Cubanas (Federation of Cuban Women, FMC), to educate women and eliminate prostitution, but it proceeded on the assumption that the revolution had ended patriarchy and that women were free to embrace their new role in society (Smith and Padula 1996:39). Particularly in the 1960s, officials and mass organizations operated on the assumption that inequality between men and women had been eradicated from Cuban society. However, by the early 1970s there was

some recognition within official sectors of continuing sexual discrimination, and a bill known as the Family Code was passed in 1975 to make household maintenance and child care the joint responsibilities of husband and wife (Smith and Padula 1996:154). The Family Code was linked to recognition of the relationship between egalitarianism in gender relations and a notion of collectivism. While women's liberation in the West had come to be associated with self-fulfillment and self-realization, in socialist Cuba it was to be found in service to the society (Lewis et al. 1977b:x). One of the motivations behind the Family Code was an effort to free women to serve in mass organizations and to increase their workforce participation rates.

Part of the emphasis on gender egalitarianism in socialist societies comes from the view that sex discrimination prevents women from engaging fully in the task of achieving collective goals, and it is up to men and society as a whole to address these problems by facilitating women's entry into the workplace as equals with men. According to Verdery (1996:64), the goal of gender equality in Eastern Europe and the Soviet Union came from the need for a labor-intensive industrialization program rather than any real commitment to equality. The requirements for female labor in Cuba could also be seen as part of the reason for campaigns against problems such as women's "double burden." The Cuban film *Retrato de Teresa* (Portrait of Teresa, 1979) brought out the ongoing problems of the double burden faced by women, who continued to be responsible for domestic work and child care in addition to their work responsibilities. *Retrato de Teresa* structures the social problematic of gender in terms of work and responsibility to the collective, giving credence to the claim that Cuba's state-sponsored policy of egalitarianism was intended to encourage women to enter the workforce.

The political leadership's attack on race discrimination was motivated by a similar desire to unify Cuban society and mobilize the full potential of black labor alongside white workers. On 22 March 1959 Fidel Castro gave a speech in which he said that there were two kinds of discrimination against blacks in Cuba: denial of access to cultural centers and ("the worst") denial of access to jobs (De la Fuente 2001:263). The government attempted to eliminate race discrimination in employment by establishing a system in which all employees would be hired through the Ministry of Labor (De la Fuente 2001:274). The state assumed a paternalistic responsibility for en-

suring the eradication of discrimination and social hierarchy, and the goal of egalitarianism served to justify the absence of race-based organizing, as well as more centralized control. It is notable that while the government set up the FMC in order to promote women's advancement in the new revolutionary society, there was no corresponding organization for Afro-Cubans.

But in addition to economic concerns, state actions were guided by an ethos of collectivism and egalitarianism that were the hallmarks of the Cuban revolution. The provision of free social services, such as education, health care, social security, child care, and housing, came from a commitment by the state to reducing inequality and encouraging collective responsibility (Eckstein 2003:34). The new emphasis on manual labor was an attempt to reduce social distinctions and elite privileges. The nationalization of private schools, the desegregation of social spaces, and the integration of blacks into traditionally white neighborhoods all sought to break down the structures of racial inequality that had existed before the revolution (De la Fuente 2001). The socialist ideology may have been a tool used by the government to encourage people to work and sacrifice for the revolution, but in Cuban society these values also became associated with a broader project of emancipation.

The Evolution of State Ideology in the Neoliberal Present

Socialism was consolidated in postrevolutionary Cuban society as the result of contestations and struggles, both domestically and internationally. At the time the Cuban revolutionary state was established in 1959, the question arose in both society and the state: What is the best way to solve the problems of underdevelopment and dependency in a small country that in all but name is a colony of the United States? At that time, vigorous debates and discussions in all spheres of political life, combined with American military threats and withdrawal of trade, led the political leadership to accept support from Cuba's only powerful ally, the Soviet Union. By the early 1970s, the answer to the question seemed fixed: socialism was the best path to Cuban national development. In official political discourse, socialism replaced the nation as the highest value of the Cuban state and debate on the question of what was best for the nation was foreclosed. People could argue about how effectively the state applied Marxist-Leninist principles or they could criticize the functioning of workers' councils or party meetings,

but they could not argue about the validity of socialism as a path for the Cuban nation.

However, the collapse of the Berlin Wall in November 1989, followed by the demise of communist states in Eastern Europe in 1990 and the final disintegration of the Soviet Union in August 1991 after a failed coup against Mikhail Gorbachev, radically altered the Cuban political and economic landscape. The failure of the Soviet Union to deliver oil supplies in 1990 caused serious disruptions to the Cuban economy (Gott 2004:286). The overall decline in Soviet aid and export income, amounting to billions of dollars, caused a severe economic crisis, prompting the Cuban state to declare a "special period in time of peace" in September 1990. Over the course of 1991, imports from the Soviet Union fell by 62.2 percent, the decline in gross social product totaled 25 percent, and 29,348 workers were laid off. The effects on the economy and living standards of ordinary Cubans were drastic. Blackouts became a common part of life. Given the reduction of oil imports in 1992, national bus schedules were reduced by 40.5 percent and train schedules by 38.4 percent (Bengelsdorf 1994:167–168). The regime coined the term "special period" in an attempt to minimize the expected duration of the difficulties.

The disappearance of the Soviet bloc undermined the Cuban socialist system and left Cuba isolated not only economically but also ideologically. Triumphalist claims that "now there is only one superpower" and declarations of "the end of history" left Cuba without alternatives in a three-decade-long struggle to break its dependency on the United States. The rhetoric of the Cuban government became increasingly nationalistic. The slogan *patria o muerte* (fatherland or death) became more prominent in public discourse than the previous *socialismo o muerte* (socialism or death). Reforms to the constitution in 1992 changed article 5's reference to the Communist Party of Cuba (Partido Comunista de Cuba, PCC) as vanguard of the working class to the PCC as vanguard of the nation (R. Hernández 1999:28). In the ideological and economic crisis presented by the collapse of the Soviet Union, the Cuban state relied on nationalist rhetoric in an attempt to preserve unity among the population. The nation once again came to supersede socialism as the highest value in Cuban political discourse. While this shift to nationalism was necessary to mobilize people in support of the state, it opened the question of what was best for the nation for the first time since the 1959 revolution.

The political leadership and prominent academics continued to argue that socialism was the best way to solve the nation's problems. According to Luis Suárez Salazar (2000:325), a political scientist at the University of Havana, "socialism was, has been, and continues to be the essential condition to guarantee the independence of the country and to resolve the nation's problems, keeping in mind the interest of the majority." Leaders could no longer assume that people believed in the superiority of socialism, but instead they had to actively justify and rationalize socialism as the most effective form of political order to deal with the crisis. Darío Machado Rodríguez, a state ideologue, emphasized that Marxist-Leninist principles still constituted the basis of official ideology, although the ideas of such nationalist and revolutionary leaders as José Martí should be incorporated. Machado (1998:64) argued that if Cubans were to save the national economy and preserve the social victories of the revolution such as health care, education, and social welfare, they must continue their commitment to socialist principles. This rhetorical commitment to socialism, combined with the necessity of adopting market mechanisms in selected areas of the economy, led to what has been called a "dual economy," described by Dilla (2002:61) as the segmentation of the economy into two spaces: "a dynamic one linked to the world market and called upon to finance the second, which remained in crisis, ruled by central planning and generally concentrated on the internal market and traditional export activities." Market reforms began to gain ground after 1993, when socialist solutions to the crisis had clearly proved unsuccessful.

During the 1990s, the tourism sector expanded dramatically as the major source of foreign exchange income; the production and distribution functions of state-owned enterprises were transferred to foreign businesses through mixed firms; traditional export markets were recovered; and the dollar was recognized as legal tender,[1] so that the Cuban economy functioned as a dual dollar-peso economy (González Gutiérrez 1997:8, Valdés 1997:103). As Dilla (1999:164) argues, these changes led to a new organization of the Cuban political economy: "the state had to adopt by force an operational code dictated by the international market: greater productivity and efficiency, which implies a more rational use of resources and the workforce." Albert Campbell (1995:39), following James Petras and Morris Morley, states that the new form of accumulation based on Cuba's participation in the world market also required a politics of austerity. But

the Cuban leadership attempted to garner support for its new program of productivity, efficiency, and austerity by drawing on socialist values. For instance, Cuban functionaries insisted on the value of work and voluntary effort in the tourism industry. In an interview in *Granma International*, the general secretary of the National Trade Union of Hotel and Tourism Workers, Rodolfo Jiménez Polanco, told workers in the tourism industry that "work and political ideological study are fundamental in tourism in the context of socialism."[2] Higher productivity and efficiency were not the goals of individual firms, but were presented as the collective aspirations of society. Values of collectivity and work became part of new strategies of labor discipline through which the Cuban economy attempted to become competitive in the world market.

While in some ways socialist values were used to further objectives of efficiency, productivity, and austerity, market-oriented measures also led to growing inequality, unemployment, and individualism. The necessity of tailoring the economy to meet the requirements of international trade meant the downscaling of large and inefficient industries, which reduced the state's ability to provide full employment. The demand for dollar inputs in fields such as health care and education meant a scaling back of the welfare state. The increased opportunities for self-employment produced a greater propensity to individualism. Dollarization of the economy and a rise in tourism increased economic inequalities among the population. It is noteworthy that more than a decade after the special period was declared, Cubans were of two minds about whether it had ended or not. The family I stayed with in 2001, who managed to emerge relatively well from the crisis, referred to the special period in the past tense. They would reminisce about "the special period when we had no electricity for days," or "back in the special period when we had to go out to the country for fresh vegetables." Others who had not fared so well after 2000 referred to the special period as an ongoing phenomenon. Paraphrasing George Orwell, Gerardo Mosquera (2001:14) quips, "the Special Period is more special for some than for others." There are obvious contradictions between the principles of equality, justice, and collectivism professed by the Cuban state and the realities of economic adjustment, which have brought about marked inequalities and unemployment.

The contradictions facing the Cuban state are not unique to the region;

parallels can be found in underdeveloped countries in Latin America, as well as in the countries of the former Soviet Union and Eastern Europe. Martín Hopenhayn (2001:112) refers to the "interior-exterior schizophrenia" being faced by many of the modernizing states in Latin America, which must meet the demands of international financial organisms and simultaneously face a host of social claims within the country. The nation-state needs to maintain the image of a sovereign state that is internally consolidated and externally efficient, while caught within vicious cycles of foreign debt and domestic social fragmentation. Similarly, the Cuban state has clung to certain principles and values in order to ensure the support of the population, while an increasing orientation to the global economy pulls in the opposite direction.

The Cuban state partly responded to this situation by developing two personalities. On the one hand, there is the pragmatic state that negotiates and deals in the international market and the local tourist trade, appropriating the language of efficiency and austerity. For instance, signs in major tourist hotels around Havana read: "More than justice, socialism is efficiency and quality." On the other hand, there is the populist state, which assures the people that market values are not virtues in and of themselves, but rather means by which to achieve the deferred goals of true communism (Valdés Gutiérrez 1996). The political leadership assures the population that it is committed to preserving the socialist model of development for the Cuban economy, in contrast to the "market socialism" followed by China and Vietnam. The state economist Evelio Vilariño Ruiz (1998) proposed a "Cuban development model," which learns from the mistakes (inefficiencies, top-heavy centralization) of the Soviet system and uses capitalist organizational jargon ("efficiency," "productivity") in efforts to "perfect" the socialist model. The rise of consumerism, prostitution, class segmentation, and inequalities are seen as "distortions" of the Cuban development model that are related to its "incomplete and inconsistent application" (Suárez Salazar 2000:339) rather than the logical outcome of market-oriented policies. But at the same time, particularly in the latter half of the 1990s, there were also shifts in Cuban politics as the state responded to changing values in the Cuban population and sought to incorporate and relate to the emergence of critical and counterhegemonic discourses.

New Modes of Reincorporation

The contemporary dynamic of Cuban cultural politics, what I refer to as "new modes of incorporation," began in the mid-1990s and continued into the new century. This move toward incorporation was linked to the emergence of the Cuban state from the worst of the crisis and its reassertion of political and economic control. The period from 1993 to 1996 witnessed a range of liberalization measures that gave greater space to human rights and professional organizations, legalized self-employment in certain occupations, and permitted private home rentals and restaurants. By 1997, many of these economic reforms had been reversed or limited, there was a crackdown on the black market, and repressive tactics were employed against critics and opposition groups. This greater repression of formal political activities was linked to the increasing toleration of criticism within the arts, where counterhegemonic expressions could be monitored by the state and reincorporated into dominant frameworks.

The political and economic liberalization of the early 1990s can be attributed to the Cuban government's need to improve its human rights record in order to secure investment, and also to the recognition that the state could not provide many of the basic goods and services that Cubans needed in order to survive. In September 1993, self-employment or *trabajo por cuenta propia* was legalized in 117 occupations (Ritter 1998:76). Agricultural markets were reestablished in September 1994, increasing food supplies to urban areas (Ritter 1998:78). In 1995, private restaurants, known as *paladares*, were legalized, and between 1996 and 1997, private taxis were permitted and a law allowing rentals of private homes, or *casas particulares*, was passed (Henken 2002:3). Ted Henken (2002:5) notes that as a result of these laws, the official self-employed sector grew from less than 15,000 in 1993 to 209,606 in early 1996.

Along with these liberalizing economic measures, the government was more tolerant of opposition groups as it attempted to improve its human rights image in order to attract investment and build support against the U.S. embargo. In 1994 and 1995, many high-profile political prisoners were released. In 1995, taking advantage of the relatively open climate, dissident groups formed the Concilio Cubano (Cuban Council), an umbrella group that would come to unite a range of groups throughout the country by the

following year. Various official mass organizations and institutes began to gain a degree of independence. The Centro de Estudios sobre América (Center for the Study of America, CEA), which was established by the Central Committee of the Partido Comunista de Cuba (Communist Party of Cuba, PCC) in 1977 to resolve theoretical problems identified by the leadership, was granted the status of nongovernmental organization (NGO) in order to project a more independent image, attract international funding, and facilitate international academic exchanges (Gordy 2005:302). Other institutes such as the Center for Psychological and Social Research and the Center Félix Varela and such journals as *Temas* provided space for debates about the crisis of state socialism (Gordy 2005:305). In 1994 the Cuban state negotiated a new treaty with Washington that allowed Cubans greater freedom to migrate (Eckstein 2003:230). During this period, severe economic problems also undercut the effectiveness of the state's vigilance and its security apparatus.

But by 1996–97, this period of openings in Cuban society came to an end. The "bureaucratic offensive," as Dilla (2005:36) refers to it, was spurred by a range of factors, including the limited economic recovery of the country, which put the Cuban state in a better position to reassume control over the provision of services; its reestablishment of trade links with other countries, which reduced the urgency of securing Western investments; internal adjustments resulting from the Fifth Party Congress of 1997; and the tightening of the U.S. embargo through Track II of the Torricelli Law in 1995 and the Helms-Burton law in 1996, which increased the defensiveness of the political leadership (Dilla 2005, Mesa-Lago 2000). In March 1996 Raúl Castro publicly criticized aspects of the economic reform, denounced certain academic institutions that he saw as fraternizing with the enemy, and called for an ideological offensive (Mesa-Lago 2000:294). A new law was introduced in 1997, putting in place prohibitions and regulations of rental activity and establishing units of inspectors to enforce the new regulations (Henken 2002:6). For instance, the legislation required renters to pay a monthly tax of U.S. $250 per room in tourist zones, after an initial registration fee of $100 (Ritter 1998:86). Taxation measures designed to limit self-employment and laws passed to stop theft of state property in 1997 were part of a crackdown on the black market. According to Henken (2002:5), the number of people officially self-employed fell to 165,438 in 1998 and

113,000 by 2000. With the influx of hard currency through tourism, taxation, and foreign investment, the state was able to replace street vendors and paladares with large chain stores operating in dollars, such as Pan de Paris.

There was also a crackdown on dissident organizations and semi-independent groups. In February 1996 the Cuban government arrested over a dozen leaders of the Cuban Council. In March 1996 Raúl Castro criticized the CEA academics Aurelio Alonso, Hugo Azcuy, Haroldo Dilla, Rafael Hernández, Julio Carranza, and Pedro Monreal for abandoning "classist principles," being tempted "to travel and edit articles to the liking of those who could finance them," and getting "caught up in the spider's web spun by Cubanologists."[3] On 16 October the academics were informed that their collective was being dissolved and they were being moved to other centers (Giuliano 1998:129). The independent women's organization Magín, which had formed in 1994 as an alternative to the FMC, was also denounced. In September 1996 the Central Committee of the PCC called a meeting of its executive committee and the steering committee of Magín to dissolve the organization. Party leaders concluded that Magín presented a risk to the unity of Cuban society and would have to be disbanded (López Vigil 1998:43). The Magín activists and CEA intellectuals fought back, but they eventually accepted the party's decisions because they knew they had no other options if they did not want to be considered dissidents and have their professional lives in Cuba curtailed.

With formal political activities prohibited, critical debate began to be relegated to the sphere of arts and culture, where, perhaps surprisingly, the state tolerated greater diversity and freedom of cultural expression. There was a shift from the kinds of censorship that had been exercised against rock musicians, visual artists, and the film *Alicia en el pueblo de maravillas* (Alice in wondertown, 1991) to an uneasy tolerance and then greater efforts toward collaboration and incorporation of critical art. The film *Fresa y chocolate* (Strawberry and chocolate, 1994) showed the possibilities for garnering international recognition and expressing the regime's newfound inclusiveness. After the late 1990s there were increasing attempts to use the arts as a way of reincorporating and reintegrating the Cuban people into a new hegemonic project, increasingly defined as national rather than revolutionary.

The Cuban leadership, seeing that economic liberalization coupled with

political suppression in the Soviet Union created an informal sphere of discontent that fed dissident political movements, sought to create spaces for critical discussion within the arts. The prominence of a new layer of actors, such as Minister of Culture Abel Prieto, were fundamental to this shift. Prieto, former president of the Unión Nacional de Escritores y Artistas de Cuba (Cuban Writers' and Artists' Union, UNEAC) and himself a writer, garnered considerable prestige and respect within artistic communities. While in his UNEAC post, Prieto had played an important role in the attack against the CEA. He organized a meeting on 17 May 1996 to discuss the party-issued report against the CEA academics, in which he defended Cuban intellectuals but also distanced himself from the CEA by invoking the "external threat" against Cuba (Giuliano 1998:102). From the late 1990s Prieto was a proponent of creating controlled spaces for critical debate. In 1996 he declared that "if something horrendous happened in those countries where real socialism collapsed, it was simulation; and if you eliminate spaces of discussion, people begin a double life. Discussion and debate always clear the atmosphere, even though there have not been answers for all the questions" (Prieto 1996:9). This awareness is partly what undergirded the shift toward new modes of incorporation in the late 1990s. In an attempt to reduce the gap between official ideology and lived experience, groups in Cuban society collaborated with political leaders to bring critical and oppositional expressions back into the purview of state organizations. But at the same time, incorporation is never complete. Incorporation necessitates some degree of dialogue between artists and the state, and this process can introduce new issues and criticisms into public discourse.

2 Old Utopias, New Realities

Film Publics, Critical Debates, and New Modes of Incorporation

The Teatro Riviera was packed with people who had come to see Humberto Solás's new film, *Miel para Oshún*[1] (Honey for Oshun, 2001). My friend Cristina and I had tried to see it twice already, but the first time the bus taking us from Cristina's house in Playa to Vedado had broken down and we could not make it to the film and the second time we made it to the theater but the projector broke down five minutes into the film and could not be repaired. There was a buzz of anticipation in the air, as is generally the case when a new film comes out in Cuba. There were catcalls and whistles as Jorge Perrugoria, the big heartthrob in Cuban cinema, came on the screen. In *Miel para Oshún*, Perrugoria plays Roberto, the son of a Cuban exile who is returning to Cuba after his father's death to know the forbidden Cuba that his father did not let him see and to find his mother, from whom he was separated when his father whisked him away to Miami. The film follows Roberto's adventures as he crosses the island in search of his mother, through breakdowns of cars, police searches, and finally a robbery that leaves him standing in the middle of the plaza in a small town in an eastern province, calling out to a growing crowd of onlookers, "I'm confused. I don't know whether I'm American or Cuban. You have difficulties here, but at least you know who you are." At this point a young woman stood up in the theater and shouted to the screen, "No, we don't know who we are. What makes you think we know who *we* are?" The audience immediately broke into laughter, conjecture, and debate with the young woman and with one another about the meaning of Cuban identity.

The culture of Cuban moviegoing is compelling from a socio-

logical point of view. The staging of Roberto's personal dilemma in front of a large crowd of onlookers is a device that filmmakers use often to draw the audience into the narrative. Solás intends to provoke debate about questions of identity and belonging, and while the audience responds to his filmic devices, they actively interpret these films in ways that parody his efforts to postulate a stable Cuban identity. Ordinary Cubans are living through a moment of uncertainty, change, and crisis; much of daily life is both monotonous and fluctuating dramatically. Cuban Americans who return to the island do not encounter the revolutionaries that they or their parents left behind. They find a weary and contemplative population questioning and searching for the value of their revolution in the midst of hardship, defeat, and new possibilities. Cubans appropriate film in order to discuss and debate everyday problems, and their own readings of a movie often go beyond what the filmmaker intends.

But these alternative interpretations are not simply spaces of social critique that allow viewers to contest hegemonic discourses, as some scholars argue (Mankekar 1993, Abu-Lughod 1997). When we look further into the kinds of debates that are provoked by Cuban cinema, we see that debates are often resolved and worked through in ways that allow for syntheses between old ideals and new realities. The selective reincorporation of new and emerging values and experiences into dominant cultural traditions is part of how hegemony works in a period of crisis. Critical debates and discussions in the public sphere of film have been a constitutive force in the new modes of incorporation in Cuban society. Filmmakers seek to assimilate newly emerging values such as tolerance, humanity, and self-cultivation into a political vision, and they promote nationalism as the basis of a shared new order. Although the audience's views may not always coincide with this political vision, viewers come to their own understandings as they reconcile their personal beliefs and investments with changing life experiences. But while some critical and emergent values are incorporated, others are repressed and silenced. Hegemony is reconstituted through a process of selection and elision that makes certain ideas invisible or relegated to the margins.

Accounts of politics that treat hegemony as "consensual rule," or consent based on shared ideology, minimize the realities of lived experience, which are always introducing motion and conflict into received notions of

world is. Roseberry (1994b:47), following Gramsci, acknowledges .ne meanings produced by ordinary life connect with the dominant .e and others may conflict with it, and he suggests that in ordinary es this does not matter much. In moments of crisis, however, disjunction may be "the focal point for the production of new and alternative meanings, new forms of discourse, new selections from tradition or conflicts and struggles over the meaning of particular elements within tradition." Building on Roseberry's insight, I propose that at these moments of disjunction, we begin to see broad changes in how citizens see themselves and their place in the world; new kinds of demands and alternative ways of being seem possible once more. But how does the state respond to these alternative visions? Why do these new meanings not always lead to larger-scale movements or political challenges?

An obvious and frequently utilized response by the state to critical and oppositional activities is repression and crackdowns, and the Cuban state has resorted to coercion at various moments in the arts and in society in general. But incorporation, adaptation, and co-optation are much less visible mechanisms of power, which often involve ordinary people and artists as agents themselves. As Florencia Mallon (1994:71) has argued, hegemony is always being confronted by counterhegemonic movements, and in fact, "hegemony cannot exist or be reproduced without the constant, though partial, incorporation of counterhegemony." The notion of hegemony as partial, selective, and active reincorporation, rather than as taken-for-granted ways of viewing the world, alerts us to what the Comaroffs (1991:22) have called "power in its *agentive* mode," as "the relative capacity of human beings to shape the actions and perceptions of others by exercising control over the production, circulation, and consumption of signs and objects." Moreover, it is not just political leaders and state officials but actors at all levels who are involved in the partial reincorporation of counterhegemonies. The concentration of film production in the hands of relatively few cultural producers and the location of filmmaking activities in a state-managed film agency make film an important site for negotiating and resolving conflicts over meaning.

The Politics of Film Production

Before the onset of the special period, Cuban cinema, like many other national cinemas in Latin America, was nationalized and subsidized by the

state. State patronage was part of a project of national cultural renewal. The Cuban cinema industry was nationalized in 1961, with the creation of the ICAIC. All film production was directed by a central administrative body of ICAIC, divided into departments of studios and labor, technical processes, finance, and programming (Burton 1997:134). The processes of centralization in the Cuban economy during the 1970s led to the further subordination of ICAIC to the state cultural apparatus through incorporation into the Ministry of Culture (Burton 1997:133). Even before 1975, ICAIC had been organized around a central administrative body. However, after 1976 it was subject to the dictates of the Ministry of Culture, which increasingly centralized decision making and planning in a select leadership. These changes were designed to give the Ministry of Culture greater control over cinema production. Between the mid-1970s and early 1980s, state-initiated decentralization measures represented by the System of Economic Management and Planning (SDPE) came to be applied to film production. In 1981 ICAIC was transformed into the Vice Ministry of Film under the Ministry of Culture.

By the middle of the 1980s, Cuban film production was being affected along with other national cinemas by economic crisis, the growing dominance of Hollywood, and the advent of cable television and video, which competed with movies as forms of mass entertainment (D'Lugo 2001, Shaw 2003). Problems in the film industry were initially addressed through a restructuring of ICAIC that gave groups of producers greater control over content and production. Whereas the ICAIC leadership had once had ultimate authority and creative control, in the late 1980s an organizational structure known as Grupos de Creación (Creation Groups) was implemented under the direction of Julio García Espinosa. Three groups, each directed by a filmmaker, oversaw the entire process of scriptwriting and production. However, after the special period and a financial recession in the film industry, the Creation Groups were terminated. As in other Latin American countries, the only way the film industry could survive was by integration into a global system of production and distribution (Shaw 2003:3). The Cuban film industry moved to become self-financing, filmmakers sought to secure funding through co-productions with foreign producers, and Cuban films were marketed to international consumers.

During the 1990s the costs of film production increased while inputs drastically declined. Although Cuban cinema still had large national audi-

ences, expenses could not be covered by box-office receipts, as the cost of a ticket for a regular feature film remained constant at 3 pesos, or 15 U.S. cents,[2] despite marked inflation. According to Diane Soles (2000:125), ICAIC employed three main strategies for generating hard currency: service fees, co-productions with foreign agencies, and distribution and sale of Cuban films abroad. For foreign producers who wished to film in Cuba, ICAIC offered production facilities and equipment, technical staff, and actors. In 1993 ICAIC earned U.S.$454,400 in service fees (Soles 2000:126). In addition to service fees, filmmakers solicited foreign co-producers to help cover the costs of a film. ICAIC offered services in kind as its contribution to the film's production, and the foreign co-producer paid for all expenses that had to be covered in dollars, such as transportation, hotel accommodations, locations, and other items not owned or managed by ICAIC.[3] ICAIC then received a percentage of the film's overseas earnings, which were put into a central fund and used for maintenance, while workers continued to be paid in pesos by the Ministry of Culture.[4] While ICAIC used to produce some ten feature films a year and about fifty short features (Levinson 1988:488), since the special period it has made only one or two feature films a year with sponsorship from foreign countries, mainly Mexico, Spain, Venezuela, Peru, and Nicaragua.

Insertion into a global marketplace resuscitated the Cuban film industry somewhat. But as Soles (2000:124) argues, Cuban filmmakers find themselves between a rock and a hard place, as they must work within the political constraints imposed by the Cuban government while at the same time catering to the demands of international markets in order to secure co-productions and global distribution. The imperatives of the market have produced new trends in Cuban cinema. Themes of homosexuality and Afro-Cuban spirituality are seen as particularly appealing to international audiences, given the attractiveness of "difference" as a marketable commodity. Paul Julian Smith (1996:81) suggests that the appeal of themes related to homosexuality drives the production of films such as Ang Lee's *The Wedding Banquet* and Tomás Gutiérrez Alea's *Fresa y chocolate*. Similarly, Afro-Cuban music and dance are highly marketable to international audiences (Soles 2000:132). The Afro-Cuban actor Luis Alberto García told me that "Afro-Cuban religion has been converted into a trope necessary to attract tourists, make money from tourists, and sell a superficial image of Cuba."[5] Notions of exotic difference have proved commercially popular, particu-

larly in Western-oriented consumer markets. Marvin D'Lugo (2001:55) also points to the marketing of well-known and highly esteemed filmmakers as "a commercial strategy to organize public reception around the cult of the filmmaker, who, for his part, is promoted as a representative voice of national culture." Films are increasingly projected through the image of the filmmaker rather than through the messages they carry.

Censorship and Self-Censorship

Interviewer: *How difficult is it for a film director to work in a state film unit in a socialist country?*

Tomás Gutiérrez Alea: *In our case, at least, we are integrated into the state and the state is ourselves. So we do not suffer from the situation where there is someone who puts up the money and tells us what to do, simply because he has the money.*

<div align="right">Cinema Papers (Australia)</div>

Although Cuban filmmakers may have more liberty as they negotiate global markets and promote Cuban culture abroad, they continue to have an ambiguous relationship with the state. On the one hand, the production of Cuban films in close alliance with the revolutionary leadership has led to a high level of self-censorship and internal monitoring. On the other hand, filmmakers have fought for and maintained a degree of independence that historically allowed possibilities for criticism and free expression not available in other art forms. This unique positioning has enabled the current insertion of filmmakers into new modes of power: they give creative rein and expression to the newly emerging sensibilities that are excluded from official discourse, and they find ways to incorporate these sensibilities back into dominant frameworks.

ICAIC has been one of the most politically conformist cultural institutions, and filmmakers are more susceptible to self-censorship than artists in other fields. For instance, in an interview with Michael Chanan (2002:50), Gutiérrez Alea discussed the process of censorship in relation to *Hasta cierto punto* (Up to a certain point, 1984): he was required to cut out sections that showed problems with management and paternalism in the workforce. The filmmaker's response revealed his willingness to comply with restrictions:

> I wanted to discuss the paternalism of the State in this film and create a stimulus to provoke discussion about this problem. But the truth is that I hadn't done

it in a sufficiently solid and consistent manner so that the discussion could develop in what I thought was the best way. So I realized that I couldn't insist on my approach, in spite of the fact that, theoretically, my position was right, because in the film itself I had not expressed it in a convincing and correct manner. So I preferred not to say it at all.

Gutiérrez Alea justifies the retraction of his criticisms by referring to his own supposed weaknesses in representing them. Filmmakers prefer to change some aspects of their work in order to have their films produced and released. As the Cuban filmmaker Sergio Giral (1994:266) said in regard to his banned film *Techo de vidrio* (Glass roof, 1982), "You exercise a form of self-censorship in not wanting to destroy the cake by sticking your fingers in it too much." Various patterns of censorship and self-censorship in ICAIC ensured that films remained within acceptable boundaries.

The willingness of filmmakers to stay within certain self-imposed limits meant that film was less subject to interference and censorship than such art forms as literature. Writers and poets had a rocky relationship with the Cuban cultural establishment: the government banned several of Virgilio Piñera's short stories and poems, and José Lezama Lima suffered intimidation and repudiation after the publication of his novel *Paradiso* (Arenas 2000). By contrast, the cultural authority of prominent filmmakers and directors such as Tomás Gutiérrez Alea and Alfredo Guevara prevented the political leadership from banning films that might have gone beyond acceptable criticism. Guevara's close personal friendship with Fidel Castro, his historic involvement with prerevolutionary cultural movements, and his relative willingness to stay within parameters ordained by the state contributed to his status and the authority of ICAIC within Cuban cultural life.

Filmmakers and cultural leaders managed to preserve ICAIC's autonomy to some extent, particularly in comparison with television, radio, and the press. One of their greatest achievements was to keep the film institute out of the clutches of the Departamento de Orientación Revolucionario (Department of Revolutionary Orientation, DOR), the body responsible for censorship; it later came to be known as the Departamento Ideológico del Comité Central del Partido (Ideological Department of the Central Committee of the Party, DICCP). While the Instituto Central de Radio y Televisión (Central Institute of Radio and Television, ICRT) was directly controlled by DOR, ICAIC was never under its administration.[6] For instance,

DOR could deem a particular program or film unsuitable for television viewing and prevent it from being broadcast, but it could not prevent the same film from being shown at theaters; that decision was up to ICAIC. ICAIC's leadership reserved the right to determine the political and ideological content of films, and in comparison with the film industry in China, whose products are regularly censored by the Propaganda Department of the Central Committee of the Communist Party (Kaige 1990), Cuba's is remarkably unfettered; the political and cultural leadership has seldom intervened to censor films.

Nevertheless, in 1991 the Cuban authorities recalled a movie from theaters. After being shown for three days, Daniel Díaz Torres's *Alicia en el pueblo de Maravillas* was banned. The film is a satirical comedy about a drama coach, Alicia, who goes to a small town called Maravillas for her obligatory year of community service. Maravillas is a parody of socialist bureaucracy, corruption, and mismanagement. The town is populated with characters who have been sent there as punishment for misdemeanors, such as Cándido, a driver for the Catering Enterprise Union, who was charged with theft of state property; Pérez, a deputy director who embezzled money from his firm; and Chini, Pérez's secretary, with whom he was having an affair. In Maravillas, official discourse functions as Orwellian double-speak: cloudy drinking water is declared to be clear; the Sanatorium for Active Therapy and Neurology (SATAN) is advertised on television as "a model of devoted patient care"; and signs such as "Congratulations, we've reached our target" follow scenes of corruption. The point is captured in a children's cartoon, where a duck begins to play in the dung. The children in the film interpret the scene as "Not everyone who covers you with shit is bad." Everyone in the town parrots the official newspeak, and the scatological imagery contributes to a sense of the characters' evasions and hypocrisy.

The director of the film and others suggest that it was banned because of the timing of its release. As Michael Chanan (2004:459) relates, when Díaz Torres began production on the film in 1988, it was seen as a farcical comedy along the lines of *Se permuta* (House for swap, 1984) and *¡Plaff!* (1988), which had enjoyed popular success. But the film came out just as communism was collapsing; as Díaz Torres said to me: "Between writing the script and releasing the film, our world ended."[7] Risky even before the 1990s, the film seemed to be a direct criticism of socialism. Before it was

released, copies of the film began to circulate. There were rumors that the director of the sanatorium was a caricature of Fidel and that the film was attacking the revolution (Chanan 2004:459). The film was released on 13 June 1991, after negotiations between the highest leadership of ICAIC and the party, but was disrupted by party militants who attended screenings and it was withdrawn four days later. The Cuban press dismissed the film as "a boring tale, full of vulgarities," a "negation of our values, with a tone that goes from irony to the grotesque," and "a work that forgets and hides the reasons for struggle and hope."[8] In May 1991, just before the film was released, the government was planning to merge ICAIC with the ICRT, the media production units of the Revolutionary Armed Services, and the Ministry of Education.[9] Many people in the bureaucracy saw the film as evidence of the wisdom of the merger.

Filmmakers protested both the proposed merger and the banning of the film. ICAIC's president, Julio García Espinosa, tendered his resignation, forcing the state to suspend all reorganization (Paranaguá 1997:167). In an article in the ICAIC magazine *Cine Cubano* Díaz Torres (1991:23–24) defended his work, saying that the film was not meant to reflect reality but rather to highlight certain aspects of reality by looking at them through the distorted lens of satire. He turned the criticism back on the critics: "Those who are used to seeing our reality through tinted glasses or a prism of hatred will see the movie not as it is but as they are, projecting their own phantoms onto the screen." Díaz Torres was backed up by Alfredo Guevara, who presented the film at the Thirteenth International Festival of New Latin American Cinema in Havana on 9 December 1991. Guevara referred to Díaz Torres as "a very *Cuban* Cuban from Cuba, a revolutionary who is not prepared to allow any manipulation." Rather than isolating Díaz Torres, Guevara and other filmmakers assumed collective responsibility for the film and defended Díaz Torres as a nationalist and a revolutionary. Yet despite the film's showing at the film festival and its circulation on videocassette, it is still banned and censorship remains in place. The events surrounding *Alicia* redefined the relationship between artists and the state; they signaled to artists the limits of critical expression and the repercussions that could follow from pushing those limits.

The early 1990s saw a shift to a kind of filmmaking that raises critical and controversial issues but stays within the boundaries that had been

demarcated during the *Alicia* crisis. The depictions of a black market and treatment of themes such as sexuality and state repression in the films of Gutiérrez Alea, the use of ambiguous symbolic language and references to migration in the films of Fernando Pérez, and the making of films that were more exploratory than didactic were facilitated by the release of films from the unique monopoly of state institutions. The political leadership began to openly register disapproval of the kinds of films being produced by ICAIC. Michael Chanan (2004:1) reports that at his closing speech at the National Assembly in February 1998, Fidel Castro launched an attack on those critics who "captured international attention by making films that, instead of celebrating the positive achievements of the Revolution, preferred negative criticisms—or worse, counterrevolutionary." Castro referred to *Guantanamera*, a film that depicts with humor the difficulties of a family who go to great lengths to have a relative buried: "To poke morbid fun at tragedies . . . is not a patriotic act" (quoted in Azicri 2000:298). Upon learning that this film was made by such a highly respected filmmaker as Gutiérrez Alea, Castro backed down, but he still maintained that the films being produced by ICAIC were too critical (Chanan 2004:2). The resistance of some sections of the political leadership to the critical narratives of contemporary Cuban films demonstrates that strategies of incorporation are not necessarily devised from above as a way of managing dissent, as some film critics have claimed.

Film Publics and the Reception of Film

An important agent in the construction of cultural meaning, and one that has been overlooked in most studies of Cuban film, is the film public. Of all the forms of art and popular culture, film has generated the largest audiences in postrevolutionary Cuba. *Cine Cubano* reported that in 1962, the first year that films were screened by mobile units that toured the country, thirty-two units carried out 7,722 movie screenings, 30 percent of them in Havana and 70 percent in other provinces.[10] The report calculates that in 1962, more than 2 million people had access to the mobile screenings. Film attendance was probably lower in the 1980s than in other years of the revolution,[11] although this does not mean that fewer Cubans saw films than before; 61.4 percent of Cubans had television in their homes and several films were broadcast weekly. Ambrosio Fornet (2001:13) reports that in 1987, 60

million spectators attended films, 32 million in movie theaters and 28 million in mobile film facilities, an indication that the mobile units were still a vital means of dissemination. Fornet locates part of the reason for the popularity of cinema in Cuban demographics. In 1987 the average Cuban was in his or her thirties, literate, and employed. Moreover, 69 percent of Cubans lived in urban areas and 56 percent of the economically active population were intellectuals, professionals, or technical workers: a large pool of people eager for cultural and intellectual stimulation.

Although the special period has brought many changes to Cuban society, the moviegoing public is still large. One major change that began earlier was the increasing availability of video, which accounted for part of the decline in attendance at movie houses. García Canclini (2001:115) notes that in Latin America, video has become the most common means of viewing films. In cities and towns across Cuba, video services stock the latest Hollywood films as well as Latin American and other world classics. Thus Cuban audiences have access to a wide range of films beyond the basic fare of Cuban, Soviet, and Third World cinema. In 1987 the National Federation of Cinema Clubs and the National Distribution Center of ICAIC began to organize video parlors around the country, particularly in mountainous regions (Fornet 2001:13). Video screenings have come to constitute a much less costly and cumbersome form of mobile cinema. Fornet estimates that a film with a so-called small audience can be seen by some 15,000 or 20,000 viewers after its run in around two hundred movie houses.

In the absence of a vibrant media culture of film criticism, advertising, and reviewing, everyday discussions about films take place in a relatively unmediated manner. Cuban movie audiences react strongly to what they see on the screen: they speak to the screen, shout advice to the characters, and debate other viewers in the theater. All this loud talk is generally not considered impolite or offensive. Cubans actively discuss films with their families, in food queues, at bus stops, and anywhere that people gather. Guevara (1960) noted that each early showing of a state-produced film "had the same significance as a plebiscite." Pastor Vega, director of *Retrato de Teresa* (1979), noted that this film about continuing discrimination against women in revolutionary Cuba was transformed into "a controversy, a continuing public debate."[12] Ordinary Cubans spoke to me about the impact that a good film could have on cultural life. One middle-aged professional woman in Havana said that when a new film comes out, "everyone watches

it, we live those days in a very intense way. . . . In the case of Fresa y chocolate, you discussed it with people on the bus, even people sitting next to you at the movies, who had to get their point of view across. It was the same with your neighbor or your family." [13] It is common for strangers to engage each other in discussion of the latest Cuban film, and actors and filmmakers are accustomed to being approached on the street by ordinary people who want to discuss their recent films.

Movie houses generally show a film continuously throughout the day and people usually enter at any time and leave when the first scene they saw comes round again or (more likely) stay to see the movie through again and yet again, especially if the projector breaks down in the middle, as it so often does. A schedule of showings is available, but people hardly ever consult it. This habit of viewing films out of sequence and seeing them several times has influenced the ways filmmakers produce films.

Sexuality, Tolerance, and the Nation

One of the initial attempts by filmmakers to articulate emergent values in Cuban society and rally Cubans behind nationalist ideals in the post-Soviet period was the film Fresa y chocolate (1994), directed by Gutiérrez Alea. The film focuses on the ways in which the socialist state has marginalized certain sections of the population on the basis of sexual orientation and religious belief. Gutiérrez explores the relationship between David, a young orthodox Marxist of working-class background, and Diego, a gay man with upper-class sensibilities, who strikes up a conversation with David one day at the famous ice cream parlor Coppelia. David, suspicious of Diego's revolutionary credentials and feeling threatened by his advances, reports him to Miguel, the leader of the Union of Communist Youth (Unión de Jóvenes Comunistas, UJC), who then orders David to establish a friendship with Diego in order to keep an eye on his activities. The film follows the developing relationship between Diego and David as David is forced to confront his views not only of homosexuality but also of the rigidity of the revolution's Marxist orthodoxy and his own entrapment in it. Diego represents a complex of values: Cuban culture and tradition, bourgeois extravagance, and prerevolutionary nostalgia. The figure of the homosexual functions as the repository of primordial notions of national culture to which Cubans must return.

Many scholars have analyzed Fresa y chocolate as an allegory of political

ation orchestrated by the state. According to Enrico Mario Santí he discourse of political reconciliation has been a cornerstone of state policy toward Cuban exiles, and the film becomes an instrument for promoting such reconciliation. Referencing Gilda Santana, a consultant on the film, José Quiroga (1997:139) describes the careful manipulation of the script in efforts to control what is represented and the way the audience responds. Quiroga, along with Paul Julian Smith (1994, 1996) and Emilio Bejel (2001), argues that gay issues are contained within a heterosexual narrative that obscures other possible solutions, such as a sexual relationship between men. Homosexuals are authorized in the film through incorporation into the nation (Cruz-Malavé 1998), but this incorporation is stage-managed to avoid modification of nationality or heterosexual masculinity (Smith 1996). Scholars emphasize the act of managing subversive aspects of the dialogue to repress the ambiguities of the relationship between homosexuals and the state.

The points made by these scholars are important, particularly as regards the incorporation of homosexuality, the management of subversive aspects of the narrative, and the networks of control within which the film functions. But these predominantly textual analyses also presume a fixed and unified audience interpretation, which is set in place by a highly controlled process of production. Scholars collapse questions of authorial intent with audience response, and hence the film, in the view of Quiroga (1997:139), becomes "utterly redundant, given the more complex realities at hand." We can indeed see a process of incorporation at work in the film. But by treating the question of reception as a nonreductive category in the process of meaning making, we can see the multiple paths through which incorporation occurs in this film as well as in other contemporary films. Rather than seeing management of the film as orchestrated from above, an ethnographic study of audience reception shows how viewers themselves manage their interpretations, a process that does leave room for modification of deeply held views about sexuality and nationality, as well as alternative readings of the film.

In order to survey the multitude of ways in which Cubans respond to films, I organized discussion groups among more than seventy-five Cubans of various classes, ages, and backgrounds. I found that middle-aged professional women in Havana tended to be by far the most likely to engage

in discussions about films. While people of a working-class background,[14] those outside of Havana, and young people also had some interest in film, they did not embrace it with the passion and fervor of the urban middle-class women. Men were also unlikely to participate in the discussions of films; they generally left the room or kept silent, perhaps because they felt that emotional engagement with any art form was properly left to women.

The broad theme of intolerance that frames *Fresa y chocolate* allows multiple identifications and permits the observer to be in the position of oppressor and oppressed simultaneously. Viewers in my discussion groups said the film showed how Cubans have operated with a Manichean division of the world into revolutionaries and counterrevolutionaries, with the latter encompassing not only those who oppose the regime, but those who have alternative ideas, visions, philosophies, and religions and those relegated to the margins of society, such as homosexuals and young black people. During one discussion with Gloria, Felicia, and Katia,[15] the women talked about these ideas. Gloria, a university professor, had come to Havana from Camagüey after marrying a party official, from whom she was now divorced. She had remarried and had two children, and she and her husband often opened their home to foreigners and students enrolled in programs run by the university. We held the discussion in Gloria's comfortable home in the middle-class suburb of Vedado. We had invited a close friend, Felicia, a professional black woman, who lived in the poorer barrio of Playa and was divorced with one son. Felicia had lived in Czechoslovakia for several years as an exchange student and was fluent in Czech. In the past she was often invited to be a translator for official delegations from Eastern Europe, but few such delegations came now, so she had begun giving Spanish lessons to foreigners to supplement her income from the state as a consultant. Felicia had invited her colleague Katia. The women had few inhibitions about expressing their thoughts after the film:

> **Felicia:** They say you're not with the revolution, but I say, what about if I am with the revolution but I have other ideas? But you know that we're like this in general, or it's not us, but it's the policies carried out by the government. If you're not with us, you're against us. Now there's a little more . . .
>
> **Gloria:** Now it has changed a little. At least there is more tolerance, and in an effort to save the revolution, there is more space. At least in terms of patriotism. Go figure, the language itself has changed. It used to be all revolution, revolu-

tion, revolution. At that time it was self-evident. You were for the revolution or not for it. There was no middle ground. . . .

Felicia: Moreover, it's the same politics today, and you can see it in all realms, in the educational system and in the general population. If the education system supports some idea, then from there it goes to the general population.

Participants identified the preoccupation with an exclusionary politics on the part of both the people and the government. Gutiérrez intended a similar reading: "Who am I engaging in dialogue? Well, the people who in one way or another have something to do with this situation, who are responsible for this situation of intolerance, and the marginalization of that which is different, and the non-acceptance of those who think with their head" (Chanan 2002:49). Gutiérrez goes on to say that it is not simply the party that he is addressing, but those extremist sectors within the party.

In the postrevolutionary period, the politics of exclusion penetrated deeply into the way people think, and many films that challenged this way of thinking provoked lively and heated disputes among people. I organized another discussion of *Fresa y chocolate* among three middle-aged black professional women—Evangelina, a psychologist; Leonor, a retired psychologist; and Yolanda, a doctor—who were old friends and neighbors in central Havana. All were divorced with one or two children. Leonor had been involved in setting up Magín, the independent women's organization that was later shut down by the state. She continued her activism around women's issues through film and various workshops organized together with foreign activists who regularly visited her in Cuba.

Yolanda, a gregarious, talkative woman, argued that Cubans who had left the country to live in Miami were counterrevolutionaries: "Those who choose to be in Miami, they're not revolutionaries. You can say you love the Cuban revolution, but if you're living there, then I know it's a lie." In response Evangelina pointed out that Diego is forced to leave Cuba when the government blacklists him for trying to organize an exhibition overseas. Diego has tried to speak out, but he has no choice but to leave. Some people who consider themselves revolutionaries don't have a choice, Evangelina emphasized: "Diego has to leave his country because he has no opportunity to work. He can't be who he is, he is obliged to leave! And they never say that here, and the people themselves know that they have to leave because they are not tolerated." Evangelina's son had left Cuba for London

when he had been unable to find a job after having some problems with the Cuban authorities. Yolanda retorted that people do have the right to stand up for themselves: "I am on this side of the fence, but on this side of the fence I have my eyes wide open and I feel my right to say strong things." The question of who is and who is not a revolutionary is so ideologically loaded that agreement becomes impossible.

Just as shared nationalism can unite Diego and David, sentiments of patriotism could unite participants with diverse political opinions. In *Fresa y chocolate*, Emilio Bejel (2001:158) argues, it is the common ground of nationalism that allows Diego and David to build a friendship and facilitates the ethical and political conversion that Diego brings about in David, which "enables a common ground to be established between Diego's nationalism and David's." By proposing unity among Cubans based on a shared sense of national belonging, filmmakers suggest the basis on which viewers can transcend their political differences. Yolanda, Evangelina, and Leonor did not come to an agreement about whether Diego was revolutionary, but Yolanda did accept the view of Evangelina and Leonor that Diego had been forced to leave the country, conceding that "Diego is denigrated by his society and because of the machismo that exists here, but regardless, he has so many positive values. Really, he is obliged to leave the country, but nevertheless he has these values of his land, of his music, of his country." Yolanda struggled with the dissonance of her opinion that people who leave Cuba are no longer revolutionaries and the reality presented in *Fresa y chocolate*, of an individual who is forced to leave. She conceded that it's possible for someone to leave the country and still remain committed to the nation, a realization that challenged her schema.

The discussions also registered shifts in notions of nationalist and revolutionary subjectivity. María Josefina Saldaña-Portillo (2003:11) argues that the dominant model of subjectivity as constructed through the figure of Latin America's guerrilla hero, Che Guevara, was based on a transcendence of gender and sexual specificity. By contrast, some viewers of *Fresa y chocolate* specifically identified the value of national feeling with homosexuality. Yolanda said:

> The film puts a lot of emphasis on human values. From the start Diego has more of a solid love for Cuba than David. He loves Havana and it hurts him to see Havana in ruins. He sees it, he feels it, and he has it inside him. And when

David asks about his family he says, "I'm my mama's favorite." He has human values, humanity, he has family values. But gays are also generally tremendous sons, tremendous brothers and fathers when they decide to have children, because they are people who give a lot of importance to family, as they are people who are very rejected. David is more of a man, in terms of the street concept of manliness, he is more than that.

Yolanda's view of gays as representing the human and family values that make for the ideal patriot is in marked contrast to Guevara's disembodied ideal of the *nuevo hombre* or "new man." Using stereotypes of gays as "tremendous" sons, brothers, and fathers, Yolanda criticized the notion of masculinity that undergirds the dominant conception of what it is to be revolutionary. She argued that family sentiment and humanity are the concepts to be valued, rather than the macho concept of *hombría* (manliness). Just as the female figure has historically represented the values of the revolutionary community (D'Lugo 1993), so the figure of the homosexual has come to embody the values of friendship and humanity that constitute the basis of a new representation of the revolution in the liberalizing society of the special period. For others, such as Julia, a young store assistant in the town of Matanzas, an hour from Havana, nationalism should be disassociated from questions of sexuality: "In the case of Diego, they show that there are things in life that don't have anything to do with your feelings as a person; what you like, what you don't like has nothing to do with your national feeling." Julia went on to reinterpret national feeling as linked to cultural values expressed in music, literature, and art.

In discussions of *Fresa y chocolate*, community is reconstituted through an appreciation of national culture and history, which becomes more important than politics and ideology. People affirmed the film's utopian leaning toward the incorporation of values of humanity and pluralism in the large-scale project of socialism. Both the Davids and the Diegos, the fervent party militants and the disillusioned socialists, must work toward a new revolutionary utopia based on inclusion, tolerance, and friendship. The first group of women discussed these ideas:

Katia: Diego has no option. He has to leave, but the ending is extremely positive because it is a song of tolerance, because in the end they decide in favor of love, the love of friends, of humanity, as children of Cuba. He has to go, for sure, but

they remain friends, and each one defends his criteria and his
neither betrays his way of thinking or his convictions, they cor
same convictions, but they tolerate the position of the othe
other.

Gloria: I think that by making Diego leave, the director is trying to put you in David's place and see that Diego is a victim, and you sympathize more with the victim, because it makes you . . .

Felicia: He's left with no other option. But it's the tolerance and the value of love that's most important.

Gloria: It's greater . . .

Felicia: It's greater than whichever . . .

Gloria: . . . whichever ideology.

Felicia: Then friendship and love are things more important.

Katia: Independent of whichever ideology, or whichever religion.

Gloria: As Che said, "You have to be human first, and afterward a revolutionary."

Katia: And you have to be motivated by feelings of love.

The women interpreted the film as promoting an idea of humanity that supersedes ideological or political affiliations. This view contrasts markedly with the idea of revolutionary brotherhood presented in films of the 1970s, in particular Sara Gómez's *De cierta manera* (One way or another), whose protagonist is forced to leave behind notions of friendship based on personal and religious ties to forge a new solidarity based on the responsibility of each individual to the collective. Gloria and Katia refer specifically to Che Guevara's notion of love. Ileana Rodríguez (1996) has described the radical potential of Guevara's androgynous model of subjectivity, which combined a desire for manliness with feminine and maternal qualities. Whereas to become a "guerrilla" one had to excise the feminine (I. Rodríguez 1996:56), in the conversations among these women we see a return of the feminine as the basis for building community.

As a film, *Fresa y chocolate* does a significant amount of work on several levels. It was the first significant attempt to unify the Cuban public behind the socialist state in the post-Soviet period, and the discussions during the film showings suggest that the participants generally supported the filmmaker's demands for the rearticulation of the revolution on a more inclusive basis. The film provokes and reflects changing notions of masculinity, subjectivity, and the nation. While it does seek to manage and incorporate

subversive discourses, the fact that it was banned from Cuban television raises doubts about the thesis that the function of the film was simply to reinforce state policies. It was partly the international and regional success of the film that created some openings for its ideas within Cuban society. The film won the Critics' and People's Choice Award in Cuba for outstanding cinema (Bejel 2001:56) and was acquired by Miramax for distribution in the United States (Chanan 2004:472). Minister of Culture Abel Prieto (1996) praised the film as "the model of a work that is profoundly critical, profoundly revolutionary and Cuban." In November 1994 the Centro Nacional de Educación Sexual (National Center of Sex Education, CNES), hosted the Latin American Congress of Sexology and Sex Education in Havana. There were presentations on the situation of homosexuals in Chile, Argentina, and Mexico, but Cuban gays' contribution was limited to wall posters. In response to protests by participants in the conference and Cuban gays themselves, the organizers set up a forum for discussion of *Fresa y chocolate* (Lumsden 1996:112). Although most critics were skeptical, the film did make certain openings available to gay activists.

Other viewers, such as Camilo, a middle-aged white nurse, and his young Afro-Cuban boyfriend, Jorge, a dancer, talked about the film's limitations. We watched the film in Camilo's rooftop apartment in Central Havana, which he often rented out illegally to foreigners. Camilo and Jorge saw the film as inaugurating a period of tolerance in Cuban society:

Camilo: Here in Cuba there has been a very slight opening up after the film. The film is very educational, there have been many themes and opinions expressed in public, and in Cuba it has served to promote the message of our humanity. In Cuba we have not had this. We have had to hide our lives for fear of what people think.

Jorge: *Fresa y chocolate* was the start of the "tolerance," because it gave rise to a cultural boom in cinema, theater, and contemporary dance. Before, if this theme was treated, it was treated very subtly, with a certain fear of censorship. Now it has been dealt with more openly, also in visual arts. The film is a start, but we still have so far to go, so far.

While they acknowledge the significant impact of the film, Camilo and Jorge also argue that it does not go far enough in dealing with the problems it raises. According to the film, homosexuals can find their place in

Cuban society by participating in the revolution, but not by organizing independently. Arnaldo Cruz-Malavé (1998:144) argues that the sexual union between David and Nancy, the suicidal neighbor, toward the end of the film reinforces the heterosexual norm and Diego and David's embrace emphasizes the fraternal relationship between revolutionaries. Homosexual desire is displaced by the promise of incorporation. As Abel Prieto indicated to me, "Fresa y chocolate is an artistic synthesis of the kind of unity in diversity that we need. That is to say, Cuban homosexuals have to submit themselves to this process of unity without losing their identity."[16] Despite its openly critical nature, the film can be tolerated and even promoted by key officials such as the minister of culture because it puts forth a narrative of incorporation rather than autonomy as the basis for recognition. The film obscures rather than "transcends" those aspects that cannot be contained within its utopian proposition, such as the possibility of independent organizing among gays and lesbians to address issues of homophobia and discrimination.

Marginality and the New Man

While in Fresa y chocolate Gutiérrez Alea proposes reconciliation between the state and homosexuals, in La vida es silbar (Life is to whistle, 1998), the filmmaker Fernando Pérez redraws this framework to include other marginalized sectors of society, such as Afro-Cubans. In La vida es silbar, the relationship between Cubans and the state is represented by a woman called Cuba and her son, Elpidio. Cuba is becoming estranged from her son because of her constant demands for perfection, and reconciliation between the two must be based on recognition by the mother/state that her sons/citizens are imperfect human beings who have the right to seek personal happiness and individual satisfaction. Pérez criticizes the kinds of voluntarism and collectivism that require citizens to sacrifice all of their personal needs and desires for the achievement of a single national goal. As the homosexual in Fresa y chocolate is a signifier of national culture and tradition, so the mother in La vida es silbar is a symbol of the regeneration of the national spirit. Gendered constructions of the nation draw their coherence from a contemporary context of crisis and renewal: the nation's recovery depends on a new form of matriarchy, where women are crucial to the reproduction of new revolutionary citizens.

Elpidio Valdés is a young musician from a marginalized background who makes his living by selling fish to tourists. He is a comic-book character, a quintessential hero such as Asterix, who is also an anticolonial symbol for many Cubans. Pérez described Elpidio as the character who is most rooted in his reality: "Elpidio is the survivor. He fishes on the Malecón. He is the popular figure who lives in the *solar* [tenements], who participates in Afro-Cuban religion."[17] The film opens with Elpidio as a young boy dancing in a classroom to the music of Bola de Nieve.[18] Throughout the film Elpidio is identified with Afro-Cuban music and the legends of this musical expression, Benny Moré and Bola de Nieve. Elpidio's mother, Cuba, is a large mulatta who cradles her children in her arms, but throughout the film her face is hidden. Carollee Bengelsdorf (1997) and Vera Kutzinski (1994) argue that the "Cuban mulatta" is a construction that lies at the heart of Cuba's struggle for nationhood. The bonding between men of different races that constitutes Cuban nation-building takes place through the body of the mulatta. The representation of Cuba as a mulatta revives this construction at a time when the nation is being figuratively reborn, while the invisibility of her face is an effacement of identity that limits the potential of her dangerous sexuality.

Sometimes the mother represents the Cuban nation and at other times she represents the political leadership; her figure conflates state and nation. The actor who plays Elpidio, Luis Alberto García, suggested that the relationship between Elpidio Valdés and his mother represents "the relationship between Cubans and Cuba, or between Cubans and the government, or between Cubans and the establishment, or between citizens and the nation."[19] The relationship between Elpidio Valdés and Cuba is represented as difficult. Cuba is always trying to control and discipline Elpidio and will not accept him as he is. At the beginning of the film, Elpidio's sister, Bebé, is shown whistling in class, and she is reprimanded by the teacher. Later, as Elpidio and Bebé are dancing in the classroom, a voice-over is heard: "No, Cuba, this girl won't change. She won't change here. She can't be kept with the others. She has to follow rules." Several other voices are heard, overlapping: "We're not changing our standards"; "From a pedagogical point of view, it is incorrect to . . ."; "She has to be like the others. She has to speak, not whistle." These voices represent the disciplinary authority of the state, trying to police the young people's behavior.

Bebé, as narrator, says that Cuba loves Elpidio very much but that Elpidio has not turned out the way Cuba wanted, and that is why Cuba has abandoned him.

Despite Cuba's rejection, Elpidio keeps a framed photo of her by his bed. Next to it he has an image of the Catholic saint Santa Bárbara. Throughout the film, Elpidio converses with, chides, and appeals to Santa Bárbara. For the filmmaker, the image of the saint is a representation of Elpidio's communication with his mother, Cuba.[20] In the Afro-Cuban religion of Santería, also known as Regla de Ocha or Lucumí, Santa Bárbara is associated with the oricha Changó, the oricha of war, struggle, fire, and passion, with whom many Cubans feel a close relationship. Whereas the traditional image of Santa Bárbara is a young girl in a white gown and crown, Pérez shows her as a highly stylized larger-than-life statue, based on a painting by the Cuban painter Zaida del Río.[21] The face is a white plaster mask, large red feathers sprout from a straw crown on her head, and her cape is made of red gauze adorned with streamers (red and white are the colors of Changó). In her right hand she holds a gold goblet, a symbol of Changó's cauldron, and in her left hand she holds a sword, which is identified with Changó's ax. The use of a syncretic image of Saint Barbara as a mediating object between Elpidio and his mother is part of an overall cinematic strategy to renew Afro-Cuban culture as the basis for national belonging.

As Elpidio becomes more estranged from his mother, he starts a relationship with Chrissy, a foreigner working for Greenpeace who arrives in Cuba in a hot-air balloon. When Chrissy sees a photo of Elpidio and his mother on the wall, he says:

Chrissy: Is that your mother?

Elpidio: She's Cuba.

Chrissy: Do you want to talk about her?

Elpidio: No, what for? (*Pause*) She left me. She went away. She thought I was no good, a bum, a lazy good-for-nothing. She got tired. Me, too. (*Elpidio is pacing and he stops and faces Saint Bárbara and looks at her in silence*) And now she doesn't send me a sign, nothing. (*Silence*)

Chrissy: I understand.

Elpidio: How the hell can you understand? You don't know Cuba Valdés. She's never wrong. She has opinions on everything. She thought her son Elpidio had to be perfect, a model, a hero, a . . .

Chrissy: A new man.

Elpidio: A new man. A new man. No way. I'm too much of a fucker to be that.

Cuba thought that Elpidio was "no good, a bum, a lazy good-for-nothing," an attitude that represents the state's view of young *marginales* such as Elpidio. He is unable to live up to the model of the "new man." Just as *Fresa y chocolate* reveals the heterosexist underpinnings of the new man, *La vida es silbar* points to the racial exclusions embodied in the concept. As Saldaña-Portillo (2003:89) argues, the new man was based on a "racialized and masculinist understanding of fully modern, revolutionary agency." To embrace life as a model revolutionary is to leave behind the person one is, the person that life has made one.

The filmmaker suggests that just as Elpidio is beginning to move away from his mother, Cuban citizens are beginning to move away from the state. The conflict between Elpidio and Cuba over his failure to conform to her values leads to their estrangement as Elpidio becomes more involved with Chrissy. Chrissy asks Elpidio to leave with her, and he must choose between his personal desires and his commitment to the nation. This dilemma is reflected in the parallel narratives of two other characters in the film. Julia is a middle-aged care provider for senior citizens who has devoted herself entirely to her career and finds herself with a strange affliction: she cannot stop yawning. Mariana is a young dancer in the national ballet who believes that if she is going to fulfill her dream of dancing the title role in *Giselle*, she must overcome her passion for men, which means denying herself any form of sexual intimacy. Just as Julia has not danced or made love or allowed herself to experience happiness, Mariana has denied herself sexual intimacy for the sake of achieving her goal. In the 1960s and 1970s, the socialist state made work and voluntary effort moral imperatives in the absence of material incentives, but the film questions the validity of this emphasis, particularly today. Throughout the years since 1959, the leadership often chose to devote resources entirely to one thing or another. For example, in 1970 the authorities decided to divert all resources and energy into producing a harvest of 10 million tons of sugar. The failure of this harvest and the consequent devastation of the Cuban economy showed the failure of single-minded pursuit of one goal rather than a strategy of diversification. In *La vida es silbar*, Pérez explores the personal and psychological costs of such extreme single-mindedness.

It is not only Julia and Mariana who have repressed their true feelings and desires, but, as Pérez suggests, Cubans in general. Everywhere Julia goes she sees others also turn faint at the mention of such words as "sex," "opportunism," and "truth." Because of their devotion to work, fear of speaking out, and single-mindedness, Cubans have locked their minds against personal happiness and truth. In order to resolve their conflicts, Julia, Mariana, Elpidio, and Cubans as a people must learn to confront their fears and speak honestly and openly about what is happening in their society. In one of the final scenes, Ismael confronts Mariana: "You don't have to choose between God, ballet, and me. You don't have to choose. The three of us love you!" He is criticizing the necessity of absolute choices. In the next scene, Julia's therapist, Dr. Fernando, takes her out into the street, moving his shoulders as he tells her he likes to dance. "You haven't danced for twenty years, Julia. You're a human being. Don't be afraid of what you were or of what you want to be. Don't sacrifice your feelings and desires. At least try!" The film affirms the necessity of personal self-cultivation, especially given the neglect of spirituality and the individual over so many years.

In group discussions people generally linked the psychoses and problems of the characters to the problems of choice that have been posed by the revolution. I organized another discussion group with Felicia and Leonor in Vedado, and we invited Felicia's supervisor, a young, conservatively dressed professional named Malcolm. Unlike many other men who had participated in the discussion groups, Malcolm had a lot to say about the film:

Malcolm: You know that we Cubans are dreamers, and therefore we have a pragmatic interpretation of one thing or another; that is, dreams and perhaps spiritual values are put above material things. This interpretation says that if we go for one thing or another we are confined, we are going to lose out, in the sense of nationality or identity. Julia is a prototype of people of earlier generations who are accustomed to working and forget about themselves. One even rejects things that normally people search for and desire: a partner, to have sex, to have fun, dance. Julia has terrible fear, because she has a problem of self-esteem. People who pass their lives in dedication to other people don't know how to look after themselves. Julia has not looked much after her own life. In the end, when they finish working, people of this kind don't have anything, all they have is work. Perhaps many people have a little of these characteristics in them. Mariana is an extreme, she sacrifices everything. She's a person who has lived so easily that

to achieve her goal she has to sacrifice. But it's not worth it. Never pay a price higher than the goal. Sometimes you have to sacrifice the objective to achieve. I think it's not worth it to sacrifice so many things to achieve a goal.

Felicia: The word "choose" is the word; that is, you have to choose between those or these. You can't have both.

Malcolm: Ismael says, you don't have to choose between ballet, God, and me, you can have all three. Why do you have to choose between the three? If you have one, why do you have to exclude the other two?

Felicia: Yes, but these are words that have come from social concepts that we have. You have to choose between being this and being that.

Malcolm: This film is heavy with symbolism. There are many interpretations. You are this or you are that. But I think that things are not black and white, there are always shades. You're either good or bad, but I don't believe this either, because the good are not always good and the bad are not always bad. It's something that we say here, you're simply this or you're the opposite. You can't dissent, because to dissent is to antagonize. You can dissent to an idea but not to a project, and this is how it becomes loaded. There are no other shades.

This conversation reflects the kind of shift taking place in Cuban society, from Manichean ways of thinking, as expressed earlier by Yolanda, to a more nuanced and graded interpretation. The film resonates for viewers because it both reflects and encourages these alternative ways of thinking about politics.

Viewers generally agreed with the criticisms posed by the film, and they drew examples from the film and their own lives to illustrate:

Leonor: For many years, if you wanted to be who you are, you increased the possibility that you would be criticized and misunderstood. People preferred to act completely in accordance with the norms and not move outside those norms. And so people developed a fear, a fear of being outside the parameters, because for many years the revolution was regulated by the observance of parameters. This is how you were measured, there were precise parameters to determine if you were revolutionary or counterrevolutionary. For example, in this case, you can be the best in the world, be the first in agriculture, be ready for all that could happen, a guard in the CDR, but if you were a religious believer, then you weren't a revolutionary.

Felicia: . . . The case of Julia is quite simple. But there are people who have had

to choose between things more important. They have had to choose between abandoning their country and staying with their family because they are pressured that they can't do this, they can't do that. It's like, to leave my family, and go and make something of my life, or I stay here, with my family, and that's what I want to be. These are things that you have to choose.

Malcolm: . . . If you had religious beliefs, if you had family outside of Cuba and communicated with them, this was looked down upon. All of this created a *doble moral*, because many people had correspondence but they hid it.

Felicia: I remember in my house, my mother was a religious believer her whole life, and my father believed in this saint and that saint, because you don't forget these things.

In the early years of the revolution, Malcolm's term *doble moral* was used in a pejorative sense, to describe a reprehensible way of acting, such as professing revolutionary ideals of egalitarianism and collectivism while privately hoarding wealth or avoiding work. Malcolm and Felicia referred to the necessity of hiding religious beliefs or communication with relatives abroad in order to avoid problems. But today the doble moral is posited as a form of resistance to a politics that tries to confine people within boundaries. Rather than conform to the official culture, you need to adopt a doble moral: if you are to continue believing what you do believe, you have to dissemble.

In the film Elpidio feels compelled to leave his mother, Cuba, whom he feels is unresponsive to his needs and refuses to listen to him. He speaks to the image of Santa Bárbara: "I'm going to leave you now. If you don't give me a sign, I'm going to cast you away from me, Cuba. I'm leaving with Chrissy." Interpretations of Elpidio's statement that he was leaving with Chrissy and of Chrissy herself varied. Several people suggested that Chrissy represents crisis,[22] specifically the crisis of the special period. Gloria, for instance, argued that Elpidio wants to leave Cuba because of the difficulties of the special period. By contrast, Malcolm associates Chrissy with the crisis brought by late capitalism:

At university we studied Marxism, historical materialism, dialectical materialism, theories that suggested that the world is now in the final phase of capitalism or imperialism and that in this phase capitalism is in crisis. The foreigner is capitalism, and it's in crisis, it's the crisis that comes . . . We were always told that Western capitalism signifies crisis. We have always seen capitalism as

a stage in constant crisis, a cyclical crisis, and it will continue impoverishing large sectors until it disappears. This is the perception of those of my generation, of Felicia and Leonor also.

Malcolm drew on theories of Marxism to explain why Elpidio wishes to leave: it's not because of crisis in Cuba but because of a crisis begun in the West. This is a common way of explaining problems in Cuba; they are always caused by something outside of Cuba, usually by Western capitalism or imperialism. The filmmaker suggested that his own interpretation had less to do with outside factors, as Chrissy represents Elpidio's personal crisis: "I think Chrissy is a catalyst. She catalyzes a crisis, the crisis of Elpidio, because Elpidio was relaxed, but in the discovery of a much more open reality represented by love, there is a crisis, which is why Elpidio says, 'I'm leaving with Chrissy,' because he would go anxiously." [23] In a highly politicized atmosphere, where leaving Cuba is associated with abandonment of the revolution, most people did not see the personal interpretation that the filmmaker intended.

The political leadership must be open to the criticisms of citizens, and both citizens and the state must work to renew political consensus, represented allegorically by the reconciliation between Elpidio and his mother. At the start of the film, Elpidio goes for a consultation with a *babalawo*, or a priest of Santería, and the babalawo tells him, "Your mother needs an offering. The road to her is within you. When she's ready, she will send you a sign." Through his relationship with Chrissy, Elpidio realizes that his freedom is within himself, and that he can resolve his problems with his mother without leaving the country. It is through his music, the driving, rhythmic, and primal force of the drums, that he can now reconnect with her. In one of the final scenes Elpidio addresses Santa Bárbara: "All right. I'll go find you, mother. I can forget your forgetfulness. Your wish to make me so unbelievably perfect. Nobody's perfect. Nobody. Shit! Let me be and think the way I want. No one rules us here." He points to his head. "You taught me that yourself. And now I'm not going to change. I'm not going to change. But I can't live without you, Cuba. I can't. If you can and want, accept me as I am, make my music take me to you." The threat of exile functions for Elpidio as a way of strengthening his voice. It has given him his mother's attention, and she must now allow him the freedom to think and must accept him for who he is rather than trying to make him into a

new man. Pérez suggests that even though Cuba accuses Elpidio of failing to become the "new man," his consciousness has changed: even though he steals some of Chrissy's money, he does return her wallet. Elpidio cannot live without Cuba; he is not complete without the nation and therefore cannot leave. Throughout this process of reconciliation, Cuba does not appear as a character in her own right; she must be represented. As Bengelsdorf (1997:245) argues, the bonding of men to form a national community was "written upon the body of the (always absent) mulatta." Bonding between Cuba's sons takes place upon the bodies of mulattas, who are both central to the discourse of national unity and invisible within it.

The ending is a reaffirmation of the individual as a crucial part of the realization of the collective. All three characters meet in the Plaza de la Revolución, a crucial historical and political site where many of the important events of the revolution took place. As they stand there, they begin to whistle. Pérez (quoted in Díaz 2000a:114) explains this meeting as crucial to the narrative:

> When the characters meet, Elpidio reaffirms his whistle and all can begin again: one path is closed, but others are opened, and this is also related to our social and political circumstances today. His whistle in the empty plaza is the reaffirmation of the individual, because many times the collective dream can annul and forget individuality, something that often happens in revolutionary processes, but individuality can never be forgotten. . . . It is the awareness that all collective dreams are sustained by individual realization.

La vida es silbar is a pragmatic reinterpretation of socialist values of collectivism with a focus on the importance of individualism, diversity, and personal happiness, factors that became more important in the liberalizing society of the 1990s but are still ignored in official discourse. Further, when I talked with him Pérez argued that "Elpidio is a representation of the national, which has always struggled. Today Elpidio has another form of self-expression in a real crisis that the country is facing."[24] Elpidio is the embodiment of the nation that has become reconciled with the state, and as a marginal young man in the society he can relate to Cuba as a country that is forced to struggle for its sovereign place in the world. Désirée Díaz (2000b:40) sees the resolution of Elpidio's crisis as his affirmation of the nation and of tradition when he reconciles with Cuba rather than seek

freedom and happiness abroad. This view was also expressed by some of the participants in discussion groups. Ana, a young black music teacher in Matanzas, suggested, "For Elpidio to leave his country is to cease to be a boy from the streets, a Cuban with his roots." Being Cuban is identified with street culture, with the roots of Santería and rumba that have been re-incorporated into the national imaginary.

The film ends with the narrator, Bebé, sitting by the Malecón and crying and whistling as she says she has found the secret to happiness: "It's easy: you just have to whistle. Because I'm happy when I whistle and I discovered that is what life is: whistling. And that's why I talk and whistle and whistle and talk." Viewers had various interpretations of this somewhat ambiguous ending. Esteban, a television editor in Matanzas, saw the whistling as a reaffirmation of Elpidio's right to speak out: "We have to confront our problems like the characters in the film, let's go to the streets, let's scream, let's air our criticisms in public. Let us live our lives fully." Ana and Raúl did not take such a proactive view, and at another moment they all agreed that whistling was a form of escape:

> **Ana:** When something doesn't interest me, I whistle and look away. I think people whistle to forget. The child in the film isn't interested in school, that's why she whistles.
>
> **Raúl:** There are countries where you can't whistle, such as the Soviet Union, where to whistle showed a lack of respect. In Cuba, to whistle is to proposition [*silbar es chiflar*]. In earlier times we had very good whistlers. To whistle is to entertain yourself, to take a rest from your thoughts.
>
> **Esteban:** To whistle is like when you are working and you need a moment to disconnect and maybe you don't whistle, but it's a form of escape. It's to say, "We're taking up again forms of expression that we've lost."

The participants in this discussion interpreted whistling as a popular, enjoyable activity that has been resumed in the aftermath of the Soviet collapse. But while Esteban also saw whistling as a means that Elpidio and the other characters use to express themselves to the state, some other discussants saw the act of whistling in this somewhat ambiguous ending as a way of avoiding confrontation and seeking respite.

Unlike *Fresa y chocolate*, which received strong praise from the critics and important awards in Cuba, *La vida es silbar* was criticized by Cuban film crit-

ics for its ambiguity, symbolism, and complexity. In a review published in the state's official newspaper in 1998, Rolando Pérez Betancourt argues that the film "leaves its main propositions only half-elaborated, it proposes intrigue and then leaves the threads hanging." [25] Although there are certain narrative resolutions in the form of the reconciliation between Elpidio and his mother, the tensions and contradictions of the ending of the film produce discomfort for the reviewer. Pérez responded a week later in an interview: "The most important thing is that *La vida es silbar*, this film, creates diverse points of view. And this polemic seems to be important, open, necessary. Because it's a film I have dedicated to Cuba with much love." [26] Pérez defends the need for films that provoke multiple meanings and polemical interpretations, and like Díaz Torres earlier, he covers his statement with the nationalist assertion that the film is patriotic and reaffirming of this country.

La vida es silbar, like *Fresa y chocolate*, allows space for the expression of critical and alternative views, but filmmakers seek to reincorporate these expressions into dominant paradigms by uniting citizens with each other and with the state. The utopian proposition of reconciliation with the state based on a renewed mutual understanding and redefinition of the terms of cooperation was perhaps less believable for viewers of *La vida es silbar*, not all of whom could identify with its final positive moments. However, the viewers did affirm Elpidio's decision to stay in Cuba and his spiritual connection to his country. But as the utopian proposition in *Fresa y chocolate* obscures the problem of discrimination against homosexuals in Cuban society, so the utopian consensus between Elpidio Valdés and his mother is predicated on the erasure of the mulatta, who is unrepresentable in the cinematic discourse. The narrative's female figure was so familiar to viewers that they did not talk about her character as problematic; in many ways her significance as representative of the national community has become naturalized.

The Power of Hegemony: Fostering Loyalty to the State

Working with a highly institutionalized art form, filmmakers can reach large numbers of people and have the cultural authority to influence them, and also the imperative to incorporate alternative and critical expressions back into dominant ideological frameworks. While films such as *Fresa y chocolate* and *La vida es silbar* do tend to operate allegorically, other films are

much more ambiguous and open. Yet the sessions with viewers showed the surprising ways in which people would continue to reinterpret even ambiguous films as requiring them to frame their criticisms positively. It is not only filmmakers that act as agents in processes of partial reincorporation; ordinary Cubans do so too.

Madagascar (1994), also produced by Fernando Pérez, presents the spiritual crisis facing Cuba in the post-Soviet era. The film traces the relationship between Laura, a middle-aged woman with a university career, and her rebellious teenage daughter, Laurita, who searches for her place in the world and rejects all the alternatives available to her. Laura cannot understand Laurita and her need to go to an unknown place called Madagascar, but by the end of the film Laura is ready to undertake the journey herself. The film addresses the question of travel as a national obsession in an island where international travel is highly restricted. Pérez explores the spiritual effects of such saturation and isolation, and the longing to know something outside of one's daily reality. He also suggests that a focus on the collective at the expense of individuality has resulted in an impoverished sense of spirituality.

Like *La vida es silbar*, *Madagascar* brings into focus the question of the place of the individual, an issue sidelined by overemphasis on the collective for so many years. In one scene, Laura is sitting with her mother, Laurita's grandmother, and looking at old photos. The grandmother holds a photo of a large crowd gathered to celebrate during the early days of the revolution. She tries to remember the actual date of the photo. Laura takes the photo from her and looks at it with a magnifying glass, asking, "Where am I, where am I, God?" Laura is overwhelmed by the need to find herself in the crowd. In group discussions of *Madagascar*, people said that the film questioned the priority given to collectivism as the highest spiritual value, and argued that the search for individuality represented by the film was important, particularly after years of subjugation of the individual to the collective. Gloria, Felicia, and Katia suggested the ways in which the spread of mass culture[27] and the emphasis on the collective have prompted both Laura and her daughter to search for their individuality:

> **Katia:** Laurita doesn't want anything to do with conscience, and she becomes manipulable, and she loses her identity as a human being. Not her flag or her ideology or anything is important to her. She knows certain living models, she

knows the important models, but they don't satisfy her, which is why she says Madagascar. It's what she doesn't know, because for her, she's not interested in what interests young people in the United States, in la yuma,[28] no, this doesn't satisfy her. She wants to find alternative models to fill this spiritual vacuum. That's why she goes to church, she keeps looking for another path.

Gloria: But I could see that up to a certain point this is what happens to adolescents. Because adolescents are rebellious. By nature and in the consciousness of their individuality as adolescents it's logical. Well, at least adolescents discovering their personality. . . . I have seen adolescents of other countries who are also searching. It could be explained as a normal process, up to a certain point, but what is not normal is that the mother also succumbs to this. Therefore, it makes you think that this is not the problem of Laurita, and it's not the problem of the mother, but this is the situation.

Felicia: It's not only Laurita's generation, but everyone.

Gloria: This is important, the spread of mass culture and the forgetting of individuality.

It is interesting that while audiences outside of Cuba tended to view the film in terms of universal themes of generational conflict and youth rebellion,[29] Cuban viewers see the added dimension of the crisis of an older generation that has made sacrifices for the revolution and is now feeling the consequences (Fowler 1996:23). The search for individuality is also related to a broader search for local models and a native identity to fill the void that was once filled by a foreign model.

The title of the film *Madagascar* is an allusion to other places, other experiences, everything that Havana at this time is not. Several shots of the Malecón, a walkway along the city's seafront, emphasize the entrapment of people within a situation from which the sea offers the only escape. There is a sense of limitations, and the characters in *Madagascar* are frustrated by the personal and professional limits imposed on them. At the beginning of the film, Laura says that she is satisfied; she is considered one of the best physics professors at her university and she loves her daughter. However, her narrative suggests otherwise, that she is trapped in a situation that repeats itself endlessly: "The problem is that I sleep, doctor, I sleep and I dream. But I dream exactly what I live every day. What others live during twelve hours, I live all twenty-four. I'd like to dream something different. But no, it's always the same." Laura's narrative is accompanied by images

of the monotony of her life; Molina, Laurita's boyfriend, chewing bread and a rat nibbling on crumbs are juxtaposed with scenes of Laura's daily routine, getting on a train and walking home from work. Molina and his family sit around a dining table eating mounds of cabbage, one of the few foods widely available during the worst of the economic crisis. Despite Laura's initial enthusiasm about her life, it appears that she is trapped in a mundane routine.

In the course of the film Laura becomes aware of the ways in which she is trapped. A scene repeated several times shows Laura sitting in a reading room with a number of other people. A man who reads newspapers aloud, his voice droning on and on, signifies the monotony of public discourse. Mercedes, who they thought would be a great researcher, is also there in the reading room every day. In her frustration Laura cries out, "What happened? No one knows what happened. A bomb. I should put a bomb in here right now. And me? Inside or out?" Laura knows that in order to survive she needs to leave this reality before she self-destructs along with it. However, her attempts to break out of her routine and begin anew result in more frustration. She moves to a new house but finds that nothing has changed. Her relationship with Laurita reaches the crisis point and Laurita finally leaves home. After these experiences, Laura finally realizes that she needs to go to Madagascar, and she proposes the journey to Laurita. The film concludes with an image repeated constantly throughout the film: Laura, Laurita, Molina, the grandmother, and Cubans of all races and ages stand on the roofs of the city, their arms outstretched, faces lifted to the sky, chanting, "Madagascar, Madagascar." Díaz (2000b:39) argues that Laurita, unlike Elpidio, who stays rooted to his homeland and resists the call to flee, receives nourishment from her dreams of travel and escape: her position on the rooftop is one of both crucifixion or subjection and liberation.

Spectators had a variety of ideas about what the journey to Madagascar actually represented in the film, but most of them agreed that the characters' desire to go to Madagascar did not mean that they wanted to leave Cuba but rather represented the search for a spiritual place where they could find a means of individual and personal reflection. In a discussion between Tania, a young student; Patricia, her mother; and Leonor, in Patricia's home in Vedado, the women agreed that the journey to Madagascar was more spiritual than physical:

Tania: I don't think the solution was to leave the country, because it seems to me they'd just find the same problems, like when Laura moves to a new house and just finds the same old same old, and like everyone in the world has problems.

Patricia: For me, Madagascar is a symbol of change, in terms of the mother-daughter relationship, in terms of the girl confronting her society. I really don't see it as escape from a situation, but well, we continue to move within the same context.

Leonor: It's a search for equilibrium, I think. Madagascar is a place where I am going to find a space of equilibrium.

Tania: Go figure, when she's well, when she's working, when her daughter is working, then she says, now we will go to Madagascar.

Avoiding the obvious associations with leaving the country, these women suggest that the problems in *Madagascar* are more spiritual than political, and that they can be resolved on a psychological level. Madagascar represents equilibrium and well-being. The women see the solution as personal realization that enables the individual to confront her society.

In another discussion group, held in the home of a working-class family in Matanzas, Julia, a young shop assistant, and her husband, Lázaro, a driver, suggested that Madagascar is a form of escapism:

Julia: Madagascar is what Laurita doesn't know. She says, "I don't want to be here, I want to live in a place I don't know, and to experiment with something new, to learn about other ways of living," as a search for new horizons, different things. It's what is different. The three generations are transferring all of the psychological problems. I don't know if the daughter realizes that all these same things happened to the mother.

Lázaro: I think Madagascar is where your mind disconnects from certain problems that you have in life. It's a place where your problems don't matter.

Julia: Many people have become alienated in the special period. For me Madagascar is a spiritual thing, more spiritual than political. *Fresa y chocolate* is more political. Here they reflect the spiritual aspect of being human, but it doesn't mean to leave the country.

Lázaro: Of course there are economic problems, there is a crisis, and people have to do what they have to do.

Julia: But listen to what they say in the end! After the daughter resolves her problems, it's as though Laura is stuck with those problems.

Lázaro: But she achieves an understanding, she is able to understand her daughter.

Julia: For me it's as though the mother couldn't get over the crisis that happened to her daughter and she is the one who is stuck in the crisis at the end. She asks, "Have you got your things ready, because we're going to Madagascar." You see everyone with their bicycles in their hands as if they're on the road in search of other horizons, but not other countries. It's like a search for tranquility and harmony. That everyone leaves behind their problems and we live in peace.

While the earlier group interpreted Madagascar as a place where people find a spiritual equilibrium, this group interprets it as a form of escaping or avoiding one's problems, a way of disconnecting from reality. Rather than seeing the characters as resolving their problems in the end, as the other group suggested, Julia argues that Laura is left with the crisis that her daughter began with, and that going to Madagascar is a way of leaving that crisis. While one interpretation suggests that Cubans are getting on with their lives, the other suggests a reality of crisis, alienation, and economic hardship. Perhaps their location outside a major city and their casual employment as unskilled labor explains why the crisis seems more intractable to the second group: they are less optimistic about their own future. However, the second group agrees that the journey to Madagascar does not involve leaving the country.

Gloria, Felicia, and Katia engaged in an animated discussion of what Madagascar represented:

Felicia: But, I don't know, the journey to Madagascar doesn't seem to me a journey to a specific place, rather a meeting with us ourselves. That is, remembering what you said [*gesturing to Gloria*], a journey to Madagascar as a call to the conscience not only of the adolescent but of Laura herself, but this journey signifies changes. The search for identity, the identity of everyone. It's not to avoid the situation and leave.

Gloria: I see it as leaving.

Katia: I don't.

Gloria: It doesn't matter where you go, because Madagascar is any place.

Katia: For me it's another model. There are times when I feel, when I see these things, no, I'm going to reflect in the following manner, I don't much like the reality that I live. Fine. I start to think as people all over the world think, I'm

going to change. If I could, I'd live somewhere else. But I don't think of living in Madagascar, I don't think of anything that I don't know, always of what I know, never mind that the models I do know don't satisfy me either. Suppose I could live in another country. And say that all the things that affect me right now will not affect me in another country because it's the conditions. But the essence is the same, because I am searching for a realization, and on this path I'm not going to find it. If I, along with everyone else, went to Madagascar, we would find the identity that we've lost because we have copied models.

Gloria: And because of the spread of mass culture.

Felicia: Because of the spread of mass culture, but this is not a journey to a specific place. It's we ourselves, in search of changes within ourselves. A change of models but we ourselves.

Gloria: But what tells you that it's changes within ourselves?

Felicia: Because I interpret it as saying that we can't all go and abandon our island.

Gloria: But I'm not saying that everyone goes, but that everyone wants to go.

Felicia: It's not to go, it's to make changes here! They tell you twice, once in the beginning, they tell you it's to engage with your society and make changes. Therefore, making changes can't be abandoning the island. In the first place, I interpret it like this because I don't want to go. I want to make changes and bring about consciousness in people, you realize, which is what you said at the start. Laurita, as an adolescent, is the one trying to make changes in her own way. "I don't know what I want, but I know I don't want to be like you," she tells her mother. I know what I don't want. What I do want I have to search for, but what I don't want is to leave and abandon the country, just because things might be easier.

Gloria's skepticism provokes Felicia and Katia to declare their allegiance to the country more passionately. Although earlier they articulated problems of inertia, alienation, and loss of individuality in socialist society, Felicia and Katia themselves sought to reincorporate their energies and feelings of frustration into a desire to struggle for and within the revolution. Gloria's challenge only serves to elicit more strongly their emotions of allegiance and responsibility to the country.

The debate among the women was strongly centered on how they viewed the nation and their place in it. What seemed to be at stake was their commitment to their country and thus to the revolution. So I was surprised

when the women turned to me at this point and asked what my view was. I would generally observe the group discussions, interjecting a brief question here and there, but not offering my opinion. Moreover, I have always felt uncomfortable with nationalism. As a child of Indian parentage growing up in Australia, I was always seen as an immigrant, not an Australian; being of Catholic background, I always felt excluded by Hindu-defined notions of Indian nationhood. In some ways I envied people like Felicia and Katia who could see themselves so unproblematically as belonging to a national collectivity, but I could not relate to that view. I dodged the question by referring to my recent interview with the filmmaker:

> **Sujatha:** The filmmaker, Fernando Pérez, said to me that Madagascar is not a geographical place but a mental space or a spiritual place. But the movie itself could suggest other interpretations.
>
> **Gloria:** For me, the message given by the film is that our situation is unbearable, that it's suffocating, that the mother ends up like the daughter, trying to escape, whether it's to Madagascar, whether it's to the sky, wherever it is, but to escape. And Laurita continues to escape by every means, escaping her reality. She tries with her music, she tries with that weird painter boyfriend. The thing is to escape, like the old woman too. The old woman is on another planet. Like thousands of people in this country.
>
> **Felicia:** She is left way behind, in 1959.
>
> **Katia:** She's here but she's not here.
>
> **Gloria:** For me, we've had it up to here [*motions to forehead*]. I'd like to see it like you [*gestures to Felicia*], but I don't. What's the answer? No one really knows, no one here knows what they want. They only know they don't want what is here.

Gloria was able to express her view that to talk about leaving is not necessarily a bad thing, that the situation is difficult and everyone knows it. The reality, she said, is that most people are not trying to change things for the better, but rather escaping in all kinds of ways, some in boats to the north, some in their minds, like the grandmother who loves to play Monopoly, screaming "I'm rich, I'm rich!" every time she buys more property, or Laurita with her music and art. Gloria backed up her position with examples from the film:

> **Gloria:** There are two allusions in the film. There is the example where Laura is talking about her student Miriam, so stupid and yet living in Paris. And the other

example is when Laura says, "You remember the mulatta, the model, so pretty, who married an Italian and left the country," and the mother says, "Oh, what luck!"

Katia: Above all, when she talks about her student, the message that you can get is that that person, who is a professional, who studied and sacrificed, worked, studied, but for nothing, she lives like this! And the person who . . .

Gloria: It's what our generation feels. It's what thousands of people of our generation feel, that we sacrificed, and many people who are now retired look back and say, "So what? I can't live on what I have." Isn't that true? Now we're not suffering from such a major economic crisis as before, but the ideological problem is bigger because we live in two worlds. At that time we were all eating cabbage together. Now there are people who are not eating cabbage and those who are still eating cabbage. It's a strong contrast. The utopia is coming apart. The model is unraveling, because we are in this strange transition, nobody knows what it is and nobody knows who will win out in the end. Will the successful ones be those who do things legally, like Laura, or those who leave?

Felicia: These are the contradictions of our reality. Because earlier we were all poor, but when the dollar was made legal, the world as we knew it ended and the problems began. And with tourism it's worse. Now we've seen the end of the utopian vision that we are all equal and that the victory is for all.

Despite my impression of Felicia as much more rooted than I in her sense of nationality and devotion to a political cause, as I came to know her it became evident that she had her own battles in the revolution, particularly as a black woman. In 2004, I returned to Havana on a university tour and one afternoon as Felicia and I tried to enter the fancy Hotel Riviera, where I was staying, we were both stopped and prevented from entering by the white Cuban security guard. Our incredulity turned to rage and then tears of pain and frustration as the guard responded to my accusations of racial discrimination with the oft-repeated line: "In Cuba there is no racism." Part of Felicia's sadness came from her sense that as a black woman she had made gains under the revolution and in the 1980s she and her husband had come to stay in this very hotel that was now denying her entry because of the color of her skin. But that day, Felicia publicly buried her disappointment and discomfort as she explained to the guard that I was a foreigner, I would never understand how things were in Cuba. Likewise, in the group discussion, Felicia followed her expressions of cynicism with professions

of loyalty to the revolution and her desire to stay in Cuba and fight for what she believes.

Fernando Pérez also interpreted the film as proposing a struggle within the revolution: "I wanted to say that we can fight against routine. It says there is always a possibility."[30] In contrast to the open, pluralistic quality that he attributed to his later film *La vida es silbar*, Pérez was still cautious in describing *Madagascar*. Cuban film critics praised *Madagascar*. A critic for *Bohemia* said that *Madagascar* was "an exceptional work, the best made by Cuban cinematography in decades," and cheered its "ideological and social role" and its "defense of our nationality."[31] The *Granma* critic Pérez Betancourt, who later disparaged *La vida es silbar*, commended *Madagascar* for the "intensity with which it poses the monotony of our daily lives, alienation, and other existential burdens."[32] Critics and Pérez himself publicly framed *Madagascar* as a film about the need for new identities and a spirituality to fill the vacuum left by the events since the Soviet Union collapsed, and not as a film about the desire of Cubans to leave Cuba. But in a personal interview, Pérez told me he intended the film to encompass all those meanings:

> Madagascar is not a metaphor of geographical travel, rather it's a journey within oneself and how one can find oneself through diverse incursions into one's own reality and identity, and one's own harmony. I suppose that here in Cuba in the 1990s, travel is also linked to emigration and concrete journeys, that many want to leave Cuba not only because it's an island, but also for economic, political, or various other reasons. I think these are two aspects of the reality, the social and the individual, and both aspects form part of the film.[33]

Several years later Pérez was willing to speak more openly with me about the ambiguity and multiple meanings of the film. But most viewers did not see the film in this way. Most participants in the discussion groups associated the spiritual vision of Madagascar with the Cuban system rather than with any country or political alternative outside of Cuba. Although some viewers said that the "model" of Cuban socialism no longer satisfied them, they refused to accept the suggestion that the journey to Madagascar could be an "abandonment" of Cuba. The film did allow people to talk about the reality of hardship, alienation, and isolation in the special period. However, most people's refusal to accept the idea that Madagascar could represent any place or journey outside of Cuba indicates that new modes of incor-

poration involve the actions and activities of viewers themselves. Viewers come up with new syntheses and they search for ways of reconciling their ideals of the revolution with the reality of the post-Soviet abyss.

People's interpretations of what Madagascar represented diverged greatly from their analysis of what Maravillas represented in Díaz Torres's film *Alicia en el pueblo de Maravillas*. Both Madagascar and Maravillas are imaginary places that represent the need for a particular kind of critical engagement with reality. But while viewers were more willing to imagine the symbolic dimensions of Madagascar, in group discussions of *Alicia*, people took the metaphor of Maravillas literally. One group of young people in Havana felt that Maravillas was a bad representation of Cuba. In a discussion group in Matanzas, Sandra, an older black doctor, insisted that "Maravillas doesn't exist, it's not Cuba. In Cuba there is no place called Maravillas." María, another older black doctor in a discussion group in Havana, expressed a similar view: "Whether I see the film now or earlier, I don't feel any identification with the reality that I live. I know that these things and worse have happened here like in other countries, but I don't associate this with what I know." Viewers looked for the purely literal meaning of Maravillas, asking whether it was a good representation of Cuban realities.

Besides the hype that surrounded the movie, which clearly shaped people's expectations, and the use of satire, it seems that the main reason why people were so hostile to *Alicia* was that it does not provide a constructive or positive frame in which a solution can be found. Alicia travels to the town of Maravillas with the intention of helping the people, and after struggling with bureaucrats and cynical directors, she gives up. Sandra was disappointed: "In one part of the film, I thought, 'She's going to do something to help these people.' As she was a theater instructor, I thought she'd put together a play, where everyone would improve and realize the problems they have, but she never did the play. . . . I don't see any beauty in this story or any message that can be instructive." María said, "I don't know what the lesson of the film is. What's the message? The ending is absurd." In the final luminous scenes of *Madagascar*, Laura and Laurita journey toward the end of a tunnel, but in *Alicia* the tunnel has no end. Without a constructive and positive ending, there is no potential for incorporation, and hence critics and viewers alike feel uncomfortable. Some people in the discussion groups did appreciate the film. While Jorge, an older engineer in Matanzas,

complained that the film did not show the positive aspects of the revolution, his son Mario, a young carpenter, responded, "If you watch television they only say good things. . . . We shouldn't think that everything is marvelous, because everything is not marvelous. And if things are good, they're not always good for everyone." But it seems that most others find critiques easier to absorb when they are presented in a positive light. Films that show a valiant crusader combating corruption, opportunism, and hypocrisy are enjoyed more than films like Alicia that hint at deeper structural flaws and require a questioning of power relations for which people may not be prepared.

Alicia and Madagascar were also less appealing to the general public because of their aesthetic. Pérez recalled that after one screening of Madagascar at a popular movie house in Havana, the Cine Payret, people in the audience stood up and shouted that everyone in the film was crazy, they did not understand what was going on. Others said the film was too heavy.[34] At some screenings people rose from their seats to shout in indignation, "But what is this?"[35] In my own discussion groups, many working-class Afro-Cubans found the long and melancholy introspective scenes in Madagascar "strange"; all that classical music, they said, did not appeal to them. Referring to one particularly emotional part of the film, where Laurita sobs as a symphony plays in the background, an Afro-Cuban woman from Matanzas confessed, "I felt quite removed from what was happening in the film." Pérez himself admitted to me that Madagascar was much more popular among professionals and intellectuals and did not have much resonance with the general public.[36] Another Afro-Cuban woman in Matanzas complained, "It's so pathetic, macabre, and gray. Everything is ugly, the sun never comes out." Another woman said, "For us Cubans, whatever we do, we do it with pachanga [rhythm]." Another added that the people in Alicia look so poor and decrepit, they don't even wear lipstick, but it's not like that in Cuba. European-derived styles and aesthetics do not always appeal to a popular Afro-Cuban audience.

While it is understood that some films appeal to only certain audiences, the general absence of Afro-Cuban actors, themes, and aesthetics from Cuban film is disturbing. With the untimely death of Sara Gómez before her film De cierta manera could be finished, the Cuban film industry lost an important Afro-Cuban voice. Other black filmmakers such as Sergio Giral

have had difficulty making films and having them screened. Giral's historical film *El otro Francisco* (The other Francisco, 1974) was more acceptable because it dealt with issues of race in the historical context of slavery, but his 1991 film *María Antonia* was highly controversial for its open portrayal of Afro-Cuban religion and sexuality. Giral's other film dealing with contemporary issues, *Techo de vidrio*, was banned because, like *Alicia*, it presented a situation where problems of administrative corruption, the funneling of resources into personal wealth, and ruthlessness are not resolved by a positive critical vision (Padrón Nodarse 1994:20). Black actors also have difficulty finding roles in Cuban film, as leads are almost always given to white actors. The only black Cuban in *Fresa y chocolate* has no lines to say. Even with the growing marketability of Afro-Cuban themes, black actors and filmmakers are still a minor presence in Cuban film and it is often white filmmakers such as Fernando Pérez (*La vida es silbar*) and Humberto Solás (*Miel para Oshún*) who write scripts about Afro-Cuban culture and religion.

The career of Gloria Rolando expresses some of the difficulties faced by Afro-Cubans in ICAIC. Since the mid-1970s Rolando has been producing documentaries with such famous Cuban documentary makers as Santiago Alvarez. But she had been working in the film industry nearly twenty years before she was able to produce her own feature-length film, *Oggun: An Eternal Presence* (1992), with the support of a foreign video company, Videoamérica S.A. As Rolando (2000:132) notes, the film "was produced to sell in tourist places and, from 1991 to this year, 1996, it has never been seen on Cuban television." Since then, Rolando has chosen to work independently with Imágenes del Caribe, a video company that she started up herself. The lack of participation of Afro-Cubans in Cuban film suggests the limitations of dominant public spheres such as film. As we shall see, it is through counterpublic spheres such as rap music and visual arts that these exclusions are discussed and Afro-Cubans have greater opportunities to put their issues on the agenda.

The integration of Cuban film into a global marketplace has opened possibilities for filmmakers even as it has produced new restrictions. As mediators between state and society, filmmakers seek to reincorporate new experiences and alternative values into dominant codes: they reconcile

.g values of individualism, personal happiness, and social equality
.ie existing socialist order, and they seek to unify Cubans under a
, inclusive vision of the nation. Spectators themselves act as impor-
tant agents in this process of incorporation. Even films such as *Madagas-
car*, which suggest that most Cubans are desperate to leave the country,
can promote interpretations that foster loyalty to the Cuban state. Hege-
monic processes involve actors on several levels, and viewers themselves,
especially when presented with critical and ambiguous discourses, feel the
need to reconcile those interpretations with their inner convictions and re-
incorporate demands for change into a need to struggle for the revolution.
The recreation of hegemony during a period of crisis involves struggle and
contestation on many levels, but outcomes, while never fixed, are tied to
the ability of the hegemonic to continue shaping and directing people's
thoughts and actions.

But the acts of translation involved in representation and reception also
produce slippages where new meanings can emerge. *Fresa y chocolate* makes
new understandings of revolutionary agency available. The representations
of gays and Afro-Cubans as part of the revolutionary project may open space
for more critical ideas and dialogue in the public sphere. There is also room
for a degree of dissent and disagreement with the utopian narratives put
forth by filmmakers. Some viewers discussed the underside to their claims
of loyalty to the revolution, their own desire to leave the country and their
sense of disillusionment with what their struggles have achieved so far.
Other participants in the discussions suggested that a film such as *Fresa y
chocolate* did not seriously address the question of gay liberation. But these
moments of cynicism are fleeting and individual; viewers do not have the
capacity to formulate demands or organize themselves into blocs around
their claims and complaints. Let us look next at the public sphere of rap
music, where criticisms are formulated as political demands on the state
and more critical performance is made possible by rap's marginal status.

3 Fear of a Black Nation

Local Rappers, Transnational Crossings, and State Power

Although film continues to be one of the largest and most far-reaching critical art forms in postrevolutionary Cuban society, engaging audiences across the country in lively and polemical discussions about politics, the 1990s saw the rise of a number of smaller artistic public spheres on the periphery of mainstream cultural life. Cuban rappers in the Alamar housing development began taking over the street corners and open parks, breakdancing and rhyming in small informal gatherings. Art collectives created public murals and used the streets of Havana as a stage for their musical and theatrical performances. Cuban rap and visual arts have developed publics outside of official cultural life, thriving in the streets and barrios rather than in official theaters, movie houses, and galleries. What is distinctive about these new cultural movements is their language of diversity and particularity; Cornel West (1990:19) has called this development the "new cultural politics of difference." Cuban rap in particular is closely bound up with questions of race, nation, and generation. Emerging from marginalized communities in Cuba's urban centers, rap music is shaped by underground American rap, large multinational record companies, and Cuban state institutions. How does the marginal yet transnational status of the rap public sphere affect its capacity for critical intervention?

Transnational rap networks in Cuba provide a vehicle for young Afro-Cubans to voice demands for racial equality, yet cultural and political leaders also harness rappers' creative energy as a way of rebuilding popular support in a time of growing racial divisions. While filmmakers were the primary agents of incorporation in the film public sphere, it is cultural leaders such as the minister of cul-

ture and rap producers who work to reincorporate alternative and oppositional elements of rap music. To some extent, rappers themselves also act as cultural intermediaries between young Afro-Cubans and the state: they continue to promote the ideals of the revolution, they are critical of the emergence of consumerist values and practices among the more commercial rappers, and they identify with the official characterization of Cuba as a "rebel nation." The transnational status of rap does extend various opportunities for critical resistance that are not available to more highly institutionalized forms such as film. The transnational rap networks of both underground African American rap and transnational record companies offer rappers alternative possibilities that prevent their wholesale cooptation by the state.

Players in the Rap Public Sphere

Cuban hip-hop[1] is shaped by a highly specific set of social and economic conditions, including the demographic restructuring of the urban metropolis and increasing racial inequalities in the special period. For the first five years of its evolution in Cuba, up until 1992, hip-hop culture was produced and consumed within the specific social context of the local community or neighborhood. At parties people would play music from compact discs that someone had brought from the United States or music recorded from Miami radio, and they would pass audiocassettes from hand to hand. There would be breakdancing competitions and people would rhyme in private houses, on the streets, and in parks. Since 1995 Cuban hip-hop culture has developed its own style and has become distinctly more complex; as it has become increasingly popular among Cuban youth, it has simultaneously become intertwined with Cuban state institutions, transnational record companies, and hip-hop movements in the United States. These developments have produced various factions, or blocs, within Cuban rap, which are identified with the broader national and transnational forces. From certain social, historical, and institutional locations emerge the commitments and solidarities that are crucial to the articulation of political demands, the reinvention of utopias, and the framing of desire.

Hip-hop culture emerged in Havana as large numbers of predominantly black populations were relocated to the outskirts of the city, where kinship networks are weakened and economic opportunities are fewer—the same

sort of circumstances that engendered it in the United States. According to Tricia Rose (1994:30), black communities in New York, impoverished by the shift from blue-collar manufacturing to the service sector, were displaced from their neighborhoods by slum-clearance programs designed to make way for commercial districts in the 1960s. Relocation to areas such as the South Bronx destroyed community structures that had built up over many years, and hip-hop culture was one of the forms that allowed for the renewal of local networks (Rose 1994:34). Brian Cross (1993:9–10) describes a similar process in Compton, a suburb of Los Angeles, where limited employment opportunities and police brutality spawned cultural resistance in the form of rap. Housing relocations and demographic changes took place in Cuba, too. After the revolutionary government came to power it embarked on a project to provide access to good housing for people living in slum areas and for the homeless. In 1970 the government planned a large housing complex in Alamar, a suburb on the outskirts of Havana, complete with day-care centers, boarding schools, theaters, and sports and health care facilities.[2] However, projects such as Alamar were propelled by the same spirit of modernism that animated such public housing projects as Chicago's Cabrini Green, with little concern for how communities would rebuild their networks and function in a vastly new environment.

While people of all social levels were relocated to Alamar, the majority were people of marginalized black communities, from slum areas such as Llegapon, Las Yaguas, La Timba, El Fanguito, and Palo Cagao. Isolated from the city, with fewer opportunities for employment and higher education, Alamar residents found it difficult to recreate a sense of community. Susan Eckstein (2003:159) describes Alamar as "large, isolated, and impersonal, and some distance from where most people can find work. The prefabricated apartment units did not allow residents to modify their dwellings as their family needs change and their income allows, or to easily use their quarters for income-generating rental and commercial purposes, as shantytown dwellers can." The need to rebuild a sense of community and to reforge personal bonds in a new terrain underlay the popularity of hip-hop music among the young Afro-Cuban residents of Alamar. Eckstein (2003: 159) also states that while CDRs (Committees for the Defense of the Revolution) and other mass organizations were established in Alamar, they never garnered the influence they had in other areas. This relative relaxation of

social control in comparison with the more pervasive regimentation of Havana was another reason hip-hop was freer to flourish in Alamar. In addition, the Cuban rap promoter Ariel Fernández told me that Alamar's location outside of Havana made it easier to gain access to Miami radio stations such as 1040 AM and 99 Jams FM that played American hip-hop music regularly.[3]

Rap music and hip-hop culture also grew rapidly in other urban areas occupied by mainly black working-class communities such as Old Havana, Central Havana, Santo Suárez, and Playa. Until the collapse of the Soviet Union, black and working-class communities in Cuba were relatively protected from late capitalist processes of economic restructuring. However, the crisis of the special period forced the Cuban government to adopt policies of austerity in order to increase Cuba's competitiveness in the global economy. Although policies of austerity and restructuring have affected Cuban society as a whole, Alejandro de la Fuente (2001:319–321) argues that the effects have been most strongly felt by blacks. The legalization of dollars has divided Cuban society into those who have access to dollars and those who do not. Family remittances are the most important source of hard currency for most Cubans, and since the majority of Cubans in the diaspora tend to be white, it is white Cuban families that benefit most. In the tourism sector, another area where Cubans are able to secure hard currency, blacks have tended to be excluded on the grounds that they do not have the education or proper appearance and attire to interact with tourists. Other options of survival in the special period, such as opening *paladares* or family-run restaurants, are less available to blacks, who tend to be based in more densely populated housing and lack the space to carry on entrepreneurial activities. De la Fuente (2001:326) also argues that racial prejudice has become increasingly visible and acceptable in the special period.

Race relations in Cuba differ considerably from experiences of race in the United States. In his work on race in Colombia, Peter Wade (1993) points to two processes that define race relations in Latin American and Caribbean countries. On the one hand, Latin American nationalist and revolutionary leaders in countries with significant black populations, such as Colombia, Cuba, and Brazil, and those with large indigenous populations, such as Mexico and Peru, have held up an image of the mestizo or mixed-race nation, where nation subsumes race as the main form of identification. To talk

of "blacks" or "race" in Latin America is problematic because race relations have not been historically perceived as primary markers of identity. On the other hand, blacks in Latin America have not become dispersed among the larger community, and they maintain distinct practices and cultural forms. According to Wade (1993:3), race in Latin America is characterized by a complex interweaving of patterns of discrimination and tolerance that cannot be understood by reference to forms of racial identity in the United States. De la Fuente (2001:335) corroborates this account of the contradictory nature of race relations in Latin America, arguing that while discourses of racial fraternity in Cuba minimized claims for justice made by blacks, the more fluid understanding of race that such discourses made possible also opened up avenues for the participation of blacks in mainstream cultural life. However, it is particularly during crises that racial inequalities, stereotypes, and prejudices reemerge in ways that promote racial conflict and restrict the options open to blacks for work and advancement.

In a period of increasing racial tensions and inequalities, Afro-Cubans find themselves deprived of a political voice. Drawing on discourses of racial democracy, the Cuban revolutionary leadership attempted to create a color-blind society, where equality between blacks and whites would render the need for racial identifications obsolete. While desegregating schools, parks, and recreational facilities and offering housing, education, and health care to the black population, the revolutionary leadership simultaneously closed down Afro-Cuban clubs and the black press (De la Fuente 2001:280). De la Fuente (2001:329) sees the possibility of racially based mobilization emerging from the contradictions of the special period: "The revival of racism and racially discriminatory practices under the special period has led to growing resentment and resistance in the black population, which suddenly finds itself in a hostile environment without the political and organization tools needed to fight against it." Santería has gained significant popular support in this period, but rap music has taken on a more politically assertive and radical stance as the voice of black Cuban youth. Some older black Cubans cannot relate to the militant assertion of black identity in Cuban rap, but it is becoming increasingly relevant to Cuba's young people, who did not live through the early period of revolutionary triumph and are hardest hit by the failure of the institutions established under the revolution to provide racial equality in the special period.

Cuban hip-hop emerged as a local response to experiences of displacement and relocation, as well as impoverishment and discrimination. However, it has grown and developed with the support of state and commercial institutions and actors with different, often contradictory agendas. The main institutional support for Cuban rap comes from the Cuban state. In the summer of 1992 the Asociación Hermanos Saiz (Saiz Brothers Organization, AHS), the cultural wing of the official Cuban youth organization, the Unión de Jóvenes Comunistas (Union of Communist Youth, UJC) created a space for rap at La Piragua, a large open-air stage by the Malecón. In 1994 this space ceased to exist and the movement began to dissipate, until the rap entrepreneur and DJ known as Adalberto created a space in the local of Carlos III and Infanta. In their account of the development of Cuban rap, Deborah Pacini Hernandez and Reebee Garofalo (1999:23) point out that Adalberto did not resemble the pioneering club promoters and DJs in the United States, as he did not gain much in the way of commercial profits, but like subsequent producers and promoters, he was well placed to make contacts with influential Cubans and foreigners. Until that time there was no real movement of rappers, only individuals improvising or "freestyling" (Fernández 2000a). From the local emerged the pioneers of Cuban rap: SBS, Primera Base, Triple A, Al Corte, and Amenaza. An association of rappers called Grupo Uno (Group One), relatively independent of AHS, was created by a promoter known as Redolfo Rensoli, and this network went on to organize the first rap festival in June 1995.

Cuban cultural representatives and music producers have played a vital role in the development of Cuban hip-hop and have acted as intermediaries between rappers and the state. The state increasingly came to see the value of rap promoters such as Ariel Fernández, who had official positions in state institutions, but also had significant credibility among Cuban rappers and in international circles. Fernández himself was one of Cuba's best DJs and at concerts he was something of a local star, in comparison with the cultural bureaucrats of the AHS and UJC, who have little knowledge of hip-hop culture and music.[4] Pablo Herrera, one of the main rap producers in Cuba, is also widely known in the local hip-hop scene, as well as in his barrio of Santo Suárez, where he works out of a small makeshift studio in the house he shares with his mother. Fernández and Herrera have impressive international connections and are aware of the influence they wield at

the local and international levels. They attempt to use this influence and the strength of the hip-hop movement as bargaining chips in negotiating with the state. As Fernández emphasized to me, the state has to recognize the rap movement "politically, culturally, and musically, because imagine if this whole mass of young people were in opposition to the revolution, if all of these people did not feel empowered by the revolution, how would they feel?"[5] Fernandez and Herrera use their credibility at the base to push for change, but they are willing to see the hip-hop movement work in critical alliance with official institutions.

North American rap music is the original source of Cuban rap music, and from the early days Cuban rappers have maintained close ties with rappers in the United States. Alan West-Duran (2004:7) sees Cuban rap, like other Caribbean black music, as part of a "diasporic dialogue," given that the pioneers of U.S. rap such as Afrika Bambaataa and Kool DJ Herc were from Caribbean backgrounds. While the early waves of hip-hop music to come to Cuba were more commercial, by the time of the first rap festival in 1995, Cubans were hearing African American "conscious" rap music. The visits of these African American rappers were crucial to the formation of Cuban hip-hop, particularly through a network known as the Black August Hip-Hop Collective. Black August was established during the 1970s in the California prison system as a way of linking up resistance movements in the Americas, and the hip-hop collective sought to draw connections between radical black activism and hip-hop culture. In its statement of purpose, the collective defines its goals as "to support the global development of hip-hop culture by facilitating exchanges between international communities where hip-hop is a vital part of youth culture, and by promoting awareness about the social and political issues that affect these youth communities." Black August concerts held in New York raised money for the Cuban hip-hop movement, including funding for an annual hip-hop concert, attended by American rappers.

Like the African American activists who visited Cuba during the 1960s and 1970s, from Stokely Carmichael to Angela Davis and Assata Shakur, who is currently in exile in Cuba, African American rappers such as Paris, Common Sense, Mos Def, and Talib Kweli spoke a language of black militancy that was appealing to young Cubans. The rapper Sekuo Umoja of Anónimo Consejo said, "We had the same vision as rappers such as Paris, who

was one of the first to come to Cuba. His music drew my attention, because here is something from the barrio, something black. Of blacks, and made principally by blacks, which in a short time became something very much our own, related to our lives here in Cuba."[6] While a black radical such as Marcus Garvey enjoyed little support among Afro-Cubans in the 1920s (Fernández Robaina 1998:125), the black nationalist aspirations of African American rappers have been received with considerable enthusiasm by a population of young Afro-Cubans increasingly feeling the effects of racial discrimination in Cuba's special period. The ways in which underground hip-hop music promotes and extends identifications based on race have been mostly absent from scholarly attempts to address global hip-hop. In his introduction to a volume on rap and hip-hop outside the United States, Tony Mitchell (2001:2) argues that global hip-hop movements are disconnected from what he describes as an "increasingly atrophied, clichéd, and repetitive" African American hip-hop culture, and most of the cases in the volume focus on appropriations of hip-hop by nonblacks. But in countries such as Cuba, Brazil, Colombia, and Venezuela, as well as in several African countries, such as Senegal, South Africa, and Mali, black communities draw on African American rap music to address local issues of race and marginality, however differently those relationships may be constituted. The importance of transnational flows based on race, particularly as promoted by the more black nationalist African American rappers, must be viewed somewhat independently of global cultural flows related to the popular music industry.

Nehanda Abiodun, an African American black-power activist exiled in Cuba, is seen as the *madrina* (godmother) of the Cuban hip-hop movement. Abiodun has been involved with Cuban hip-hop since its beginnings and has helped to shape its social and political concerns. Like Black Panthers and other black-power activists exiled in Cuba, Abiodun has negotiated a space for herself in Cuban society, and along with Fernández and Herrera she has played an important role in mediating between rappers and the state. In September 2001 Abiodun helped to organize a New York tour for three Cuban rap groups: Anónimo Consejo, Raperos Crazy de Alamar (RCA), and Obsesión. At the meeting held before the trip at Abiodun's house, she emphasized to the rappers that they had to return to Cuba after their tour: "Don't forget, your struggle is here with your people and you

must return to them." One of the RCA rappers did stay behind in New York, so Abiodun's fears were not groundless. It is clear that Abiodun has a vital role to play in shaping the commitments of rappers and ensuring that they continue to work and collaborate with the Cuban revolutionary project.

The global market, via multinational record companies, has also been an important avenue of transnational participation in Cuban hip-hop. While hip-hop started in the United States as an urban underground movement, it is now a major commercial product, distributed by five of the largest multinational music labels: Universal, Sony, BMG, EMI, and WEA. Records are judged by their sound-scan numbers, or the number of records they sell in the first week, and the industry values sales more than artistic quality, creativity, or political message. According to Mimi Valdés, in North American hip-hop, rappers who are getting the airplay, videos, and record sales are those who have embraced the "bling-bling formula," using the imagery of expensive cars, clothes, and exorbitant lifestyles to publicize the new wealth of the hip-hop generation.[7] The multinational labels with their promises of videos, discs, and large contracts are tempting to Cuban rappers, whose resources are scarce. At times signing a deal may mean leaving the country; the Cuban rap group Orishas have been living in France since they signed with EMI.

Cuban rap has been influenced by these diverse networks of African American rap and transnational record companies. Fernández (2002:43) argues that the movement of Cuban hip-hop is divided by a major dispute between those who see themselves as underground and those who see themselves as commercial. He describes underground groups as having two main qualities: first, "they maintain an orthodox and radical stance along the lines of the origins of the genre and they distance themselves from any possibility of fusion for its commercialization"; and second, "they focus much more on an integration of politically committed lyrics with the social context." Commercial groups are those that "incorporate popular Cuban rhythms in order to be more accepted, achieve authenticity, and become commercially viable." In Cuba, rap groups considered commercial draw larger audiences. While most underground rap music is limited to small clubs and shows, the biggest gathering being the annual rap festival in the large stadium at Alamar, attended by up to three thousand young people,

commercial groups such as Orishas[8] have reached the broader Cuban public, and their music can be heard in discos, private homes, and parties and blaring from cars.

The underground and commercial categories have some resonance in Cuba because they reflect real contests over access to resources and diverging ideological positions. Some Cuban rap groups that identify themselves as underground resent groups that attract foreign funding and attention because they are willing to dilute their political message. In their song "El barco" (The boat), Los Paisanos criticize the more commercial rappers who are funded because they have compromised their politics and dedication to the purity of rap, "those shameless ones who call themselves rappers but get a following because they mix their rhythms." The rapper vents his anger at those who choose the commercial path: "I shoot words at them, I don't kill them but I detest them, and I don't silence the truth but I say it straight up." Los Paisanos, which started off with three members, lost one of them when he signed a foreign deal to make more commercial-sounding rap mixed with salsa, forsaking both the group and his place in the local hip-hop movement.

The Orishas, now generally seen as commercial because of their mainstream success both in Cuba and abroad were once part of a group called Amenaza, which was central to the evolution of the underground Cuban hip-hop movement. Although the Orishas maintain close ties with Cuban rappers and have spoken about returning to Cuba to join the hip-hop movement, some Cuban rappers view them with the contempt they feel for any group that has abandoned its political stance and sold out to commercial interests. In their album *A lo cubano* (The Cuban way), released in 2000, the Orishas popularized the prerevolutionary iconography of Cuban life, such as rum, tobacco, and 1930s Chevys and Oldsmobiles. Like the internationally marketed film and disc of the Buena Vista Social Club, the Orishas represent Cuba as a nostalgic fantasy that has been preserved intact from the 1950s. In *A lo cubano* the Orishas provide an image of a Caribbean island where people dance in the streets, drink rum, and smoke Cuban cigars: "Cuban style, bottle of rum, Havana tobacco, women on both sides, rap concert in Guano's house, this is not a life for fools." The musical style, the pre-1959 stereotypes, and the use of Afro-Cuban imagery on the album cover are part of a strategy that seeks to sell Cuba to Western audiences.

Given the marketing of Afro-Cuban culture as an export commodity and a lure for tourists, rap musicians themselves seek to exploit local and international markets by reproducing representations of blackness that sell.

Other rap groups have challenged these stereotypical representations of Cuba. At a concert at Café Cantante in August 2001, the group Reyes de la Calle entered the stage wearing flip-flops and broad-brimmed straw hats. Seating themselves in a large blown-up inner tube, the three sang about the *balseros*, or Cubans who leave for Miami in boats. The contrast between the frivolous beach paraphernalia and the serious theme of the balseros, who face the treacherous journey to Miami in hopes of prosperity in the United States, underlines the superficiality of imagery that portrays Cuba as a fun Caribbean resort. Rap music became consolidated through the transnational openings in the 1990s, but musicians employ different strategies as they negotiate local and international markets for blackness.

Although some Cuban rappers identify themselves as underground and others as commercial, these labels cannot be applied unproblematically in the Cuban context. While the distinction between underground and commercial in the United States derives from a perception of authenticity and commercial success as opposites, American rappers often accord an authenticity or underground status to their Cuban counterparts, given Cuba's image as a successful revolutionary government among sections of the African American community (Gosse 1998:266). At times Cuban rappers themselves acknowledge that the distinction is somewhat less relevant in Cuba than in the United States. In a song called "I don't criticize what is commercial," the rapper Papo Record suggests that underground and commercial are all the same in Cuba because there is no market. "Commercial" is also something of a misnomer because not all groups that mix salsa and other instrumental forms with rap are funded by record companies; some just enjoy those styles. In Cuba the dichotomy between authenticity and success is further complicated by the state's promotion of underground rap. Cuban rappers who maintain a political orientation are more likely to receive state sponsorship than the commercial rappers, so that the association of underground with exclusion from the mainstream is disrupted.

Members of hip-hop culture are creators who themselves participate in constructing the parameters of their public sphere as rappers, breakdancers, writers, DJs, and poets. The rap performance is an act that encour-

1. DJ Flipper at the hip-hop festival in Alamar, August 2001. PHOTO BY ANGEL JAVIER MACHADO LEYVA.

ages participation. During Cuban rap shows it is common for a group to come onstage with friends, family, and others who sing along and dance. Audience members climb onto the stage during the performance, disrupting traditional boundaries between performer and spectator.

Strategies of Cultural Contestation

Young Afro-Cubans have used rap music as a means of contesting racial hierarchies and demanding social justice. Paul Gilroy (1993:83) sees the transference of black cultural forms such as hip-hop as related partly to its "inescapably political language of citizenship, racial justice, and equality," a discourse that speaks to the realities and aspirations of black youth globally. Through their texts, performances, and styles, Cuban rappers demand the inclusion of young Afro-Cubans into the polity and they appeal to the state to live up to the promise of egalitarianism enshrined in traditional socialist ideology. Cuban rappers, particularly those who identify as underground, point out the race blindness of official discourse and the invisibility of the experiences and problems of marginalized communities in a society that has supposedly resolved questions of race. Given the lack of forums for young Afro-Cubans to voice their concerns, rap music provides an avenue for contestation and negotiation within Cuban society.

Racial Egalitarianism in the Special Period

Rappers criticize the political leadership for ignoring questions of race in Cuban society by declaring the eradication of racism. As De la Fuente (2001: 266) explains, in the early years of the revolution Fidel Castro organized conferences on racism and campaigns against it, but by 1962 all discussion of the race question had been silenced, except to praise Cuba's achievements. Because the revolution had supposedly resolved all questions of institutional discrimination, it was considered unpatriotic to speak of race or to identify oneself in racial terms, rather than as just Cuban. In a song titled "Mambí," released on their 2002 album *La Fabrik* (The factory), the rap group Obsesión refer to the rhetoric that masks the silencing of questions of race. The song is an identification with the *mambises* or Afro-Cuban fighters in the war of independence with Spain. In a spoken word style accompanied by the ritual *bata* drum, Obsesión evoke the era of slavery. The song opens with the gentle strumming of a *berimbau*, a stringed instrument associated with Afro-Brazilian capoeira, and water sounds produced by the traditional *palo de agua*, which gives the sense of being near a river or stream, identified with the rural roots of slaves. The rapper begins to recount the changing landscape of racial relations in Cuba:

Those winds brought these storms,	Aquellos vientos trajeron estas tempestades,
it happened this way (unexpectedly):	resulta q' así (de pronto):
Suddenly my race had a lot of good qualities,	Un montón de cualidades cayó encima de mi raza,
and many went en masse to pass a course	y muchos fueron en masa a pasar un curso
in how not to be racist.	de como no ser racistas.
They graduated with high honors,	Se graduaron con honores y fiestas
and still today they are hidden	y hasta el sol de hoy permanecen
behind this sentence:	escondidos en la frase esta:
WE ARE ALL EQUAL,	SOMOS IGUALES,
WE ARE ALL HUMAN BEINGS.	TODOS LOS SERES HUMANOS.

Obsesión tell how blacks went from being at the bottom of the social hierarchy in prerevolutionary Cuba to having "a lot of good qualities" when they became the new social subjects of the revolution. However, Obsesión

suggest that white revolutionaries only pay lip service to antiracist ideals, going "en masse to pass a course in how not to be racist," rather than engaging with the reality of racism in Cuban society. The song depicts the self-congratulatory manner of revolutionaries who proclaim the eradication of racism even as racial tension and hierarchy go on.

The resurgence of racism in the special period is strongly contrasted to the postrevolutionary euphoria of Afro-Cubans who saw in the revolution the possibility of an end to racial discrimination. In a poem written in 1964, "Tengo" (I have), the celebrated Afro-Cuban poet Nicolás Guillén lists the changes that the revolution has brought for blacks:

I have, let's see,	Tengo, vamos a ver,
that I've learned to read,	que ya aprendí a leer,
to count,	a contar,
I have that I've learned to write	tengo que ya aprendí a escribir
and to think	y a pensar
and to laugh.	y a reir.
I have that I have	Tengo que ya tengo
a place to work	donde trabajar
and earn	y ganar
what I need to eat.	lo que me tengo que comer.
I have, let's see,	Tengo, vamos a ver,
I have what was coming to me.	tengo lo que tenía que tener.

Borrowing the title and format of the Guillén poem, Hermanos de Causa describe the situation of young Afro-Cubans in the special period:

I have a dark and discriminated race	Tengo una raza oscura y discriminada,
I have a workday that demands and gives nothing,	tengo una jornada que me exige, no da nada,
I have so many things that I can't even touch them,	tengo tantas cosas que no puedo ni tocarlas,
I have facilities I can't even set foot in,	tengo instalaciones que no puedo ni pisarlas,
I have liberty between parentheses of iron,	tengo libertad entre paréntesis de hierro,
I have so many benefits without rights that I'm imprisoned,	tengo tantos provechos sin derechos que a mí encierro,

I have so many things without having what I had.	tengo tantas cosas sin tener lo que he tenido.

When they say "I have so many things that I can't even touch them" and "I have facilities I can't even set foot in," Hermanos de Causa are referring to the political leadership's claims that the revolution has provided everything for Afro-Cubans in the way of health, education, and welfare, yet the rapper doesn't see them. The revolution was fought to free a nation from American neocolonialism, yet this liberty can be exercised only within severe constraints, or "parentheses of iron." While the revolution has given so many benefits to young Afro-Cubans, it does so patronizingly, without recognizing their rights. In contrast to Guillén's optimism, "I have what was coming to me," Hermanos de Causa say that "I have what I have without having what I had": while the revolution has brought material benefits and opportunities to young black people, it has taken away their right to speak out as a minority. The group Junior Clan pose the question: "For blacks I keep asking the question, Where is your voice?"

Rappers recast street life and the experience of marginal communities as a valid and real part of Cuban society, in contrast to official reports that want to claim the eradication of marginal communities and ways of life. Hermanos de Causa point out the realities of life for marginalized young people:

I entered the school of the streets very young,	Yo matriculé en la escuela de la calle a muy temprana edad,
I'm not a daddy's boy who gets everything I want, no way!	No soy hijito de papá que todo se me da, ¡qué va!

The rapper points out the difference between the experiences of young people in marginalized communities and the children of white middle-class families, who are coddled and given everything they want. A happy nuclear family with both mother and father present is only a fantasy for many Afro-Cuban children, who are often raised by single mothers. As the rapper of Los Paisanos claims in a song called "Q' será" (What will be):

I study, she works, I hardly see my mother,	Yo estudio, ella trabaja, casi no veo mi madre,
I don't have my father, I don't know what's wrong with us,	me falta mi padre, no sé que nos pasa,

for five years I've been the man of the house.	desde los cinco años soy el hombre de la casa.
Those who are like me accept me and those who aren't reject me,	Los que son como yo me aceptan y los que no me rechazan,
'cause the street has become my second home.	porque la calle pasó a ser mi segunda casa.

When neither society nor the family provides positive reinforcement, young blacks look to the streets for acceptance and solidarity. Talking about their experiences as black youth in the special period, rappers draw a picture of the lives of communities that are still marginalized despite the claims that equal opportunity for all has eliminated marginality.

Cuban rap musicians use their lyrics, style, and performances to play with stereotypes of blacks as delinquents and criminals. According to De la Fuente (1998:5), racialized notions of proper conduct have continued to be enforced by the law, with *peligrosidad social* or "social dangerousness" still punishable by law. Rappers appropriate these stereotypes, adopting a posture of aggression to turn fears of the "urban black threat" back upon those who have created them. Fernández described how the militant pose of rappers is a part of their performance: "You can see a rapper screaming with an ugly, bad face, but this is their artistic pose for singing. If you are singing about something that's not good, you don't sing with a smile, nowhere in the world. At the moment of performance, rappers project this strong, serious, energetic, violent, macho image."[9]

This posture is also a defense mechanism against the reality of life in marginalized communities. As Tricia Rose (1994:12) argues, "the ghetto badman posture-performance is a protective shell against real unyielding and harsh social policies and physical environments." Although the harsh environment that Rose describes is in the United States rather than Cuba, Afro-Cuban communities have been subjected to forms of policing that become more severe in times of crisis. The adoption of an aggressive posture serves as a form of self-defense, particularly when young black Cubans are being constantly harassed by the police and asked to produce identification, and when the broader Cuban society views them as criminals and drug dealers.

Rap musicians employ a direct style that addresses the authorities, the state, or those in positions of power. Cuban underground rappers chal-

lenge police harassment and the silencing of dissent by the state. In the song "A veces" (At times), Anónimo Consejo draw a picture of corruption, the black market, and bribery. However, reversing stereotypes about marginalized communities, the rapper locates the sources of these problems in the government:

Guys with money are dealing in their offices,	Los tipos con "money" trafican en sus oficinas,
they shout "We resist!" and they drive around in fancy cars day and night,	gritan "resistimos" y andan en carro noche y día,
robbing the public like the scorpion her young.	robándole al pueblo como el alacrán a su cría.

The rapper renders the police and the officials criminals in an attempt to destabilize their moral authority. While the police target poor blacks for crimes such as illegal trading and theft, the rapper shows that they themselves are engaged in these activities. He points to the hypocrisy of government officials who use revolutionary rhetoric of resistance but actually separate themselves from the public in their offices and fancy cars. Cliente Supremo challenge the futile practice of requesting identification, asking, "In reality what will become of me when my youth is gone? Will I have to be worried about my personal documents like you all? What ID? For what?" Los Paisanos also talk about police harassment of young black Cubans in their song "El barco" (The boat). When the police threaten the rapper, he shouts "Seremos como el Che" (We'll be like Che). The rapper repeats this slogan, recited daily by children in day-care centers and schools, partly as a way of invoking the youthful rebelliousness of the revolution's founding martyr and partly as a way of inoculating himself against reprisal.

Anónimo Consejo draw links between a history of exploitation and a present of racial inequality. According to Gilroy (1996:363), one of the core themes of African diaspora music is history, a concern that "demands that the experience of slavery is also recovered and rendered vivid and immediate." Slavery becomes a metaphor for contemporary injustice and exploitation. In "A veces," Anónimo Consejo connect the history of Cuban slaves with the situation of contemporary Afro-Cubans. The rapper begins with his geographical location, he identifies himself as "*el cubano del Oriente*,"

2. Anónimo Consejo in concert at the Cine Riviera, Havana, August 2001. PHOTO BY ANGEL JAVIER MACHADO LEYVA.

a Cuban from the eastern region, which is considered less cultured than Havana. He is lying in his "poor bed" thinking about slavery and the struggle of black people in his country, when the similarities of the present situation occur to him:

You think it's not the same today,	Hoy parece que no es así,
The official tells me, "You can't go there, much less leave here."	El oficial me dice a mí, "No puede estar allá, mucho menos salir de aquí."
In contrast, they treat tourists differently.	En cambio al turista se la trata diferente.
People, is it possible that in my country I don't count?	¿Será posible gente que en mi país yo no cuente?

The rapper uses the racial hierarchy of the past as a way of identifying contemporary racial issues, such as police harassment of young black people and the preferential treatment of tourists. He identifies himself as "the descendent of an African," as a *cimarrón desobediente*, or runaway slave, linking himself to a past rooted in slavery and oppression.

The open treatment of issues of race in Cuban underground rap music challenges the official discourse of race blindness and the claim that racism no longer exists in Cuban society. In an official organ of the state, *El Haba-*

nero, Tony Pita cautioned, "Beware, the songs that deal with race could turn into a two-edged sword, and we will start encouraging the recurrent obsession of creating a little 'ghetto' when actually the road is free of obstacles."[10] Just as the early postrevolutionary leadership was worried about what it considered the "divisive" effects of racial politics (C. Moore 1988: 259), one of the official responses to rap music has been a concern with its racial identification and the potential for mobilization along race lines. Afro-Cuban youth use rap music as a way of asserting their voice and presence, in contrast to attempts by state officials to play down the salience of race in Cuban society.

Hustling, Consumerism, Morality

While rappers who identify themselves as underground appropriate hip-hop as a way of framing their demands for racial equality and social justice, challenging racial stereotypes, and exploring the history of slavery, other rappers promote hustling and consumerism as strategies for survival, particularly as employment opportunities for young blacks decline and access to a market economy increases.

After the dollar was permitted to circulate in the 1990s, the majority of the population, employed as state workers, found their income worth much less than it had been earlier. Administrative workers earn about 150 pesos a month (U.S.$7.14), professional workers such as nurses, accountants, and teachers earn about 300 pesos ($14.29), and doctors earn about 500 pesos ($23.81). While housing, education, and health care are still free, and transport, utilities, and basic food items on the ration remain at the same low prices relative to income, daily household goods, appliances, food, and clothing are scarce and difficult to obtain through the ration or peso currency stores. The dollar stores, which supply essential goods such as oil, flour, meat, clothes, and household appliances, are inaccessible to people whose only income is in pesos. The farmers' markets, which sell produce in pesos, are also fairly expensive; a pound of tomatoes costs 12 pesos (57 cents), about one-sixth of the average weekly pay, and a single onion costs up to 5 pesos (24 cents). People who have access to dollars usually have relatives in Florida who send them money or have been able to get work in the tourist economy or in mixed firms, such as party members with good revolutionary credentials. For young black people who fit neither of these

categories and are at the margins of the regular workforce, survival can be difficult.

Family arrangements, housing access, political involvement and professional qualifications all structure the differences between black and white Cubans which make it all the more difficult for black youth to achieve economic security in the special period. Comparing a white family and a black family with whom I became close in Havana can shed some light on these differences. In the white family, both parents were professors at a university, and when they found their incomes drastically reduced during the special period, they began to rent out rooms in their house in the middle-class suburb of Vedado to foreigners in dollars to supplement their income. The father, Luis, president of the local CDR and a loyal party member, quit his university position to take a position in an Argentinean mixed firm that was offered to him because of his political status, and although he continued to receive his regular state salary in pesos, the firm gave him a car, paid for the gas, and provided such perks as bonuses in dollars and trips overseas. His wife, Isabel, an English professor, began Saturday classes in English for Cuban students whose parents could afford to pay in dollars. Their older son, Rolando, also a loyal party supporter and member of the UJC, was given a job in the tourist industry, where he sold hand-crafted wooden tobacco boxes to foreigners and received commissions in dollars. In addition, Isabel had a niece in Miami who sent them gifts. The family was able to afford textbooks and a computer for their younger daughter, Digna, who was studying information systems at the university. They were also able to afford new household appliances, clothes, and regular vacations to the beach resort of Varadero.

For the black family, renting out rooms in their house in Central Havana to foreigners was not an option, as they barely had room for themselves, and the house drastically needed repairs if they were to continue living there themselves. The family consisted of the parents, their two daughters, and one son, all of whom had children from previous marriages but were now single. The parents continued to work as administrators for the state, living on state incomes. The eldest daughter, Ivette, had a state job that she supplemented by teaching Spanish to foreigners. The other daughter, Matilde, was an accountant who supplemented her income by "making friends" with foreign men and letting them support her and her eight-year-old son. Their

brother, Alfredo, engaged in black-market activities until he was arrested, and fined U.S.$400. He was now unemployed. Ivette's son, David, was also studying information systems at the university, but his chances of finding work when he graduated were poor, since he could not afford the necessary books or a computer. Both families had roughly the same incomes before the special period, but now the disparities between them had increased. The differences between Ivette's son David and Luis and Isabel's daughter Digna, both studying information systems, were marked. The white family had many sources of dollar income, whereas the black family had only the dollars paid by Ivette's clients to supplement their meager pesos to support eight people and pay for house repairs.

While the work ethic was still strong in the white family and among the older members of the black family, there was a certain turning away from this value among younger members of the black family. In the special period such values as *lucha*, or struggle, have been emerging in contrast to the work ethic, particularly among the poorer, marginal sectors of society. Molina Cintra and Rodríguez Lauzurique (1998:71) describe a situation in which many Cubans are forced to bend the rules here and there; hotel employees, for example, take bottles of rum from their workplace and sell them on the black market. While in the past this may have been seen as stealing, it has come to be understood as *defendiéndose*, "defending oneself," or *luchando*, "struggling." The special period has seen the reemergence of forms of remunerative activity that once were unavailable, one of the main ones being *jineterismo*. In this practice *jineteros* (literally "jockeys" but here applied to street hustlers) earn an income and acquire consumer goods through contacts with foreigners, either by befriending them or by engaging in romantic or sexual relationships with them.[11] Whereas full-time work in a government job can bring in $7–15 a month, a jinetero can make between $20 and $80 a day by driving tourists around, selling cigars, or acting as a tour guide. Robin Kelley (1997:75) has explored the ways in which marginalized African American young people, facing either joblessness or low-wage service work, remake the realm of consumption into a site of production, blurring the distinction between play and work that is characteristic of wage work under late capitalism. For some Afro-Cuban young people, too, play becomes a creative survival strategy.

In the more commercially oriented rap music, hustling has been pre-

sented as a political strategy to get by in the special period. The song "Atrevido" (Daring) in the Orishas album *A lo cubano* tells the story of a couple who take advantage of tourists to bring themselves out of rural poverty. Over an upbeat salsa dance track and heavy bass, the rapper describes the situation of the poor couple in the countryside:

Once upon a time there was a deprived couple, little noticed,	Había una vez una pareja desprovista, poca vista.
Without money they were thinking about a tonic,	Sin dinero pensaban tónico,
a chronic tonic how to live,	tónico crónico cómo vivir,
to leave the black muck in which they were drowning, plotting.	salir del negro fango que la ahogaba, tramaba.

The couple leave the countryside for the city, where the husband, acting as a pimp, sets his wife up with a tourist, and she begins to work the tourist for money and gifts. The song parodies the clueless tourist, who thinks that he is the one taking advantage of the woman. The rapper portrays the woman as the aggressor and the tourist as her helpless victim. The song continues with the following chorus:

Everything she asked for, the idiot paid for it.	Todo lo que le pedía, el punto se la gastaba.
A pretty room at the Cohiba, the idiot paid for it.	Una linda habitación en el Cohiba, el punto se la gastaba.
A dress for her and a shirt for me, the idiot paid for them.	Un vestido pa' ella y una camisa pa' mí, el punto se la gastaba.
If she wanted to go to the beach, the idiot paid for it.	Si quería ir a la playa, el punto se la gastaba.
He was running out of money, but the idiot paid,	Ya la cuenta no le daba, no le daba, y el punto se la gastaba,
To dance at an Orishas concert the idiot paid.	Al concierto con Orishas a bailar, y el punto se la gastaba.

The Orishas present jineterismo as a vacation for the woman: she is taken to the beach, receives new clothes, and has a fancy room at the Hotel Cohiba. The Orishas even write themselves into the song, saying that she gets the tourist to take her to an Orishas concert, but also suggesting that the Ori-

shas are somehow themselves jineteros, producing suitably exotic music for an international market. Finally the husband comes to take his wife from the hotel room and on their way out they rob the tourist of everything he has left. The Orishas celebrate jineterismo as a practice that puts control in the hands of the women and men who trick tourists into giving them a life of ease. Jineterismo becomes a strategy for raising oneself up. For the Orishas it turns the tourist's designs back on himself by making him an object of ridicule. In contrast to the traditional values of work and study put forward as a way of improving one's condition, the Orishas suggest that tricking and robbing tourists are the way to rise from poverty.

The relative autonomy of commercial groups that are based outside of Cuba and funded by a transnational record label, as the Orishas are, allows them scope to broach topics that are threatening to the Cuban government. The ability of jineteros to hustle tourists for dollars challenges the labor discipline the state seeks to impose. The Workers' Center of Cuba (Central de Trabajadores de Cuba, CTC) put out documents stating that practices such as jineterismo encourage a decline in the work ethic (cited in Suárez Salazar 2000:345). Many foreign construction companies, foreign agencies contracted to do infrastructural work, and even the smaller free-trade zones require local labor.[12] The foreign companies pay the Cuban government about $8 to $10 an hour for each laborer and the laborer is paid 200 pesos ($9.52) a month by the state (Corbett 2002:125). But jineteros can bypass official avenues for earning money. The values of jineterismo contradict socialist ideology and disrupt the state's attempts to justify new forms of labor discipline to enable Cuba's insertion into a global economy. As the Cuban state seeks to channel foreign currency through its bureaucracy, black and mulatto youth siphon off some of the dollars that have begun to enter Cuba.

Moreover, on a social level, the lifestyles and values of consumerism and sexual licentiousness represented by the jineteros are an affront to the high moral tone taken by the revolutionary leadership. Luis Suárez Salazar (2000:344) quotes Fidel Castro as saying that tourism has "led to various types of disgraceful social behavior (such as prostitution) and an increase in delinquency . . . these acts point to a significant erosion of the ethical values and morals that have been promoted in the diverse formal and informal educational and ideological institutions of Cuban socialism." Through

their open celebration of consumption, sexuality, and desire in narratives dealing with jineterismo, commercial rappers are subverting conventional standards of morality. In some ways, Cuban commercial rap has affinities with Jamaican cultural forms such as reggae and dancehall, which Carolyn Cooper (1995:141) argues "represent in part a radical, underground confrontation with the patriarchal gender ideology and the pious morality of fundamentalist Jamaican society." Groups such as Orishas, by promoting hustling as a viable option for young blacks, challenge and mock the conservative ideology on which Cuban revolutionary morality is based.

Most underground rappers, however, reject jineterismo as a way of surviving in the special period, suggesting instead that socialist values of honesty and work are important in efforts to raise oneself up. The criticism of jineterismo in underground rap music is a polemic against the consumerist mentality that has emerged with increased access to a market economy and a condemnation of the desire of young people to find an easy fix rather than work hard to achieve the goals of the revolution. In their song "Jinetera," released in 1998 on the album *Igual que tú* (The same as you), Primera Base talk about the young girls who walk the streets to attract the attention of foreign men. The girls "don't have any sense" and "only think about dressing up and living in the moment." Their vanity and desire for consumer goods are presented as highly antithetical to revolutionary values. The rapper concludes with his incredulity at this phenomenon:

They're all lost, this is why they're at risk of contracting AIDS,	Todos están perdidas, por eso están a expensas a contraer el sida.
But they go on hustling, brother,	Pero andan luchando, brother,
they go with foreigners, that's the most important thing to them,	andan con extranjeros, esa es la causa fundamental,
offering up your body to triumph in life.	ofreciendo tu cuerpo para en la vida triunfar.
That's why I say this, and really it's surprising to offer yourself for money,	Por eso digo esto y de veras la sorprende entregarse por dinero,
these are things I don't understand.	son cosas que no entiendo.

The rapper sees jineterismo as dangerous, a risky surrender to consumerist desires. There is a certain focus on the body as a receptacle of morality,

which must be defiled in order for consumerist and materialistic wants to be fulfilled. The jineteras who walk the streets are attractive to the rapper, "they're very pretty, yes!" but they are empty inside: "inside they are all plastic and materialist." The rapper claims that external beauty and material trappings are unimportant compared to political and spiritual goals.

Gender, Sexuality, and Women Rappers

Arguments over consumption and morality in Cuban hip-hop are gendered. As Gina Ulysse (1999:158) observes, the black female body becomes a primary site of exhibition and commentary in black popular culture. For Primera Base, the body of the jinetera represents the moral purity of the revolution, which must be defended against consumerism as a form of spiritual disease that is infecting the body politic. In the Orishas song, the jinetera is objectified by the pimp who uses her to avenge himself against the tourist; the female body constitutes a form of what Ulysse (1999:159) refers to as "the ultimate cultural capital." Given the historical conception of women as objects that are traded between men as a way of constructing their masculinity (Rubin 1975), it is not surprising that the female body would again become a site of contestation, a means by which black working-class men assert their masculinity in a context where they are increasingly being disempowered and displaced.

Male-defined notions of jineterismo, sexuality, and the female body are present in rap music, but women rappers contest these ideas and introduce alternative narratives into public discourse. Through their contacts with women activists in Cuba and abroad and their politicization in the hip-hop movement, women rappers have been able to develop more radical feminist perspectives. When I first visited Cuba in 1998, women's presence in hip-hop was still negligible. At concerts I would come across male rappers with their gold medallions, Fubu gear, and lyrics about women, cars, and guns, the latter two hardly a reality for most young Cuban men. Over the years there have been important changes in gender politics in Cuba, particularly in rap music, and female rappers feel empowered to speak of issues such as sexuality, feminism, gender roles, and stereotyping. In interviews with Pacini Hernandez and Garofalo (2000:23), Cuban women rappers mentioned American female groups and rappers such as TLC, En Vogue, Salt-N-Pepa, Monie Love, and Da Brat as important influences. Prominent African

American feminist artists such as Erykah Badu have performed at Cuban rap festivals and concerts, and have been important in providing role models for young aspiring women rappers. Visits and performances by grassroots feminist rappers such as Mala Rodríguez from Spain, Vanessa Díaz and La Bruja from New York, and Malena from Argentina have also been crucial in developing perspectives and exchanging ideas.

Women rappers have been part of the Cuban hip-hop movement from the beginning. Although there were no women performers at the first hip-hop festival in 1995, the 1996 festival featured a performance by the first all-women's rap group, Instinto. Another rapper, Magia MC, was part of the male-female duo Obsesión, which has come to be one of the most prominent rap groups in Cuba. Magia has played an important role in raising the profile of women in the rap movement, and she defines herself as a feminist: "All of us who promote and give a push to the representative work done by women and who try in one way or another to see that this work is valued and recognized, we are feminists. . . . Women's presence to me is fundamental, with their work to be shown, with their things to say, with their pain and happiness, with their knowledge, their softness, with the prejudice they suffer for being women, with their limitations, with their weakness and their strength." [13] Other women such as DJ Yary also see themselves as part of this tradition: "With all my work, I seek to strengthen the role of Cuban women in hip-hop. Men are thought to be more important in this movement, but young women have shown what we can do to enrich it." [14] The first all-women's music concert was organized by Obsesión in 2002 in a popular venue for rap music known as the Madriguera. The concert included not only rappers but photography and art exhibitions, guitarists, poetry, and dance. The concert was repeated twice in 2002 and 2003, and then in December 2003 the Youth League organized an all-women's hip-hop concert as part of the rap festival. The sold-out concert, titled *Presencia probada*, or "Proven presence," signaled the strength of women rappers in hip-hop.

In the first years of the twenty-first century there were about thirteen women rappers and rap groups in Cuba, a small but prominent number, since several of these women are among the relatively limited number of artists who have produced discs through both official and unofficial channels. Given the small number of discs produced by the state recording

agency, EGREM, and the lack of airplay for Cuban rap on state-controlled radio stations, many musicians have begun to produce their own discs with foreign funding and help from friends, and their efforts have produced a growing underground distribution network. Magia MC, as part of Obsesión, has released two discs, one with EGREM and another as an independent label. The other woman rapper working in a mixed rap group is Telmary Díaz, of the group Free Hole Negro, who have produced discs both in Cuba and elsewhere. La Fresca, more commercial than the others, brought out her first disc in 2004.[15] The trio of rappers known as Las Krudas have produced their own disc, and they frequently perform in popular and official tourist venues such as the Sunday-morning rumba at the Callejón de Jamel. Other women rappers also sing independently or in all-female groups: Oye Habana (previously known as Explosión Femenina), Esencia, Yula, I & I, I Two Yi, Atómicas, Mariana, Soy, and Las Positivas in Santiago de Cuba. Women have participated in other areas of hip-hop culture such as graffiti and DJing. Two women disc jockeys, DJ Yary and DJ Leydis, put out a CD in 2004 titled *Platos rotos* (Broken plates) with tracks by major Cuban rap groups such as Anónimo Consejo and Hermanos de Causa. DJ Yary and DJ Leydis have participated in DJ battles, the Havana hip-hop festival, and concerts with major Cuban rap groups. Not all of these women address feminist issues and their prominence in hip-hop varies, but they do represent a growing positive force for change.

The networking of feminist rappers with older Cuban feminists has helped bolster their voices in hip-hop and their concerns in society. On 8 March 2003, International Women's Day, the activist Sonnia Moro and the women rappers organized a forum, "Machismo in the Lyrics of Rap Songs." Another activist, Norma Guillard, organized two forums, "The Importance of Educative Messages in Rap Lyrics" and "Rap and Image: A Proposal for Reflection." During one of the rap festival colloquiums in 2004, Guillard presented a paper, "Las Krudas: Gender, Identity, and Social Communication in Hip-Hop." The feminist activists have also offered their writings and poetry to the rappers to incorporate in their songs. For instance, Georgina Herrera gave her "Guerrillas of Today" to Las Krudas to make into a rap song. Guillard notes that the women rappers are much more open to feminist ideas than an earlier generation was: "I've observed that young women don't confront the same subjective conflicts as we did, they have no prob-

lem recognizing themselves as feminists, they didn't live through the same era we did. We recognize that among the rappers there are feminists — that is, with a more radical focus, more autonomous." [16] Because of the inroads made by earlier feminists (Fernandes 2005), it has been easier for this new generation to claim a place for themselves. The older feminists regularly invite the women rappers to their forums, they offer them materials to read and help them understand more about feminism, and they have spoken about women's rap in forums inside and outside of Cuba.

Women rappers, given their experiences in racially defined transnational hip-hop networks, identify with the ideas and principles of black feminism as it emerged from third-wave feminism in the United States. These ideas, as defined in the black feminist statement by the Combahee River Collective, consist of a recognition that race, class, and sex oppression are intertwined; women must struggle with black men against racism and with black men about sexism; black women face psychological obstacles and minimal access to resources and they must pursue a revolutionary politics (Combahee River Collective 1997). These themes occur frequently in the texts of women rappers. Indeed, Cuban women's rap fits closely into what some black feminists in the United States have referred to as "hip-hop feminism" (Perry 1995, 2002; Pough 2002, 2003). Just as the music of American rappers such as Salt-N-Pepa, Queen Latifah, and MC Lyte helped inspire the feminist consciousness of a generation of black women who listened to hip-hop (Pough 2003:235), feminist rappers in Cuba are also producing new kinds of political awareness among young women affiliated with the growing movement of Cuban hip-hop.

Cuban women rappers attempt to talk about practices such as jineterismo without vilifying the women who practice it. In a song written by Magia MC in 2002, "Me llaman puta" (They call me a whore), Magia talks about the desperate conditions that give rise to prostitution and the sad lives of the many women forced into it. The song opens with the sounds of a *caxixi*, or woven basket rattle, over the deep tones of a vibraphone. The entry of a traditional drum ensemble including the *bata*, the *bombo andino*, a mellow low-pitched drum, and the *campana*, a heavy cowbell, evoke the rhythmic pulse of hip-hop. The song's chorus begins with the phrase "They call me *puta*," deliberately employing the derogatory word used for female sex workers in order to invoke the humiliation and degradation associated with this occupation.

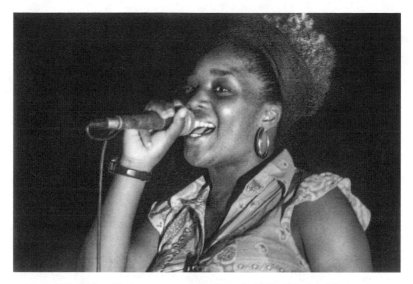

3. Magia MC of Obsesión in concert at Julio Antonio Mella, Caimito, July 2005.
PHOTO BY JAY DAVIS.

Magia originally said that "Me llaman puta" was about prostitution in capitalist society. At a concert at the Cine Riviera organized by Obsesión in August 2001, I sang back-up vocals for Magia when she performed the song. During one rehearsal, a male rapper said to Magia that he thought prostitution was a legitimate way for women to earn money to survive and support their families in Cuba. Magia replied that since the revolution provides women with housing, health care, and child care, there should be no need for women to become prostitutes, indicating that the song was intended to provoke debate. Magia later told me she feared the song would be too controversial for the Cine Riviera, and that the theater managers would not allow it; perhaps that is why she initially couched it in terms of capitalist society. But the song was clearly meant to provide an opening to discuss these issues in Cuba, and in a conversation with members of the audience after the concert, people did talk in more depth about the realities of the lives of jineteras in Cuba. Everyone had stories or anecdotes: the sad spectacle of a fourteen- or fifteen-year-old girl accompanying a sixty-year-old European man to a club; a mother who keeps her child playing next to her while she works; the professional woman who must work the nightclubs to earn money to support her family. Both men and women acknowledged that many jineteras are caught in desperate situations and turn to sex work as a means of survival.

In contrast to both the objectification of women's bodies and the confining revolutionary moralism, women rappers seek to define their own notions of sexuality and desire. Many American scholars have seen rap music as a reassertion of black masculinity (Baker 1991, Gates 1988), but as Rose (1994:151) notes, this definition not only equates manhood and male heterosexuality but "renders sustained and substantial female pleasure and participation in hip hop invisible or impossible." In Cuba, female rappers seek to carve out an autonomous space within the broader hip-hop movement, in which they narrate female desire and the materiality of the female body on their own terms. In the song "Te equivocas" (You're wrong) in her 2000 album *Un montón de cosas* (A lot of things), Magia derides an ex-lover who has mistreated her and asserts her rights to her body and her sexuality. Magia tells her ex-lover that he is no longer welcome in her life, she is not the weak and dependent girl he thinks she is: "You're wrong to tell me I'd die to kiss your mouth." Magia attacks her old lover's machismo and egoism: "With egotistical machismo, you yourself fell into an immense abyss of false manhood." Magia demonstrates that the myths her ex-lover has created about his virility are false. He is not worth even one-thousandth of all she has gone through for him and he has denied her happiness. She tells him she will no longer be used by him: "I'm through being your toy." This kind of assertion of female agency has a history in black popular culture, which dates back to American blues and Cuban rumba. As Imani Perry (1995:526) argues, the music of black female artists "functions in strong contrast to the 'sex innuendo' and objectification of the female body that is generally seen in popular music." Women rap artists continue this legacy of negotiating sexuality and power with their lovers and asserting their presence as sexual beings, not objects.

A notable feature of Cuban hip-hop has been the participation of women openly identified as lesbians. Given the homophobia of the Cuban political leadership and Cuban society in general, as well as the absence of queer issues from the mass media, the presence of the lesbian rap group Las Krudas represents an important opening. Las Krudas, consisting of Olivia Prendes (Pelusa MC), Odaymara Cuesta (Pasa Kruda), and Odalys Cuesta (Wanda), openly refer to their bodies and sexuality in the songs recorded on their 2003 demo CUBENSI. In "120 horas rojas" (120 red hours) Las Krudas talk about menstruation as symbolic of women's enslavement to their biology in a male-dominated society:

Painful drops of vital liquid blood	Gotas dolorosas de líquido vital sangre
color our most intimate parts,	colorean nuestras más íntimas soledades.
weakening our bodies,	debilitando nuestros cuerpos,
weakening our minds,	debilitando nuestras mentes,
weakening our voices.	debilitando nuestras voces.

The female bodily functions are the reason women are perceived as physically and intellectually weaker than men. Las Krudas address men when they say, "You don't want to listen? Thanks to this red source you could come to know this world." Las Krudas speak openly and directly: "With a single seed I develop you in my vagina cradle." For the rappers, the very processes that are hidden, used to devalue women's participation and silence them, are what brings life into the world.

Black women exist at the intersection of race, gender, and class hierarchies; as Las Krudas rap in "120 horas rojas," they are "marginalized by the marginalized, at the bottom, in all senses." While male rappers speak about historical problems of slavery and marginality, black women must face forms of enslavement and marginalization by men themselves. In another song from their album, "Eres bella" (You are beautiful), Las Krudas point to machismo as an "identical system of slavery" for women. Just as male rappers point to the exclusion of rap from major media programming, venues, and state institutions, Las Krudas challenge male rappers for their exclusion of women: "I have talent and I ask how long will we be the minority onstage?" Black women have been made invisible, objectified, and silenced in the historical record, and popular culture is no exception. In "Amiquimiñongo" Las Krudas argue that since the time of slavery black women and men have been stereotyped as "a beautiful race," "so strong," "so healthy," but they point out that black women have never been given a voice: "When I open my mouth, poof! raw truths escape from it, they don't talk of this, they want to shut me up." In contrast to the reification of the mulatta as representative of the nation in such films as La vida es silbar, Las Krudas and other women rappers restore subjectivity to black women, as actors with voice and agency.

Women rappers demand inclusion in the hip-hop movement and in society generally. As Las Krudas claim: "There is no true revolution with-

out women." Female rappers are "ebony guerrillas" who are fighting for a place in the struggle alongside black men. The all-female rap group Oye Habana, consisting of Yordanska, Noiris, and Elizabeth, celebrate female power and black womanhood. In their song "Negra" (Black woman), Oye Habana celebrate black female beauty, in contrast to dominant representations of beauty:

Black woman with my thick lips,	Negra con mi bemba,
there is nothing that surprises me.	no hay que me sorprenda.
Black woman with my nose and my	Negra con mi ñata y mi grande pata,
big legs, black woman . . .	negra . . .
Who said that for my dark color	¿Quién dijo que por mi color oscuro
I should hang my head?	debo bajar mi cabeza?
This is how I am, black woman!	¡Así soy yo, negra!

Negative and racist descriptions of black-identified features are fairly common in Cuba; it is not unusual to hear complaints about *pelo malo* (bad hair) and *mejorando la raza* (improving the race) by having children with lighter-skinned people. The rappers of Oye Habana reject these stereotypes; they assert the beauty of African features and the power and presence of black women. For the women rappers, questions of self-esteem are related to pride in who they are as black women. In her spoken-word piece "¿A donde vamos a parar?" (Where are we going to end up?), DJ Yary claims, "My example of a woman to follow: It's me! And my favorite artist: It's me!"

Cuban women rappers such as Instinto, Magia, Las Krudas, and Explosión Feminina have developed styles and attitudes that reflect their distinctness as women. Perry (1995:528) describes how some American women rappers such as Yo Yo, Harmony, Isis, and Queen Mother Rage seek to carve out a space of empowerment within hip-hop by adopting explicitly Afrocentric styles, wearing braided or natural hairstyles, African head coverings, and nose rings and self-naming. Cuban women rappers also use style to project a political message, and assert their individuality, presence, and identity as black women. Magia and the rappers of Las Krudas usually wear head wraps, African clothing or baggy shirts and pants, and natural hairstyles. In the song "Mujeres" (Women), the rapper Mariana states her desire to be taken seriously as a star performer, alongside men. She declares:

I call myself "Star!" but in competition and not in bed,	Yo me nombro "¡Protagonista!" pero en la pista y no en la cama,
as many prefer to go from rapper to rapper to soak up fame.	como muchos prefieren ir de rapero en rapero para comer fama.
I, Mariana, show the world that the Cuban woman doesn't only know how to move her hips,	Yo, Mariana, hago demostrar al mundo que la mujer cubana no sólo sabe mover sus caderas,
but when it comes to hip-hop we're the best,	sino cuando se habla de hip-hop somos las primeras,
the realistic ones,	las realistas,
even if we're discriminated against by macho notions.	aunque seamos discriminadas por conceptos machistas.

In contrast to the eroticization of black and mixed-race women in a new tourist economy as sexually available, good lovers, and sensual dancers, Mariana reclaims for women the capacity to think, make rhymes, and produce the best hip-hop. Mariana rejects the available role models for young women: cooks ("Nilsa Villapol with her recipes") and models ("Naomi Campbell in her magazine"); she chooses to be a hip-hop artist because of the power it gives her.

Despite the important inroads made by feminist rappers into hip-hop and their use of the form to advance a feminist agenda, women still face obstacles in their efforts to participate in a largely male-dominated genre. As Margaux Joffe (2005:22) notes, of the nine rap groups officially represented by the Cuban Rap Agency, only one group has a woman, Magia MC of Obsesión. Most Cuban rap producers are men. Joffe quotes Magia as saying that female artists are grateful for the recognition they receive at the annual festival, but she saw the organization of a special section for women as "patronizing": "women should not be pitied or put on a pedestal." Part of the problem facing women rappers is that they are part of a broader movement of hip-hop that is closely tied to state institutions, in which men still make most of the decisions. Yet their attempts to engage with sexism and machismo represent an important step for women rappers; the issues are being discussed and they are part of an ongoing dialogue and debate. Rap music has provided a space for dialogue between older and younger feminists, as well as between black men and women in the hip-hop movement.

Rap Musicians and the Cuban State

Cuban rap plays a challenging role in Cuban society, but the state has harnessed various sectors of the movement as a way of recapturing popular support in the special period. Some anthropological accounts have demonstrated how cultural politics can be drawn into hegemonic strategies by political elites. Katherine Verdery (1991:314), in her study of Romanian intellectuals under Nicolae Ceaucescu's rule, describes how the discourse of the nation, deployed in counterhegemonic ways by intellectuals, was adopted by the socialist state "in order to overcome it, incorporate it, and profit from its strength." In the same way, Cuba's dominant groups have absorbed the discourses and strategies that provide opportunities to voice critical resistance.

The Cuban state has had an ambivalent relationship with the various trends in Cuban rap, as some sectors at different levels of state institutions build alliances with certain networks and as persons in official positions seek to appropriate various transnational agencies for their own political ends. In the early days, state disc enterprises such as EGREM chose to promote commercial-sounding rap music as representative of the movement. According to Ariel Fernández (2000a), while the discs of the more politically engaged groups such as Obsesión and Primera Base gathered dust on the shelves of music stores and broadcasting studios, the more commercial disc of SBS, with its dance-oriented mixture of salsa and rap, was heavily marketed. He argues that the SBS disc was "much more vigorously promoted because of its popular and commercial character, because it had nothing dangerous in its words, and it made the people dance." At first the state promoted commercially oriented rap as a way of diluting rap's radical potential. The global marketing of the disc brought in a large wave of foreign producers. They "came with money in hand trying to buy Cuban talent with their low prices, suggesting the fusion of rap with Afro-Cuban music, with son, with salsa and timba." The Cuban state exploited the more commercial rap for its revenue-earning potential, as part of a push to attract foreign funding through Cuban music and arts. Foreign producers' promises of money and promotion did cause several Cuban rap groups to change their music and become more commercial, or to break up as members disagreed over whether or not to sell out.

Those rap groups that did not sign deals or change their music continued to build the Cuban hip-hop movement, with the help of Ariel Fernández and Pablo Herrera, who brought rap groups from the United States and from all over the world for the festivals. Particularly since the early years of the twenty-first century, the Cuban state has realized the need to relate more to the underground rappers, partly because of the increasing appeal of their radical message among Cuba's black youth. The political leadership put a high priority on promoting rappers loyal to the revolution. In July 2001, Minister of Culture Abel Prieto held a meeting with leading Cuban rap groups, where he talked of providing rappers with studio space, air time, and their own music agency, and he pledged ongoing support for Cuban rap. The following month Prieto told me how impressed he was by the young rappers, "with the level of commitment they have to this country and the seriousness and rigor with which they take on real problems, at the same time rejecting commercialism." After attempting to sideline the underground rappers by supporting the commercial groups, the state turned to praising the underground groups for their rejection of commercialism. Political leaders' efforts to ally themselves with hip-hop artists can be seen in Latin America and elsewhere in the Caribbean as well. In Brazil, President Luiz Inácio "Lula" da Silva and Minister of Culture Gilberto Gil met with Brazilian hip-hop artists in March 2004 to discuss state funding of hip-hop in the form of a National Executive Commission of Hip-Hop.[17] The role that hip-hop can play in engaging black youth is being taken seriously by many governments, particularly leftist governments that can build alliances with the hip-hop movement.

But Cuba's political leaders do not relate to the underground rappers only because of their increasing influence in Cuban society and as a way of alienating the more commercial rappers; they also realize that they can harness the energy of these rappers to bolster the image of Cuba as a mixed-race nation with African roots. Historically the state has appropriated forms of Afro-Cuban cultural expression as a way of fostering national cohesiveness, particularly during times of crisis. For instance, Robin Moore (1997:220) describes how performers, politicians, and intellectuals constructed Cuba as a mixed-race nation as a way of creating ideological unity in the 1930s, a period of sharp racial antagonism. In the postrevolutionary period, racial identification has also been an important source of na-

tional unity. De la Fuente (2001:307) argues that the identification of post-revolutionary Cuba with the independence struggles taking place in Africa, the anti-apartheid movement, and the civil rights movement in the United States inscribed the imagery of Africa into the revolutionary project, helping to construct internal unity. In postrevolutionary Cuba, race has served the additional purpose of being a "formidable ideological weapon against the United States" and "a source of domestic and international political support" (De la Fuente 2001:18). Given the increasing racial disparities in Cuba's special period and growing cynicism among Afro-Cubans about the ability of the revolution to continue to address their needs, the state draws on articulations of blackness in Afro-Cuban cultural expression to reconstruct national unity and regain popularity.

Journalists and cultural critics identify the egalitarian ideals of Cuban rappers with Castro's calls for equality and justice in the international arena. In a speech after the attacks on the World Trade Center in New York in 2001, Fidel Castro argued that the global economic crisis was "a consequence of the resounding and irreversible failure of an economic and political conception imposed on the world: neoliberalism and neoliberal globalization." Taking a stance of moral authority, Fidel claimed that the path being forged by the Cuban nation will provide a solution to the crisis: "The fundamental role has been played and will continue to be played by the immense human capital of our people." Various social and political actors associate Cuban rap with these ideas of Cuba as a rebel nation, forging a more just alternative to neoliberalism. The music journalist Elena Oumano argues that "the government here is a major power in the rest of the world, so when hip-hop is rebelling . . . they're really rebelling against the status quo worldwide, the new world order. . . . Cuba itself is kind of the underdog and the rebel in terms of the world scene, it's the last bastion of Marxism, so there's more of an allegiance between the government and hip-hop."[18] Similarly, the Cuban poet and cultural critic Roberto Zurbano (2004) insists that "one element . . . shapes the thought of Cuban rappers and . . . differentiates them from others in the world: the emancipatory vision that these young people share with the Cuban Revolution, its forms of struggle, its acts of resistance; as its characteristic cultural *cimarronaje* at work from the time of the Haitian Revolution until Cuban Culture and History today." Images of rebellion and resistance in Cuban rap are drawn into broader geo-

political strategies of black cultural opposition; these are identified with the Cuban revolution and by extension the Cuban government as the lone voice contesting neoliberalism in a largely capitalist world order.

The image of Cuba as a black nation rebelling against neoliberalism is evoked by rappers themselves, partly because it is attractive to them and partly because it can be deployed strategically as a way of gaining official recognition for the genre. In their song "Pa' mis negros" (For my blacks), Cien Porciento Original propose, "Let's help one another for a nation of blacks more sensitive, for a nation of blacks more stable." Rappers associate the Cuban nation with the underground condition, with its connotations of political awareness and rebellion. In their song "Juventud rebelde" (Rebellious youth), the name of the official youth newspaper, the rappers Alto Voltaje claim that "Like a cross I go, raising the underground banner for the whole nation," and in "Mi patria caray" (My country, damnit!), Explosión Suprema say, "We are the Cuban underground, almost without a chance, but with the little we have we are not dissenters." Rappers identify their movement with statements by the political leadership about justice and sovereignty in the international arena. For instance, the Cuban state issued several statements condemning the conviction and imprisonment of five Cubans in Miami in 2001 for spying for the Cuban government in the United States. A Cuban solidarity campaign to "free the Cuban Five" attracted followers around the world. In the song "Asere" (Cuban slang for friend or "homie"), a collaboration between Obsesión, Anónimo Consejo, and the Puerto Rican rapper Tony Touch, the rappers link the campaign for the Cuban Five to the struggles of Puerto Ricans to stop the U.S. Navy from using the small island of Vieques for target practice, and they criticize U.S. hegemony in the region. Local actors comply with and reinforce official narratives in strategic and self-conscious ways.

Brazilian hip-hop artists have also identified their movement with the government, particularly since the moderately leftist Lula has come to power. In Lula's 2003 campaign for the presidency, he derided previous administrations and promoted his own this way: "The Collor government was one of hillbilly music, the FHC [Cardoso] government was one with no rhythm, and my government will be a government of hip-hop."[19] Quoting Lula's words, the Brazilian hip-hop artist Gog proclaimed, "We have the courage to say that all of us here from Hip-Hop support President Lula."[20]

Derek Pardue (2004) makes the important point that Brazilian hip-hoppers are active organizers and negotiators who gain employment and sponsorship by linking hip-hop to official pronouncements and projects. But as in Cuba, various hip-hop artists also identify with the possibility of a radical government that represents their interests. Another hip-hop artist, Ghóez, declared, "We continue to construct this government, and this government is for the poor, it's a popular government."[21] Like Cuban rappers and some Venezuelan rappers, such as Benito of La Séptima and Familia Negra, who collaborate with the revolutionary leftist leader Hugo Chávez, Brazilian rappers seek to raise the profile of hip-hop and claim their share of power in their negotiations with the government.

The collaboration of Cuban and Brazilian rappers with the state calls into question some of the assumptions of globalization theories, which suggest that the growth of transnational cultural flows based on such concepts as race leads to the increasing obsolescence of the territorially bounded nation-state. Arjun Appadurai (1990:14) argues that global cultural flows constitute a danger to the nation-state: the flows of ideas about democracy in China become "threats to its own control over ideas of nationhood and peoplehood"; and the lifestyles represented on international TV in the Middle East and Asia "completely overwhelm and undermine the rhetoric of national politics." Gilroy (1987:158) also suggests that "the African diaspora's consciousness of itself has been defined in and against constricting national boundaries." What these accounts of transnational cultural forms ignore is the potential alliances between transnational and national bodies. As Aihwa Ong (1999:15) has argued, "there are diverse forms of interdependencies and entanglements between transnational phenomena and the nation-states." The potential for transnational cultural practices to reinforce the hegemony of the Cuban state lies in the attractiveness of ideas of egalitarianism and sovereignty in a world system marked by increasing inequality and dependency, as engendered by free-trade agreements such as NAFTA. While Cuban rappers build networks with U.S. rappers based on race and marginality that transcend national affiliations, they simultaneously generate a critique of global capitalism that allows them to collaborate with the Cuban state.

Partly as a result of the appropriation of rap music by the Cuban state, rappers have succeeded in winning greater visibility in Cuban society. After

the 2001 rap festival, a session of the nationally broadcast television talk show *Diálogo abierto* (Open dialogue) featured a discussion among several rap promoters and Cuban artists about Cuban rap, showing footage of performances from the rap festival. During the 2001 Cubadisco music festival, attended by producers and recording labels from around the world, rappers and rock musicians were given their own stage in Playa and the rap group Obsesión was nominated for an award. The increasing visibility of Cuban rap has helped some political leaders admit that racial discrimination exists in Cuban society. "We are supporting this movement," the minister of culture acknowledged, "because the message of Cuban rap profoundly reflects our contradictions, the problems of our society, the theme of racial discrimination, and it strongly highlights the dramas of marginalized barrios."[22] Instead of criticizing rap music for its racial content, as the state had done earlier, leaders now praise rap for addressing issues of race.

The state has also given more institutional support to rap music in recent years. After the 2000 festival, Grupo Uno, the somewhat independent organization of rappers, was disbanded by AHS, so that AHS directly organizes concerts and activities related to rap music and coordinates the yearly rap festival. Between 1998 and 2001, rap groups were organized under a system of *empresas*, or agencies related to music, under the Ministry of Culture. Rappers belonged to four agencies: the Benny Moré Empresa, dedicated to popular music; the Ignacio Piñeiro Empresa and the Adolfo Guzman Empresa, specializing in soloists and singers; and the Empresa Nacional de Espectáculo (National Entertainment Agency), which organized rappers and rock musicians. The latter three agencies had little to do with rappers and did not pay them. The Benny Moré Empresa was the most innovative in its promotion of rap and paid rappers a commission based on the number of performances they gave rather than the fixed salaries that had been the norm for musicians. Mercedes Ferrer, a commercial specialist at Benny Moré, said that they relied on AHS to select the rappers to join the agency. The agency then decided which groups could produce compact discs; so far only two groups, Obsesión and Primera Base, have released compact discs through the agency.[23] After Prieto met with rappers in 2001, the state created a rap agency and invited various rappers to join. Groups such as Obsesión and Anónimo Consejo left their former agencies to join the new one. But in 2004 rappers complained that the problems of discrimination,

marginalization, and lack of resources were still as bad as they had always been.

The institutional support given to Cuban underground rappers and the greater prominence accorded their demands for social justice and racial equality have come at the cost of autonomy. Fernando Jacomino, the vice president of AHS, said that the function of AHS is to "create a cultural and political leadership among the rappers who are able to pressure the institutions to give them support so that they can give their concerts." [24] Rather than give the rap movement cultural and political autonomy, AHS seeks to encourage a relationship of dependency: rappers must appeal to state institutions for the funds and permission to do their work. The paternalistic relationship was evident at the provincial meeting of AHS musicians held at the University of Havana before the national meeting scheduled for November 2001. During the meeting, attended by the leadership of AHS and about fifty rap, rock, and *nueva trova* musicians, the young musicians had seats on the floor of the room while the panel of leaders were seated on a platform above them. The musicians voiced their complaints, such as the need for more publicity, more funds to produce compact discs, larger spaces for performance, and payment for promoters. The leadership did not deny the validity of their claims but encouraged them to talk more about these things, in effect establishing the authority of AHS over rappers and their consequent dependency on AHS.

Increasing institutionalization of rap music also means that the state can exercise greater censorship over rappers' activities. During the August 2001 festival, the group Reyes de la Calle wanted to do their song about the balseros and they wanted to have images of the balseros on a screen behind them. However, Fernández told me that the president of AHS vetoed this suggestion, "because CNN may be filming it and this would lend support to the counterrevolutionaries." [25] The direct support given to the rap festival by the Ministry of Culture and AHS enables people in official positions to exert control over aspects of the artistic process. Rappers are aware of the control being exercised over the rap movement as it becomes increasingly integrated into state institutions. Osmel Francis Turner, a rapper in Cubanos en la Red, expressed his belief that rappers need to maintain their independence and build networks outside the state: "Rappers can't wait for the state to resolve their problems, because tomorrow I might say some-

thing that bothers the state and then I'll have to forget being a rapper, because they're going to tell me I can't do it."[26] Other rappers speak about not being able to appear on radio programs unless they remove certain "offensive" language or incendiary political statements. Given the historical cooptation of vibrant cultural forms by revolutionary institutions, as happened with *nueva trova* in the 1970s (Díaz Pérez 1994), rappers are especially concerned about protecting the autonomy they have struggled to build. Fernández, echoing Turner's concerns, said, "Cuban rap will lose its essence the day it doesn't criticize anything, the day it doesn't protest against anything."[27] Although they welcome the more prominent profile that Cuban rap has achieved through institutionalization, rappers and young Afro-Cubans in general view the state's sponsorship of rap with some suspicion.

Certain incidents indicated what would happen if rappers pushed the boundaries too far. In 2002 a rap group called Clan 537 began performing a song called "¿Quién tiró la tiza?" (Who threw the chalk?), evoking a typical classroom scene where someone at the back of the room throws a piece of chalk and the teacher searches for the culprit. The song's refrain, "That black kid, not the doctor's son," evokes the racism and classism underlying perceptions of culpability (West-Duran 2004). The song was mainly performed in small clubs and recorded in underground studios, until it began to generate a substantial following and was played on major Havana radio stations. The journalist Eugene Robinson (2004:207) relates that the state's response was to release a song titled "Tiraste la tiza, y bien" ("You threw the chalk, and good"). When Cubans ridiculed the official song, the state retaliated by taking "¿Quién tiró la tiza?" off the air.

Commercial rap has not been appropriated by the Cuban state in the same way as underground rap, partly because the more commercial rappers have greater access to outside funding and partly because they generally celebrate consumerism and individuality, values and strategies that are not easily identified with the state. But even commercial rappers find certain points of correspondence and accommodation with the state, particularly given the trajectory toward a mixed-market economy based on new modes of consumption, desire, and leisure. As the Cuban state embraces market reform and ideology, the strategy of jineterismo may in some ways coincide with strategies of the state itself.

One Saturday afternoon in 2001 I saw a salsa band called Dan Den at

the Casa de la Música (House of Music) in Miramar. The Casa de la Música used to be a popular Cuban venue showcasing Cuban salsa bands; it charged a 5-peso cover charge for an afternoon show and 10 pesos for an evening show. Cubans of all ages swarmed there to dance, drink, and listen to salsa. In the late 1990s, needing tourist dollars to finance its operations, the Casa de la Música raised its prices to 40 pesos in the afternoon and $10 at night, gradually paring down its Cuban clientele and increasing the number of dollar-toting tourists. When I attended the Dan Den performance, the audience consisted mainly of foreigners and the jineteros for whom they were paying. A few other foreigners were there with Cuban friends, as I was.

During one song, Dan Den's lead singer switched to the chorus of the Orishas song "Atrevido," and the Cuban members of the audience sang along. The singer would call out, "Everything she asked for," and the Cuban audience members would reply, "The idiot paid for it"; then the singer would say, "A pretty room at the Cohiba," and the audience would sing, "The idiot paid for it." The Cubans were dancing, clapping, and singing along loudly to the chorus, especially the jineteros. There was a solidarity among all the Cubans dancing and singing along in a shared recognition of their position in relation to the foreigners who had paid their cover charges and drinks, and most likely for other things as well. The foreigners, dancing along too, had no idea what the lyrics meant; even Spanish-speaking foreigners would not likely have been able to decipher the song's Cuban slang, so the whole chanting of the chorus was a shared joke at the expense of the foreigners.

In the context of the mixed audience at the Casa de la Música, "Atrevido" functioned as a hidden transcript (Scott 1990) that conjured up Cubans as a community united against the foreigners. Rocio Rosales (2004) claims that the function of sexual labor as a means to meet economic needs is leading to a shift in morality: sex work is coming to be seen as a source of empowerment for families and the community rather than as immoral. Such experiences draw links and parallels between the strategies of ordinary Cubans and the practices of the political leadership. Like the jineteros, who see their activities as robbing from wealthy tourists to support themselves and their families, the state sees tourism as maintaining the social structures and welfare mechanisms of the revolution: the tourists' dollars

fund schools, hospitals, and child-care centers. Jineterismo may actually be useful to the state, as jineteros direct foreigners to state tourist venues and encourage them to spend money. Moreover, in the global marketing of Cuba as a tourist destination, the Cuban state relies on stereotypes of tropical sexuality and female promiscuity as promoted in commercial rap, even though these stereotypes may contravene revolutionary morality. These correspondences between the commercial sectors and the evolving Cuban state point to possible future alliances, especially as groups such as Orishas begin to garner greater recognition abroad.

The Contradictory Space of Cuban Hip-Hop

The state harnesses the oppositional potential of underground rappers to maintain its hegemony in the difficult special period, but the continued participation of these underground rappers in multiple networks of African American rap and the global music industry actually allows them to resist some aspects of state co-optation. Since only a few rap groups have access to television and major record labels, the hip-hop movement as a whole continues to identify as underground. Moreover, an exploration of underground rap demonstrates the contradictory desires and impulses present within the genre. Consumerism and black nationalism overlap in multiple ways, as those who identify as underground fuse activism with consumerist desire, style with politics, and hard-edged critique with a celebration of black culture. Transnational networks do not map neatly onto distinct groups of rappers; rather they infiltrate and constitute Cuban hip-hop in ways that prevent the reduction of rap music to any one political agenda.

Although some underground rappers oppose the commercial and consumerist tendencies of groups such as Orishas, the underground hip-hop movement in Cuba is shaped by capitalist consumerism even as it resists it. The hip-hop movement in Cuba reflects trends in American hip-hop such as conspicuous consumption, and American clothing has also been used to make certain political statements. It is undeniable that the wearing of designer-label clothes such as Fubu and Tommy Hilfiger, which are associated with the hip-hop movement in the United States, has also worked its way into Cuban hip-hop. Most members of hip-hop audiences are attired in baggy pants, sweatshirts, and baseball caps or stocking caps. They are not simply adopting an American style; they are signaling their refusal to con-

form to the dominant society. Dick Hebdige (1979:3) suggests that styles have a double meaning: "On the one hand, they warn the 'straight' world in advance of a sinister presence—the presence of difference—and draw down upon themselves vague suspicions, uneasy laughter, 'white and dumb rages.' On the other hand, for those who erect them into icons, who use them as words or curses, these objects become signs of forbidden identity, sources of value." Cuban rap audiences use their clothing and their adoption of American slang such as "aight" and "mothafuka" as a way of distinguishing themselves as a group and highlighting their identity as young black Cubans. Their style has not gone unacknowledged by state officials, either; they recognize the subversive potential in this form of dress. Tony Pita derided rappers for wearing hats, long pants, and stocking caps in the tropics.[28] But more is at stake here than the suitability of clothes to the climate: the most salient factor is the association of the clothing with a culture and society forbidden to Cubans.

Some black nationalist Cuban rappers wear hand-printed African shirts, dreadlocks, or natural Afro hairstyles, and others wear hand-crocheted caps and T-shirts with images of cannabis, Bob Marley, or Haile Selassie, associated with the subculture of reggae. Kobena Mercer (1990:259) describes how, in the absence of organized black politics in the 1940s and finding themselves excluded from official channels of representation, African Americans announced their politics through the conk hairstyle, the zoot suit, and jive talk, which "reinforced the terms of shared experience— blackness—and thus a sense of solidarity among a subaltern social bloc." Similarly in Cuba, black styles signify an embracing of African identity, an assertive stance for rappers to take in the present climate. Carlos Moore reports that in the 1960s, the Cuban state harassed Afro-Cubans who deviated from the revolutionary norm by appearing in dashikis and Afros. The tensions between the revolutionary leaders' desire to align themselves with the black power movement in the United States and their reservations about the "divisive" effects of black cultural politics were apparent in confrontations over style (Moore 1988:259).

For Cuban rappers, these styles are also a way of exhibiting their crossnational identifications, of asserting a collective sense of black identity in contrast to the racially integrative program of the Cuban state.[29] The rappers of Anónimo Consejo, formerly known as Yosmel Sarrías Nápoles and

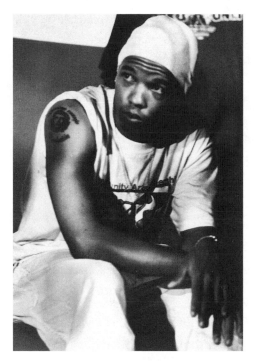

4. Adeyeme Umoja of Anónimo Consejo, Cine Riviera, Havana, August 2001. PHOTO BY ANGEL JAVIER MACHADO LEYVA.

Maigel Entenza Jaramillo, took on the African names Sekuo Mesiah Umoja and Adeyeme Umoja in an act of what they refer to as "homage to their African ancestry" (quoted in Fernández 2003). Sekuo and Adeyeme say that this reinvention of identity is more than a style; it forms part of their legal connection to the House of Umoja, which is based in the United States and has representatives around the world.[30] Although Anónimo Consejo continue to promote a message of racial unity, they draw strength from the expression of their ongoing spiritual and political connections with Africa and the African diaspora.

Underground rappers may seek to insulate Cuban hip-hop from the market, but they are forced to face the realities of cultural commodification. The rap producer Pablo Herrera told me that after he was interviewed by *Vibe* magazine, an American producer came to Cuba and offered him clothing from the Edge label. Herrera felt himself pulled in two directions: on the one hand, he recognized the producer's attempt to take advantage of an opportunity to market the Edge label in Cuba; on the other hand, the clothing was very fashionable, and it's not easy to find good clothing in Cuba. Networks of fashion labels and transnational record companies, as

well as cultural exchanges such as Black August, provide multiple options for Cuban rappers to improve their current circumstances. Like African American rappers who see hip-hop, like sport, as an activity that "embodies dreams of success and possible escape from the ghetto" (Kelley 1997:53), Cuban rappers see rap as an avenue to prosperity or a way to solve their problems without recourse to the state. In the song "Prosperaré" (I will prosper), Papo Record suggests that the current poverty of Cuban rappers will eventually be rewarded by material success:

Today I sing in a small concert,	Hoy te canto en una peña,
tomorrow I'll go on tour,	mañana doy una gira,
the next day I want to travel abroad.	pasado quiero viajar.
Today some hundreds for a song,	Hoy unos cientos por un tema,
tomorrow some thousands for a disc.	mañana unos miles por un disco.

When foreign travel is an impossibility and many Cubans barely make enough to live on, rap music provides the fantasy of wealth and stability. It is undeniable that material desires that have shaped the movement in the West also inform the movement in Cuba. A range of diverse, often contradictory practices constitute fallback options in a period of uncertainty. In the song "El barco" Los Paisanos point to the dire situation of rap musicians in Cuba:

The situation of Cuban rap in this era doesn't prosper,	La situación de rap Cubano en esta era no prospera,
the money my imagination produces doesn't materialize in my wallet.	el dinero que produce mi imaginación no hace estancia en mi billetera.

Rappers are not convinced that if they join the AHS and work through the agency system, they will be able to make careers as rappers. Working through AHS may be the only practical way for rappers to organize their concerts and get paid for their work, yet the young marginalized rapper has a vision of larger fame and glory beyond state institutions.

But the fantasy of wealth as represented by American commercial rap music is not so realistic a survival strategy as hustling. Few Cuban rappers are likely to amass large fortunes through their music. Mimi Valdés argues that as hip-hop has become big business in the United States, contracts look more like loan agreements, as expenses that used to be paid

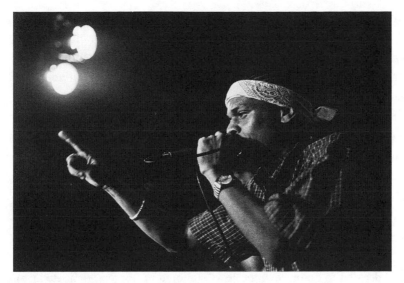

5. Papo Record in concert at Café Cantante, Havana, 2001. PHOTO BY ANGEL JAVIER
MACHADO LEYVA.

by the label are being passed on to the artist.[31] If artists do not sell large numbers of discs and are constantly on tour, they will never make enough money to enjoy the lavish lifestyle represented in the hip-hop videos. Even Orishas suggest that in their encounters with EMI they are little more than workers: "You have to work because there's a company that has invested in you, you're a worker. You have to draw the maximum from yourself because this is going to have repercussions for your future" (quoted in Fernández 2000b:7). Despite the optimism expressed in Papo Record's "Prosperaré," a fantasy shared by many rappers that through rap music they can make lots of money and tour the world, Orishas suggest that commercial fame does not guarantee wealth, and even artists who have been able to create top-selling albums feel under constant pressure to sell more. The pressure to sell and perform is new to Cuban artists, most of whom are accustomed to operating within a system where appealing to a mass audience is less important than political connections.

At the turn of the century rappers began to break away from their dependence on the AHS and, like many underground rappers in the United States and elsewhere, to produce their own discs. At a concert in March 2004 I purchased homemade discs from more than eight hip-hop groups. Rappers make most of their money by selling their discs for $5 to $10 each

to foreigners or organized tour groups that attend the rap concerts, or they sell the discs to Cubans for pesos. Producing discs is a way of generating a local market outside of the official recording industry as represented by EGREM. In a disc co-produced by Obsesión and Doble Filo in 2003, the first song, "La Fabrik," opens with the sounds of an assembly line and then over these sounds the rapper Alexei introduces the co-production as an independent project: whether it's good or bad doesn't matter; what matters is that it's their own project. Rappers need to be doing their own projects, because, as Alexei raps, they cannot rely on the state: "What are we waiting for? Who will do it, EGREM?" We hear derisive laughter in the background. As Vitalicio of Doble Filo said, "Cuban record labels aren't interested in producing rap. If you wait to be promoted here or for an offer to record, or for interest in your project, you can be sure you won't succeed. That's why we've decided to do our own projects" (quoted in Borges-Triana 2004:7). In view of the exclusivity of Cuban record labels, rappers have decided to move out on their own.

In a period of economic uncertainty and stagnation, Cuban rappers devise multiple strategies by which to revitalize utopian promises and express their needs and desires. The focus on consumerism as a new vehicle for young blacks to define and express their individuality by theorists of cultural resistance such as Manthia Diawara (1998:273) may be applicable even in Cuba, where neoliberal globalization produces new possibilities as it closes older options. But Diawara's assumption that consumerism is the new activism and the most transportable global element misrepresents the diversity of the hip-hop movement outside of the United States. In contrast to Diawara's (1998:276) claim that "black nationalists, especially, have seen their values labeled archaic by the transnational hip-hop culture," I have found that young Cubans are strongly attracted by the black nationalist politics of African American rap. Cuban hip-hop combines a politics of race, style, consumerism, nationalism, and anticapitalism into a multifaceted movement that reinforces local and global forms of power while also providing a voice of resistance. Rap is drawn into hegemonic strategies by both the Cuban state and multinational record companies, but the participation of these rappers in multiple transnational networks simultaneously gives them an opportunity to resist the institutionalization of dissent that has occurred with other cultural forms. The appropriation of

clothing styles, whether American, Afrocentric, or Rastafarian; the adoption of American slang; and the fantasy and reality of foreign travel, cultural exchanges, and contracts with foreign labels allow rappers to carve out a somewhat autonomous role for hip-hop, even as it operates partly within state institutions.

This analysis of Cuban rap illustrates several processes that characterize the relationship between artists and the state in the contemporary period. First, Afro-Cuban young people appropriate rap music in order to express their criticisms of the Cuban state, highlight issues of racial discrimination and social justice, develop alternative strategies for economic survival, and explore avenues of pleasure and desire. Second, those rappers who identify as underground share the socialist language and ideals of the Cuban state and they criticize commercial rappers who embrace such alternative values as consumerism and hustling. Third, cultural and political leaders promote underground rap as a way of marginalizing the commercial rappers and maintaining the hegemony of Cuban socialism in a period of increasing social disunity and economic instability. Fourth, despite the collaboration of Cuban rap musicians with the state, their continuing participation in transnational networks of both African American rap and transnational record companies provides rappers with alternative options that prevent their wholesale co-optation by the state.

The relative marginality of rap music, as a form of black cultural production with little mainstream or commercial promotion, has made a greater degree of agency available to rap producers and consumers. As George Yúdice (2003:157) has argued, "agency succeeds to the degree that an individual or a group can make its own the multiplicity of venues through which initiative, action, policy, and so on are negotiated." Although the state may appropriate rappers' calls for a "black nation" in an effort to rebuild popular support and national unity, rappers' demands and strategies are not reducible to the state's agenda; hip-hop culture can actually have an impact on the ways in which racial issues are depicted in public discourse. Culture has become an important arena in which to make political demands and assert rights and agency. Yet at the same time, the agency of the artistic public sphere relies on citizens as cultural producers and consumers. Cultural contestation is easier to contain and incorporate than political action.

Rap may be the vehicle through which a range of radical movements are nurtured, from black activism to feminism, but its ability to translate cultural politics into a political movement depends on the ability of artists to build and sustain broader alliances with a range of social and political groups.

4 Postwar Reconstructions

State Institutions, Public Art, and the New Market Conditions of Production

"Postwar," for its similarity to the physical state of the city, the inner being of the people, the social status of art.

Tania Bruguera, Memoria de la Postguerra, 1993

The Cuban artist Tania Bruguera compared the devastation felt in Havana after the collapse of the Soviet Union to the aftershocks of a war. Indeed, the euphemism devised by the state to describe the moment, "special period in time of peace," was adapted from a contingency plan to be activated in the event that the country found itself under military attack. The drastic deterioration in living standards, the food and power shortages, the increasing siege mentality, and the constant calls to mobilization did resemble a country at war. "Postwar" could also refer to the end of the Cold War, a time when many small nations such as Cuba and Angola were used as pawns by larger powers. Visual artists explored the psychological, social, and political impact of "postwar" Cuba in the 1990s. After the early years of the special period, marked by a shortage of materials, an exodus of artists, and censorship, artists began to reconsolidate and rebuild the visual arts in the new conditions imposed by a foreign market and ongoing censorship of the arts. Like literature, the visual arts are marked by a strong orientation toward the international art market and tourism.

The late 1990s and early 2000s have also seen the reemergence of public art as a movement of visual artists, mainly art teachers and their students, who seek to revive socialist values such as collectivism and negotiate with state institutions for inclusion. Art teachers began to popularize the notion of public art as a way of renovating an ethos of collectivism against the encroachments of

the international art market. Unlike more established artists, art students have little opportunity to travel and sell their work to foreign buyers and are dependent on the state for their subsistence. The students produce art that deals with contentious social and political themes and they negotiate with the state for the right to display their critical works. Certain artists dealing with themes of race and racial identity have also sought to produce socially engaged art that is critical of the market fetishization of Afro-Cuban religion and culture, as well as the silencing of race issues within Cuban society. These various currents form alternative public spheres, where actors achieve limited critical exposure through their involvement in cultural markets and state institutions.

One of the main differences between the visual arts[1] and other art forms in Cuba is the exposure that an emerging sector of visual artists have had to places outside of Cuba through their participation in global art markets, involving travel and study in other countries, and through self-initiated contacts with artists abroad. Through their exposure to other societies, these visual artists have come to see crisis and stagnation as not unique to special-period Cuba. Whereas visual artists directed their criticisms against the Cuban state in the 1980s, these cosmopolitan artists focus more on global capitalism. But at other times, the Cuban political leadership may be implicated in critiques of global capitalism because of its own involvement in the global economy through tourism and joint ventures.

The search for resources to survive the onslaught of the special period has led visual artists to look to the international art market for scholarships, residencies, and exhibition opportunities. Although some visual artists seek to work in collaboration with state institutions, others seek to build new public spaces and forms of community that extend beyond the boundaries of the nation-state. Much like the Cuban state itself, the field of visual arts has been reconstituted through an opening up to the rest of the world: both have reinvented themselves as they have forged new alliances. One of the central dynamics of contemporary Cuban visual arts is the building of cultural links between Cuban and Third World artists and people and between Cuban artists and Chicano, African American, and Cuban immigrants in the United States, links that go beyond the formal diplomatic links and economic pacts designed by the Cuban state. The diplomatic activism of artists, building new networks and relations, may be crucial to the way Cuba evolves.

Confrontations, Censorship, and Renewal

The emergence of radical critical art in Cuba is generally identified with the Volumen Uno (Volume One) group, whose exhibition opened on 14 January 1981 in the Centro de Arte Internacional in Havana. This exhibition by such artists as José Bedia, Juan Francisco Elso Padilla, and Flavio Garciandía was the starting point for a series of group shows that represented an important departure from established Cuban art traditions. The exhibition opened the way for self-referential issues not engaged by earlier generations of artists, began the incursion into the international art world, and heralded the use of new techniques such as hyperrealism and performance art. Yet despite this difference, their break with the past was not so radical, as the artists of Volumen Uno remained within a well-established framework of Western modernism that had survived the revolution (Camnitzer 1994:4–5).

During the same period, another group of artists known as the Grupo Antillano (Antilles Group) challenged the modernist visions of Volumen Uno. Guillermina Ramos Cruz (2000:148), a member of the group, argues that in contrast to the Grupo Uno artists with their Eurocentric vision, the artists of Grupo Antillano sought to highlight the history and presence of the African diaspora in Cuba and more broadly in the Caribbean or Antilles. Following the precedent of eminent Afro-Cuban painters and artists such as Wifredo Lam and Roberto Diago and the anthropological work of Fernando Ortiz, the members of Grupo Antillano sought to build a cultural movement that could translate African culture into the Cuban revolutionary context. Judith Bettelheim (2005:36) relates that Grupo Antillano's first exhibition, in September 1978, was sponsored by the Ministry of Culture, and by 1979 the group had seven core members, among them Rafael Queneditt Morales, Rogelio Rodríguez Cobas, Ramón Haití Eduardo, and Arnaldo Rodríguez Larrinaga. The celebrated Afro-Cuban artist Manuel Mendive also began to exhibit and tour with the group. The Grupo Antillano had exhibitions in Surinam, Barbados, and Guadeloupe and participated in the Caribbean Arts Festival, CARIFESTA, held in Havana in 1979 (Ramos Cruz 2000:148).

Despite the Ministry of Culture's early support, the Grupo Antillano gradually found its movement stifled. According to Ramos Cruz (2000:149–150), the Ministry of Culture's critics and advisers began to express some concerns: art based on Spanish or peasant culture was legitimate, but art

based on African history and identity was not. A series of incidents, including interviews that were never published and television programs never aired, began to atomize the group. As the artists of Volumen Uno began to achieve international recognition with the Ministry of Culture's support, the Grupo Antillano found itself excluded from national and international events and deprived of funding. The black members of Grupo Antillano found their culture appropriated by white artists in Volumen Uno, such as José Bedia, who began to win prizes for works that incorporated indigenous and Afro-Cuban themes. Later black cultural movements and collectives moved into the spaces opened by Grupo Antillano, and they confronted many of the same problems and exclusions faced by earlier Afro-Cuban artists.

The '80s generation of Cuban visual artists built on the atmosphere of critical activism and the challenging of taboos that accompanied the political climate of the 1980s, and one of the main forms they used was public art. Wendy Navarro (2000:47), a Cuban art critic, defines "public art" as experiences or performances in urban space that aim to confront the political, social, and institutional order. One of the main features of public art in Cuba were the "happenings," which varied from carefully staged performances to improvised, spontaneous events. Around 1986, young artists came onto the art scene in groups or collectives, including Grupo Provisional, Arte Calle, Grupo Puré, and Grupo Imán (Camnitzer 1994). Seeking to destabilize institutional norms and established procedures, they used irreverence and parody to convey their messages. For instance, during an event on sex held by UNEAC in 1986, two young artists, Consuelo Castañeda and Humberto Castro, burst in wearing giant penis costumes and spraying milk on the panelists (Camnitzer 1994:177). The following year, the members of Grupo Provisional barged into a UNEAC conference on art, turning it into a pompous awards ceremony and offering skeletons emblazoned with the word "artist" to the "winners" (Camnitzer 1994:179). These artists sought to challenge the conventions of the art world and its methods of bestowing legitimacy.

However, art collectives of the 1980s attempted to go beyond criticism of the art world to address society and politics in general. The art critic Gerardo Mosquera (1999:27) relates that in the 1980s the visual arts "took on the role of assemblies as well as the totally controlled mass media as

they converted themselves into a space for expressing the problems of ordinary people." Mosquera sees the visual arts as serving the function of civil society: "the visual arts became the most daring platform, and some street performances . . . were true demonstrations." The criticisms and political commentary continued to grow stronger, until a series of events in 1989–90 dispersed the groups. In February 1989 an exhibition at the Castillo de la Real Fuerza was closed when it was found to include a portrait of Fidel Castro in drag with large breasts and leading a political rally, and Marcia Leiseca, the vice minister of culture, was relocated to the Casa de las Américas (Camnitzer 1994:258). In response, artists organized a baseball game at the José A. Echeverría Stadium, where permission is needed for a gathering but not for a ball game; but when the group Paideia read to the crowd a manifesto denouncing the "subordination of the intellectual to hegemonic structure," the stadium was immediately cleared (Valdés Figueroa 2001:17). The confrontation between artists and the authorities came to a head at an exhibition at the Centro de Desarrollo de las Artes Visuales (Center for the Development of the Visual Arts) in 1990. After defecating on a copy of the official newspaper, Granma, Angel Delgado was declared guilty of "public scandal" and sentenced to six months in prison (Hernández 2001:25).

By the 1990s, repression had severely weakened the visual arts in Cuba. Many artists ceased work for lack of institutional support. As these developments coincided with the special period, art supplies became unavailable and artists had no income. The difficulties of working in Cuba at this time led to mass migrations of Cuban visual artists to the United States, Mexico, and elsewhere in Latin America. Many of these artists severed personal and professional ties with Cuba as they started over. The combination of a generation that had abandoned the art scene, the lack of resources, the stagnation of the country, and censorship led to a situation that many referred to as a period of silence in Cuban visual arts.

One way in which critical art was kept alive in the public sphere at this time was through rumor. Particularly in the early 1990s, fear of censorship moved some of the most provocative art from the galleries to the streets and private homes. Between 1990 and 1991, Carlos Garaicoa painted the numbers 6 and 39 at various points in the city (see Figure 6). Valdés Figueroa (2001:18) relates that these markings "gained symbolic power over time, altering the rituals of daily life and producing new ones. They functioned

6. Carlos Garaicoa,
Homenaje a 6, 1992.
Biblioteca Luis
Arango, Bogotá,
2000. REPRODUCED BY
PERMISSION OF CARLOS
GARAICOA.

like a street rumor; passersby experienced surprise, and they came up with their own stories of the numbers' genesis." Given the uncertainty of the early days of the special period for artists and ordinary Cubans, rumor was an avenue for self-expression and communication that had no parallels in the official art world.

Tania Bruguera also sought to produce art that could be inserted into reality. Bruguera put out two issues of a newspaper in 1993 called *Memoria de la Postguerra* (Postwar memory), which brought together writings by Cubans inside and outside of Cuba. According to a note in the first issue, she called the period "postwar" because of "its similarity to the physical state of the city, the inner being of the people, the social status of art." Lillebit Fadraga Tudela (2000:66) relates that after the second issue, in 1994, Bruguera was summoned by the highest leadership of the National Council of Plastic Arts. The leadership began by criticizing the aesthetic character of her work: "The direction cited her supposed violations: the invalid use of state resources, the illegal distribution of subversive propaganda. The censors were most disturbed by her gathering together artists, until now mostly disparate, including those outside Cuba, who until now had not made contact

with Cuba" (Fadraga Tudela 2000:66). The council banned the newspaper, but it continued to circulate clandestinely. People photocopied the paper and distributed it by hand. Even though it had a small print run, the power of rumor and illicitness enabled the paper to reach a fairly wide audience. For Bruguera, the newspaper did have an impact: "At the time there wasn't a single art magazine," she told me, "because there was no money. But five months after I put out *Memorias*, many other journals began to come out, like *Artecubano*, and a lot of other journals." [2]

Some artists of the '80s generation who continued to live and work in Cuba also sought to keep the traditions of public art alive. Two of these artists were Lázaro Saavedra and René Francisco Rodríguez. In 1989 Rodríguez started up an artist collective with a group of students at the Instituto Superior de las Artes (Higher Institute of Arts, ISA), known as Desde una Pragmática Pedagógica (From a pedagogic pragmatism). The aim of the group was to develop radical new methods of teaching pedagogy, where students became the professional colleagues of the professor. [3] Desde una Pragmática Pedagógica started a project known as *La Casa Nacional* (The national house): they lived in *solares* (tenements) with the regular residents and used their artistic skills to create the living spaces the residents wanted. In 1992 the group was revived as the Departamento de Debate y Exposiciones (Department of debate and exhibitions). This time it brought together such artists as Carlos Garaicoa, Chino, Jaqueline Brito, and Fernando Rodríguez, who are now well established both in Cuba and abroad. One of the Departamento's activities was to organize public debates about what had happened in the 1980s. In 1992 René Francisco Rodríguez organized a workshop to re-evaluate the viability of the '80s generation's strategies in the special period (Tonel 1998:65). Rodríguez told me, "It was a time when no one wanted to know about the '80s, the institutions avoided talking about the '80s, the artists had gone and the institutions wanted to end the whole business. For these young artists, the '80s were like a big wall that they couldn't see over." [4] In the wake of the violations and repression, artists felt a need to analyze what had happened so they could get back on their feet and recover a critical perspective.

The series of clashes between artists and the state in the late 1980s and the subsequent exodus of artists had an important effect on the state's ability to negotiate and incorporate critical art in the 1990s. Bruguera de-

scribes the 1980s as a time when artists had greater access to power, largely because of the influence of Marcia Leiseca: "Leiseca believed in giving artists access to power, and she opened a small space for artists. For the first time artists and the state worked together to devise cultural policy." As artists became more daring and bold in their cultural expressions, the level of tension increased: "In the 1980s they had their feet on our necks, it was a time of machista confrontations, meanwhile they learnt, everyone learnt, the artists and those in power." The degree of censorship made clear to the artists the limits of acceptable criticism and closed certain avenues of free expression that had been available to the artists of the 1980s. As Bruguera characterizes it: "If in the 1980s there had been a 'collaboration' with the government to create things, in the 1990s there was an 'understanding,' which is different because it is not the same access to power, it is more passive and submissive." There was not the same level of confrontation and censorship in the 1990s, because both artists and the state understood the rules of the new game. Artists tended more to self-censorship, to stay within the boundaries of acceptable criticism. The state has become more sophisticated in its dealings with artists. Bruguera said that while the cultural officials of the 1980s were bureaucrats and party militants who understood little about art and "would refer to some law of 1964," in the 1990s these officials were people who had been trained in art history and knew how to talk with artists about art.[5] The state was in a better position to co-opt and incorporate critical activity as a result of experiences during the 1990s, and artists also adapted their approach and their work in order to continue their access to power.

The New Market Conditions of Production

The visual arts were revived after the exodus of the early 1990s largely through the production, distribution, and exhibition of Cuban art in international circuits. Before the 1990s, Cuban artists had fewer opportunities to exhibit and sell their work abroad because of the U.S. embargo and the restrictions imposed by the Cuban government. When intercultural exchange took place in the 1970s and 1980s, it was mostly with the Soviet Union and other countries of Eastern Europe. After the collapse of the Soviet Union, these barriers began to break down. In 1988 the U.S. Congress amended the embargo to allow the exchange of informational materials. But accord-

ing to Sandra Levinson, director of the Cuban Art Space at the Center for Cuban Studies in New York City, the official description of "informational materials," did not include original Cuban art.[6] Levinson and the Center for Cuban Studies, as well as the lawyer Michael Krinsky and the critic Alex Rosemberg, were part of a successful lawsuit brought by the National Emergency Civil Liberties Committee against the U.S. Treasury Department and the Office of Foreign Assets Control in 1991. After the lawsuit, the importation and sale of Cuban art was legalized, and artists and curators began traveling back and forth between Cuba and the United States.

In the first years of the 1990s it was illegal for Cuban artists to receive payment for their works in dollars, but a resolution passed by the Cuban government in 1993 established their right to receive payment in convertible currency for works they sold abroad (Monzón Paz and Vázquez Aguiar 2001:67). Visual artists could now establish direct relations with international galleries, collectors, and institutions for sale of their artworks and for residencies, tours, and exhibitions. Partly as a result of these new commercial relations, Cuban galleries became increasingly independent of the Cuban Collective of Cultural Properties (Fondo Cubano de Bienes Culturales, FCBC), which had previously administered all matters pertaining to sale and promotion in galleries and had been the sole distributor of visual arts and crafts in Cuba and abroad (Monzón Paz and Vázquez Aguiar 2001: 64). New state-managed galleries sold Cuban artwork to foreign buyers for dollars; the artists received up to 70 percent of the sale price and the remainder was retained by the state (Hernandez-Reguant 2002:358). In addition, deals outside the gallery became much more frequent, as they did not commit the foreign dealer to a binding contract, and prices were generally lower (Monzón Paz and Vázquez Aguiar 2001:68). The ability to negotiate directly with foreign parties was a unique privilege accorded to certain sectors of the artistic world, such as prominent visual artists, musicians, and writers, who became financial and symbolic assets to the state.

Art exhibitions are an important means of exchanging artworks for hard currency. The international exhibition of contemporary art known as the Havana Bienal brings many Cuban artists in contact with foreign curators, artists, and buyers. The Bienal was first staged in 1984, and its numbers and prestige have been growing since then. Holly Block, director of Art in General in New York City, told me in 2004 that some hundred visitors from

the United States attended the 1994 Bienal and six years later that figure had grown to about three thousand. Like the annual book fair, which, as Esther Whitfield (2002:344) relates, is besieged by foreign agents and publishers who are "hoping to sign up the newest darling of the *nuevo boom*," the Bienal is a marketplace for both collectors and artists. The Bienales have generated numerous opportunities for Cuban artists in the United States and elsewhere. In 1997 Block organized a National Residency and Exhibition program in the United States, which was a collaboration between five Cuban artists and six partner sites, with support from the Cuban Ministry of Culture, the U.S. Interests Section in Cuba, and the U.S. State Department (Block and Hertz 1997:5). Gary Garrels, Marilyn Zeitlin, Dan Cameron, and Rachel Weiss also began introducing Cuban work into the United States.

As art comes to generate important flows of money among world capitals, private investors have arrived on the scene. Mari Carmen Ramírez (1996:30) points out that these "entrepreneurial collectors" have increasingly taken over the role of art patronage that used to be played by national governments. Ramírez identifies these people as the Latin American neoliberal elites; in Cuba they are the predominantly Cuban-American and Latino entrepreneurs who return to Cuba to position themselves for openings in the market. One of these entrepreneurs is Manuel González, director of the art program of the Chase Manhattan Bank in New York. González described his role in the early Bienales, teaching the organizers basic financial management skills: "My role was peculiar. It was like Capitalism 101 — how to underwrite an exhibition, because they had no idea. . . . It was like the airlines, the minister of tourism, the City of Havana, and how to get the whole thing underwritten either by cash contributions from embassies and corporations or by trade between hotels in Havana and the Bienal."[7] Given their greater experience in finance, accounting, and business, entrepreneurial collectors are well placed to negotiate transactions on behalf of artists and the state.

The renewed interest of foreign collectors and curators in Cuban art is partly related to what the Chilean cultural critic Nelly Richard (1996a:137) has referred to as the "international circulation of postmodern notions of 'difference,'" where the periphery can respond to the center only "through a series of communicational standardizations that cut and paste the available information in the way that all international models are prepared for

consumption and reproduction." As in film and rap music, Afro-Cuban religious symbolism and religious imagery have become highly marketable in the international art world. Cuba has become attractive to international art curators because of its exotic locale and a sense that it contains a wealth of talent and culture waiting to be exploited. This can be seen in the arts section of the *Time Out* guide to Havana, where Holly Block declares that "the fruits are ripe for the picking" and that visitors are being "lured by the thought of uncharted territory (not to mention unmined gold)" (Block 2004:145). The expectations of global curators impose new constraints on the production of visual arts. In 2002 the artist and cultural critic Tonel told me:

> With the market come certain expectations and certain desires; this demands an art that meets these expectations and desires. Collectors come searching for a canvas, a painting that goes well with the furniture in their house; their intentions are more decorative. Or in the way the object is made, it conforms to certain notions about what art is, and often these notions are very conservative. And this type of collecting is promoting a kind of production in Cuba that tries to satisfy it.

Besides the collectors who look for "well-made" art, there is also a public for what Mosquera calls "airport art," or art that caters to the tastes of tourists. In Old Havana several "art galleries" display paintings of vintage cars, bodegas, dancing mulattas, palm trees, and cartoon depictions of the old buildings and twisted streets of Central Havana. Artworks are also focused on Afro-Cuban religious culture; religious practices such as Abakuá and Palo Monte are offered as symbols of Cuba's uniqueness (Miller 2000:177).

Tourism and the international art market have encouraged the production of artwork and crafts that cater to those markets, and the promotion of individual artists has assumed unprecedented importance. A few highly mobile visual artists have access to sums of money that most Cubans can only dream of. An article in the online magazine *Art and Antiques* reports that in November 2003 a foreign visitor paid Sandra Ramos nearly $10,000 for some of her paintings.[8] Since the average Cuban's income is between about $15 and $25 a month, it is not surprising that, as Block says, most visual artists with transnational connections are seen as members of the upper middle class.[9]

As more established artists move up and out of Cuba, the visual arts

movement is being sustained by those artists who remain working in Cuba. Whereas transnational artists focus on gallery exhibitions, paintings, sculpture, and photography, arts students take art into the streets, much as the '80s generation did. The presence and reach of a visual arts movement have also created public spheres of critical discussion and activity related to art. These public spheres still include galleries. Camnitzer (1994:118) has reported that regular gallery exhibits usually draw 100 to 400 people to the opening, and then a continual stream of visitors. Galleries are ranked by size and location; the more centrally located and larger the gallery, the better for the artist. The First Bienal drew a total of 200,000 visitors and the Second Bienal drew more than 300,000, fairly significant numbers in a city of two million people. The multimedia artist Roberto Diago notes that while the Saõ Paulo Bienal is still quite elitist, the Havana Bienal "goes more to the streets, to confront the public with social reality."[10] Moreover, the emphasis, particularly among the younger generation, on public art, performance art, and interactive activities has also been important in making the visual arts part of the lives of ordinary Cubans.

Many art critics and scholars have written about Cuban visual arts in the 1990s, and I do not intend to replicate their scholarship. Rather, following suggestions by the art critic Orlando Hernández, I seek to provide an alternative methodology for interpreting the arts. As Hernández (2005:20) says, to understand the cultural references in Cuban art it is important to understand the culture in which this work is inscribed. "Art criticism should perhaps review its models of interpretation and analysis based on general aesthetic principles. Taking a cue from anthropological fieldwork, art criticism may benefit from adopting ethnographic methods."

Art Collectives and the Reemergence of Public Art

Cultural institutions were not to be "assisted" nor to be denied, but were to be penetrated in spite of themselves, in order to fulfill our goals, in spite of them. These were the terms of a proposed new attitude that used conceptual tools and sociocultural know-how earned by the "new Cuban art" of the eighties. From that was born a strategic sense, expert in manipulations and tricks for slipping in subversive meanings.

Lupe Alvarez

In the 1990s, art teachers and their students began to form cooperatives that sought to incorporate artists in state institutions, revive the value of

collectivism, and negotiate with cultural and political leaders. These co-operatives had an important influence on the new visual artists who gained international prominence later on, such as Garaicoa and Bruguera. They were reinvigorated in the late 1990s among younger visual artists, particularly in response to the growing commercialization of art.

In 1997 there was a movement among students to return to the idea of public art. René Francisco Rodríguez helped to organize DUPP, a group that included such artists as Wilfredo Prieto, Joan Capote, Inti Hernández, and Juan Rivero. Until then, Rodríguez told me, the younger artists had been looking mainly to the international art market with hopes of working abroad. With DUPP, artists turned their attention to the development of cultural life in Havana, reviving the idea of collectives and working in public spaces.[11] In 1999 another group of students from ISA began putting out a magazine. Lázaro Saavedra entered ISA and with his experience in performance and art collectives helped the students to form the group ENEMA. Given the costs of materials for traditional artistic production, ENEMA decided to work with their bodies in performance.[12] Another group, Departamento de Intervenciones Públicas (Department of Public Performances, DIP), emerged later with the intention of working in the city and in open spaces, away from institutions and galleries.

The return to public art in the late 1990s has come largely in response to the increasing hegemony of the art market in Cuba. According to Rodríguez, the agenda of groups such as DUPP was to revitalize the political thrust of art against the restrictions placed on artists by commercialization: "We propose somehow to rescue the spirit of the 1980s, this transgressive spirit, committed to social contexts, committed to the necessity of speaking out, and not thinking so much about how I can make my next work so it will sell, but how I can construct my next work so it will communicate with the public. We want to break with this commercial art that's increasingly empty and cold."[13]

Rodríguez sees the art market as dividing people by making them compete for foreign funding and invitations to show their work abroad. He argues that the aim of groups such as DUPP is to reintroduce the idea of "working in the city, making a connection with people, with us ourselves. Instead of going abroad, come back."[14] At a time when artists are being enticed by the promise of overseas travel and individual enrichment through

participation in the art market, the universities and groups such as DUPP encourage artists to preserve an ethos of collectivism and help the younger students to become socialized with these values. DUPP was formed at a time when artists were preoccupied with personal survival in the special period, the art student Ruslan Torres pointed out. "Galería DUPP started the process of dialogue, communication, and forming collectives." [15]

The current revival of collectivism is based strongly on a notion of self-knowledge and personal exploration. Rodríguez said that organizing collectives among his students helped him to understand himself: "It's a means of investigation, a way of knowing myself better as an artist, for them to know themselves better, and above all to learn more." Such an interpretation of the collective relies on an understanding of how communities sustain individual growth. "DUPP revived the idea of working in public contexts, the idea of developing the personality of each individual with the help of everyone in the group." [16] Like the filmmakers who seek to reformulate ideals of collectivism through a focus on individual introspection, visual artists see renewed individuality as crucial for collective growth. Such a community-based vision is parallel to developments in the West, where, as Casey N. Blake (2002:55) argues, artists began to "consider themselves members of a 'community arts movement' rooted in local ethnic and geographically based constituencies." Members of art collectives in Havana see these values of community and individual self-cultivation as contrasting markedly with the ideas of individualism being introduced by the art market. Lino Fernández, a member of ENEMA, emphasized that the focus on collectivism helped to overcome some of the negative tendencies of atomization and individuation generated by competition: "Working as a collective challenges the idea of work as an individual act that's done at a certain time for a certain public. The work of any one of us rejects the idea of the author and challenges the idea of performance as something that can't be repeated." [17]

The young artists working in collectives seek to negotiate much more with state institutions than earlier generations. In 2000 ENEMA decided to curate a show of male transvestites within the ISA. Transvestites have generally been an invisible and marginalized group in Cuban society. Although they acquired a somewhat higher profile in the 1990s,[18] transvestite performers are still excluded from mainstream institutions and venues. The

members of ENEMA decided that transvestite performances should be recognized as a valid form of artistic expression, and this was the argument they put to the department heads of ISA. "The main problem we faced," Fernández explained, "was that ISA was an academic institution, and they didn't permit anything they didn't consider art to be presented in an academic institution. But it was precisely with this in mind that we made this proposal—it was to demonstrate that there were other ways of making art. Many of them had never seen a drag show, so they were judging it without knowing anything about it. We were looking for confrontation and debate." In the end, ENEMA was given permission to put on the show, and according to Fernández, they attracted a large public that went "with great expectations of debate, of confrontation and cultural analysis of the social juncture in which we are living." [19] Male spectators were quite taken with the feminine beauty of the performers, and after the show there was a long line of people seeking autographs. Another member of the group, Adrián Soca, said that heterosexual male spectators were attracted to the performers as women: "How pretty they are!" they said; and heterosexual women were attracted to them as men: "They're gorgeous!" [20] Yet at the same time, all the spectators were well aware that they were looking at men in drag. The show at ISA enabled gays to become visible and ordinary Cubans to examine their own ideas about gender and sexuality.

But even more than the actual event, ENEMA's confrontation with ISA was an important experience for the young artists. They were involved in long meetings with ISA's top directors in their ultimately successful efforts to convince them that they should allow a transvestite show within the institution. The shift from rumor and underground networks as the site of artistic production in the early 1990s to staging a controversial and radical performance within a state institution is part of the dynamic of partial reincorporation in which visual artists and arts students have begun to participate.

The incorporation of previously underground or unofficial practices in state institutions can be seen not only in forms such as rap music and art shows but also in artistic expressions such as tattoo art. Until very recently, *tatuadores*, or tattoo artists, much like early hip-hop artists, were part of the life and culture of distinct barrios. They worked in makeshift home studios in places such as Vedado, Víbora, Cerro, Marianao, and Alamar. These tat-

too artists created local styles and motifs that developed in conversation with tattoo artists from other barrios, with themes of international tattoo masters, and drawing on the history of Afro-Cuban religion, which forms the spiritual base of much tattoo art (Véliz 2001:77). Tattoo artists have always had an uneasy relationship with state authorities, because they work in unofficial channels and because among their most popular designs are the American flag, the Statue of Liberty, and other symbols that undermine official anti-American rhetoric.

But in recent years tattoo artists have also come to be incorporated in state institutions and independent art networks. Ben Corbett (2002:212–213) reports that in the mid-1990s, seven of the most prominent tattoo artists in Havana formed an association known as Lienzos Vivientes (Living canvases) and joined the visual arts section of the Youth League. In 1995 these tattoo artists helped organize the first national tattoo exhibition in Havana. Ironically, a tattoo of the U.S. flag won first prize in the tattoo competition. When a Miami newspaper published an article about the tattoo competition, scandalizing the Cuban government, the artists were subject to inspections by the state. One of the artists, Yovany, retorted to the inspectors, "The writer was a nobody making propaganda against Cuba and we had nothing to do with it. . . . This particular tattoo won because it was excellent work, the line quality, the shading, not because we're counter-revolutionary." Events in 1996 brought further prominence to tattoo artists: TatuArte, an exhibition of tattoo models in the Patio de María, and shows at an independent exhibition hall run by Sandra Ceballos, known as Espacio Aglutinador; and individual and collective shows at local *casas de la cultura* (cultural centers) in Alamar (Véliz 2001:77). Incorporation in public and state venues gives artists more exposure, but it also makes them all too visible to public officials.

Part of the reason why artists are able to negotiate with the state is that they can defend their work as art rather than politics. After launching their newspaper self-titled ENEMA, the group brought out several issues of the paper. At the Havana Bienal in 2000, ENEMA presented their video of a news broadcast called NOTINEMA, modeled on Cuba's only television newscast, *Noticieros*. NOTINEMA presented ENEMA's actions and performances as a way of disseminating information about the group through a mass medium that is a state monopoly. Artistic collectives have at times taken

on the function of what Rodríguez called "micro–ministries of culture," becoming institutions for promoting and disseminating art themselves. Visual arts in the 1990s have been able to function somewhat in parallel with official media and political institutions, providing an alternative space for critical views and debate.

Negotiation with the state can amplify the scope of what is possible in cultural politics, but it also helps to delineate the boundaries of what is officially permissible. Two pieces shown at an exhibition by Wilfredo Prieto of DUPP at the state-run Centro de Arte Contemporáneo Wilfredo Lam (Wifredo Lam Center of Contemporary Art) in 2002 were deemed offensive by the authorities. One piece, *Papel periódico y papel sanitario* (Newsprint and toilet paper), consisted of a roll of toilet paper made out of the newspaper *Granma*. The other piece was a video of feces moving clockwise around a toilet, titled *Planetas* (Planets). Officials of the Ministry of Culture and the Ministry of Foreign Relations found the *Papel periódico* piece offensive because Fidel Castro's name was on one of the pieces of newspaper on the roll of toilet paper. Prieto refused to remove either piece, saying he would withdraw the entire exhibition if those pieces were banned. He argued that the *Papel periódico* piece was making a statement about the real lives of most Cubans: they have no toilet paper, so they make do with *Granma*. After several discussions between high-level bureaucrats and artists intervening on behalf of Prieto, the pieces were allowed to stay. When the minister of culture visited the exhibition later, he praised it as a powerful tribute to the revolution.[21] The political leadership has come to realize the political benefits that accrue from identifying with critical art even as its censorship warns other artists of the limits of what is acceptable.

Contemporary visual artists seem to be preoccupied with the scatological. Such works as Prieto's pieces, the name of the group ENEMA, and earlier Delgado's defecation on a copy of *Granma*, as Valdés Figueroa (2000) notes, reflect the growing popularity of the scatological in the international art of the 1980s. A pioneer of scatological imagery in Cuban art has been Tonel, with drawings such as *El vómito es cultura* (Vomit is culture), shown in the artist's home in Havana during the 1991 Bienal in an exhibition titled *La Felicidad* (Happiness) and *Orinar con estrellas* (Pissing with stars), exhibited in the state-run/commercial Galería Habana in 1994. Valdés Figueroa (2000:39) sees the secretions and incontinence of Tonel's characters as

showing "traces of their insecurity, fears, and evasions," which are hidden in trivialities and displaced to other places. Following Peter Stallybrass and Allon White (1986), I further interpret these continual references to excrement as transgressive of the norms of official "cultural" circles, which seek to dissociate themselves from the vulgar and the bodily. While Stallybrass and White are concerned with eighteenth-century British bourgeois society, and hence the class boundaries being policed by such exclusions of the "other," I read these references in Cuban visual arts as critical of a form of revolutionary morality that seeks to preserve itself from contamination by outside influences. The frequent association of *Granma*, an official propaganda organ, with feces is an attempt to defy the strictures of revolutionary purity and acknowledge bodily processes, marginality, and the impure. The work of Delgado and Prieto draws the ire of officials because it threatens to disrupt the neat categories through which social life is ordered, contained, and policed.

Some artists have been able to create space for their critical art through negotiation with state institutions, but others do not seek permission for their bold acts. The group DIP has carried out several performances in public space to highlight questions of power and surveillance. Ruslan Torres, a member of DIP, described DIP's concept of power and its contrast with that of the '80s generation: "For the '80s generation it was very political to use an image of Fidel Castro. We don't talk so much about Fidel Castro, we talk about power. We are more interested in the psychological, because when you address the psychological aspects of surveillance, you're talking about politics in a much stronger form than a painting that says, 'Down with surveillance,' as in the 1980s. I think Cuban art never stopped being political; what has changed is the form."[22] DIP's Foucaultian concept of power contributes to the group's ability to evade censorship: when power is seen as dispersed, it can be confronted in the psychology of individuals and thus is harder to police. One of DIP's actions was to create identity cards inscribed with the group's full name, Departamento de Intervenciones Públicas, in order to test the way officials control public spaces. The members of the group produced these cards whenever they were stopped by the police, and the cards looked so official that the police let them pass.[23] Producing the cards is both an act of empowerment for young people who are constantly harassed by police on the streets and a means of demonstrating how authority and control operate.

DIP chose 4 July 2002 for another public performance, exploring how ordinary Cubans respond to official mandates. On that day Cuban-Americans had threatened to send boats to Havana to bring Cubans to Miami and police were posted on the Malecón. DIP sent citations to people whose names they chose at random from the phone directory, ordering them to be at the Malecón at a particular time. According to Torres, no one knew what was going to happen on 4 July or why they had been summoned to the Malecón. Suspicion and tension were palpable when a large group of people arrived at the Malecón in response to the false citations. The action was an indictment of citizens' obedience to official mandates, but it was also a demonstration that state power can easily be usurped.

Artists may also be able to exercise a degree of critical agency because they can access the market and transnational networks. Young visual artists find themselves in a situation similar to that of underground rap musicians; although they are critical of the foreign art market, they seek ways to use it. Visual artists have become streetwise; now that they are aware of their own personal needs, their situation is quite different from that of the artists of the 1980s, who had more access to state funding. Members of ENEMA told me they aimed to make their own serious work commercially viable, and hoped that eventually they could finance their work through sales of their works, such as their video NOTINEMA.[24]

Many people who produce art for sale to tourists do so as a way of financing their more serious art projects, engaging in what Mosquera calls "artistic jineterismo."[25] Most young artists, he said, have a schizophrenic attitude toward their participation in the tourist market. With the money they make selling "airport art" they buy a video camera to make sophisticated avant-garde art and see no contradiction in what they are doing. Torres confirmed that young artists are aware that they are devaluing their own work by selling stock images of bodegas and Chevrolets in the Plaza, but they accept these contradictions with great cynicism.

Public Performances and Daily Life

Public performances have proved particularly useful at a time when the economic crisis, the growth of tourism, and the functioning of a dual economy produce contradictions for many Cubans. Artists seek to bring about awareness of the increasing gap between official socialist values and the realities of life in the special period, rather than to resolve those differences.

As we have seen, the revolutionary values of work and labor are no longer valid for most Cubans. The dynamics of "earning" and "buying" are central to Western capitalist countries, but consumerism is foreign to people in socialist countries, as they usually receive their basic necessities at little or no cost from the state. As Caroline Humphrey (2002:44) has noted in her ethnography of Russia in the post-Soviet period, "the sovereignty of the Western shopper, enticed to wander and inspect, to titillate desire, to take pleasure in the whole process—that is, shopping promoted as a leisure activity—had not occurred and seemed indeed far from Russian reality." In a socialist system modeled on the Soviet Union, people consume what the state distributes. Any income they receive is of minor significance, because in "economies of shortage," the Hungarian economist János Kornai's (1980) term for socialist economies, little is available to spend it on.

In pre-1990s Cuba, the average income was about 180 pesos a month (Ritter 1998:75). But at that time one peso was equivalent to about U.S.$1.25 (Rosendahl 1997), so a salary of 180 pesos was around $225 a month, although since the economy was not based on the dollar, the conversion was largely irrelevant. Since basic necessities were taken care of, Cubans had a fairly large disposable income. Fancy clothes, television sets, cars, and other luxury items were not readily available on the market, but smaller luxuries were. It cost an ordinary Cuban 15 pesos a night to stay in the five-star Havana Libre hotel or the Meliá Cohiba by the Malecón, and 10 pesos to eat in a fancy restaurant downtown. For about 100 pesos, Cubans could vacation in Varadero or Viñales, popular resorts. Many Cubans have fond memories of those days before the special period. My friend Felicia told me that she and her husband used to come once a month to stay in the Havana Libre. Now those rooms are occupied by foreign tourists who can afford the $120-per-night rate.

With the onset of the special period, inflationary pressures caused the peso to rise to a brief high of 150 to the dollar in the summer of 1994 (Ritter 1998:76), gradually returning to about 21 to the dollar in 2000–2001. As incomes did not rise, their value was dramatically reduced. Since state-provided goods and services were severely affected, Cubans actually needed to buy the goods that were no longer available on the ration, but in a dollar economy they could not afford them. In July 2002, in a regular store selling household fittings and appliances, a fully automatic washing machine cost

$495, while a machine without the spin-dry function cost $195. Materials needed for building bathrooms and kitchens were quite expensive. A stove-top was around $120. A toilet bowl cost $40, and a tub anywhere from $150 to $200. With soaring inflation, the automatic washing machine would be the equivalent of 10,395 pesos, three times the average yearly income. At 840 pesos, even a toilet bowl was beyond the reach of most Cubans. Families must now pool their incomes to pay for such daily household necessities as oil and meat, which are difficult to obtain through the ration cards. In this absurd situation, Cubans cannot "buy" the goods and services they need; they "resolve" or "deal with" them. "¿Has resuelto tus cosas?" (Have you dealt with your business?) is commonly heard in Cuba.

"Dealing with" one's business usually involves buying things on the black market, where they can be paid for in pesos rather than in dollars and at a lower rate. It also involves drawing on informal networks in the workplace and among friends to get things done. I took a taxi to my friend Yaquelín's house in Central Havana one day, and the moment we pulled up outside her house, the taxi driver was accosted by a group of young men trying to sell him various items, but he wasn't interested and drove off. When I told Yaquelín what had happened, she pointed to the department store across the road, selling household appliances. Nobody can afford to buy anything there, she said, so the employees steal things and then sell them to the hustlers on the street, who resell them at a markup; the price is still much less than the store is charging. Although Yaquelín is an active party member, these goings-on did not seem to offend her. In fact, she said that she was renovating her bathroom and she had to remember to ask downstairs if they had a toilet bowl available. Another friend, Lydia, said that if she has the money to buy something she needs, she buys it in a store because she feels it's wrong to steal and cheat the government. For instance, she desperately needed a washing machine for her large family, and since she had managed to save up $200 from her job as an English translator for groups of visiting Canadians, she bought the cheapest washing machine in the store rather than get a better one on the black market. Lydia still has to spend a lot of time wringing out the clothes, as her machine doesn't spin them dry, but she feels more comfortable buying things legally. However, Lydia did admit that it's not often she has dollars, and most of the time she, too, has to resort to the black market.

Personal networks also constitute an important way of dealing with one's business. Sara and Cristina, sisters, are in the process of renovating their house, and since neither of them has an income in dollars, they must rely on the black market and informal networks to get the job done. When I returned to Cuba in July 2002 after being away for nearly a year, I noticed that Sara and Cristina had a completely new bathroom, windows in the kitchen, partitions in the bedroom, a new front door, and new tiles on the roof. Cristina's boss is an engineer in charge of construction materials. "He knows my situation," she said, so he provided her with cement and new tiles for the roof. But such arrangements can't be counted on. Changes have been made in her workplace, and the new manager is someone Cristina does not know, so she is unlikely to get any more materials this way. Sara and Cristina have a friend who is a builder, and he has done most of the construction without charge. The builder friend is a lonely older man who likes female company, so he would spend the weekends working on their house, and every fifteen minutes he would take a break and the women would ply him with coffee, rum, and attention. In the course of a year he had done a significant amount of work on the house. Many Cubans point to friends, family, and professional networks as the most important means of dealing with their business.[26] They never have to be afraid that they will end up on the street, they say, because there are enough people looking out for them.

It is widely acknowledged that the black market is necessary for survival, but officially, of course, it doesn't exist. Humphrey (2002:62) notes that in the Soviet Union, "the Soviet person was ideologically constituted as legitimately producing and consuming only within the state sphere." Similarly, in Cuba, official rhetoric continues to promote a fantasy of the benevolent, providing state, and black-market activities transgress revolutionary morality. On the evening news one night there was a report about a couple who had been arrested for secretly manufacturing and selling shoes from their house. Among the goods that were confiscated were bags of shoes and more than 20 million pesos. Typed reports appeared on the screen with information about the couple and people who had helped them. At the end of the report a voice-over stated that the Cuban people would continue their fight against illegality. Most of the Cubans watching the report with me knew the couple and had bought shoes from them for years. For such a racket to be carried on under the nose of the government for so long, either

the customers and all the people who sold the couple their supplies formed a close-knit group or officials were being bribed, or both. Despite the official talk of "illegality," most Cubans do engage in black-market activities.

Visual artists aim to expose these contradictions and provoke public acknowledgment of the black market. In 1999 the artists' collective DUPP organized a public performance in a large department store, La Epoca, in Central Havana. La Epoca has a grocery department in the basement; cosmetics, toiletries, and stationery departments on the first floor; an electronics department on the second floor, selling televisions, videos, and stereos; a furniture department on the third floor; and an appliance and housewares department on the fourth floor. The store is always full of people who come to look at the items and fantasize about owning them, but few Cubans can actually afford the prices. DUPP's public performance involved turning the department store into a museum, because, according to Wilfredo Prieto, "in La Epoca everything is sold in dollars, but people don't have dollars, so how do you buy in dollars?" For the members of DUPP, department stores in Cuba are like museums because people go there only to look, not to buy. The DUPP members stationed themselves throughout the store, interfering in the selling and buying processes. One of them made announcements over a speakerphone, promoting the various exhibits. Others were strategically placed in the windows as living models. In a textile display, the artists put labels on the fabrics as if they were exhibits in a gallery. Some people had come to see the performance, as DUPP had advertised it all over the city, but many people had come just to see the store's offerings. Prieto claimed that the idea was not to break up the store's commercial activities, but rather to make the people aware of the absurdity of what was happening in the store.[27]

Other visual artists also intend to confront people with the contradictions that they live. In 1999 Manuel Piña created a series of placards that he called Labores Domésticos (Domestic labors). On one placard is an image of a hand signaling stop and next to it the words "Stop! Enough of this stupidity. You can't be such a shit-eater. STEAL!" The placards were part of a catalogue for an exhibition to be held in Tirana, Albania, but the exhibition was canceled for lack of funds. Piña's placards were then supposed to be part of an exhibition in the II Salon de Arte Contemporáneo in Havana, but they were censored. Many people were able to see the placards before

they were censored because so many people were involved in organizing the Salon exhibition and because the Tirana exhibition catalogue had circulated widely in Havana. The placards appear quite aggressive; Piña calls them "shock therapy," forcing people to confront themselves rather than hiding behind false values and ideals that no longer make sense. Piña's shock therapy can be seen as what Raymond Williams (1977:212) calls "confronting a hegemony in the fibers of the self." According to Piña, it is important for Cubans to rethink their moral framework rather than live in two distinct realities. Stealing may have been undesirable and morally unethical before the special period, but it has come to be the only means of alleviating critical shortages.[28] Many people pay lip service to honesty while hiding their loot under a blanket.

The act of censorship again illustrates the relationship between repression and incorporation. Unlike the transvestite show put on by ENEMA, which related to the cultural visibility of homosexuals in Cuban society, Piña's placards spoke to the falsity of official discourse, a much more sensitive theme. Although most people do hustle and derive income from sources other than their official jobs, their experiences remain outside of official representations of Cuban life and culture under late socialism. The state has always feared that an open acknowledgment of the falseness of official rhetoric will pave the way for a more widespread systemic collapse. As Slavoj Žižek (1993:234) says, all it takes is a moment, a couple of seconds, for the spell to be broken. The revelation of the vulnerability of power can have a spiraling effect. Piña said that his shock therapy placards should be limited to underground networks, because if they were to be placed out in public, they might incite people to overtly flout the state's authority, and that was not his intention.[29] Whether or not Piña made this claim as a way of protecting himself, the reality is that exposing contradictions in state ideology is a more radical act than seeking to resolve those contradictions. Piña's work spells out the limits of a strategy of incorporation, as some ideas must be repressed and silenced in the public sphere.

But in such cases, censorship could actually encourage other kinds of discussion and public debate. Given the limitations that exist for artists such as Piña, underground showings may be the only way that some of his work can be seen. In July 2002 I attended an exhibition at the state-run Centro de Desarrollo de las Artes Visuales on the theme of art and the

environment, where the works of several prominent Cuban artists and art collectives were being displayed. When I arrived I was told that the opening had been delayed, and people were looking frustrated. When we were finally permitted to enter the gallery, we were informed that the president of the National Council of Plastic Arts had come to see the pieces and had censored two of them, including one by Piña. Despite the hushed, subdued atmosphere of the opening, there was a buzz about what had happened, and as each person stopped to greet friends and colleagues there was an intense whispered exchange about what had happened. People gave their own versions of the events, adding whatever extra information they knew, and if they were familiar with the piece, they gave their own evaluations of it. Piña was surrounded by people, all asking his opinion of what had happened. I found myself caught up in the speculation, the aura of illicitness, and the power of knowing what others might not know. As I stopped to talk to people and tell them my version of events, each time I changed the story slightly to add a little drama, pleased with the power I had over my captivated listeners. The conversations went something like this:

> **Person A to me:** Did you hear? Piña's piece was censored, that's why we were all waiting outside so long. Another piece with a flag in it was also censored.
>
> **I to person B:** Piña's piece was censored, they say there was something with an image of police or state security. A piece with the Cuban flag was also taken out.
>
> **Person B to me:** I heard it was the director of the Consejo Nacional himself who came and censored the pieces. What did the flag piece symbolize?
>
> **I to person B:** I think it was a comment on how nationalist rhetoric manipulates people.
>
> **Person B to person C:** There were two pieces taken out, one that talked about police and state repression, particularly in the special period, and another that looked at the problems and difficulties with nationalism and state rhetoric.

All this time the pieces that were actually in the exhibition were being overshadowed by the censored pieces. Reflecting on the events later, I realized that the censored pieces received more attention by being removed from the exhibition than they would have had if they had been exhibited. The event showed that rumor is indeed a powerful method of dissemination. The truth value of the rumors lost its importance as the discourse that was being constructed took on strategic functions of its own. Roger Lan-

caster (1992:74) sees rumor and gossip as a medium by which "actors engage themselves in the social world, negotiate their multiple relations with others, formulate and justify their courses of action, and thereby, little by little, reconstruct the world." Although Lancaster perhaps underestimates the ways in which gossip is situated in and also shaped by relations of power, he conveys a sense of how gossip and rumor can act as a form of semipublic discourse.

Cultural *Cimarronaje*: Racial Politics in the Arts

What many of us do via the arts is cultural cimarronaje. When Tosca sings, it is not a song, it is a cry; when Nancy Morejón recites with high lyricism, it is an arrow launched by the wind; when Mendive with his painting depicts a figure like Oggún, it is also a way of saying, "We are here"; when Chucho Valdés calls his disc Yemayá, it's a way of saying, "We are here." What I am doing is something similar to a painting or a rap song.

Roberto Diago, multimedia artist

Alongside the movement of art collectives and public performances that reappeared in the mid- to late 1990s, another kind of cultural collective began to take shape among artists concerned with themes of race and racism in Cuban society. Like rap musicians, Afro-Cuban artists confronted a situation of silence about race issues. Since the gradual disappearance of Grupo Antillano in the 1980s, only a few artists such as Mendive had dealt with issues of race. Ironically, it was the circulation of postmodern notions of difference in the periphery that gave renewed impetus to this theme globally and, as Richard (1996a:138) argues, ideally should have made available "a range of material that can be discussed and reformulated (or rejected) according to local critical needs." The exoticization of Afro-Cuban themes by the global market, combined with the development of folklore tourism and the prioritization of the African presence in the Americas by international foundations such as UNESCO (Ramos Cruz 2000:150), gave a degree of legitimacy to representations of African identity, and Afro-Cuban artists took advantage of these openings to express their concerns. Yet as Richard (1996a:137–138) goes on to argue, the dependency that shapes center–periphery relationships means that in reality these performances are themselves commodified.

The exhibition Queloides I (Keloids I), organized by Alexis Esquivel and Omar Pascual Castillo in 1997, brought together artists who had been work-

ing on issues of race, among them Manuel Arenas, Gertrudis Rivalta, Douglas Pérez, René Peña, Elio Rodríguez, and Roberto Diago, in addition to Esquivel himself. *Queloide*, meaning raised scar tissue, refers to the scars left on the skin of slaves by whippings.[30] The artists involved in the exhibition had a fairly fluid understanding of race as a psychological and cultural construct that can act as both a barrier and a symbol of cultural survival. As Esquivel said to me, "Racial identity can be a refuge for the manifestation of personal identity, a base for individual orientation in an immense sea of cultural possibilities, but at the same time it can be a straitjacket, a jail that restricts free individual expression."[31] Despite the lack of support from mainstream art institutions in Havana, Esquivel went on to participate in another exhibition organized by the art critic Ariel Ribeaux at the end of 1997, titled Ni músicos ni deportistas (Neither musicians nor athletes). The title refers to the social stereotypes that confine the cultural contributions of Afro-Cubans to music and sports.

The pieces in the exhibition spoke to these themes from various perspectives. Esquivel's work draws on the social and political significance of a rope known as the *soga*, which was used to separate whites and blacks at dances. Figure 7 shows the artist tying the rope in knots around his head, expressing the violence of racial discrimination and the restrictions it places on the individual. In the Queloides series Peña presents close-up photographs of scars on black skin, evoking the title of the show in a visceral manner.[32] The marking of black bodies by powerful histories and social stereotypes is a theme of Peña's work. In another of his pieces titled *Cuchillo* (Knife), the replacement of the penis of the black man with a knife is a comment on the fears and myths of black male sexuality. Manuel Arenas's pieces *Carné de identidad* (ID card) and *Cuidado, hay negro* (Watch out for the black man) recall the songs by rap artists in their protest of police harassment of young black men. In *Carné de identidad*, the image of a black man showing his ID card is set against the Cuban national emblem. Arenas told me that the work is meant to represent the irony of the "formal assessment game that directly or indirectly reduces the black man's ability to the strictly physical." The replacement of one of the symbols in the national emblem by a penis dramatically demonstrates the conflation of official documents with the physical body in the game of requesting an ID: "it forces together nationalist and patriotic symbols in the primitive self-portrait of an erect

7. Alexis Esquivel, *La soga maravillosa*, 1999–2001. Performance, Center for Development of the Visual Arts, Havana. Tufts University Collections Selections. REPRODUCED BY PERMISSION OF ALEXIS ESQUIVEL.

penis." In *Cuidado, hay negro*, which recalls the signs often seen in front of houses, "Cuidado, hay perro" (Watch out for the dog), Arenas warns intruders to be cautious: "I position the socially negated individual in a privileged place, endowing him with essential opportunities such as debating and expressing himself."[33] Arenas turns social stereotypes on their heads, employing threatening imagery to reclaim the social existence of the black man.

The exhibitions were provocative because they offered a critique of the notions of race and blackness being fetishized by global markets and the state-promoted tourism industry. According to Esquivel, the exhibitions looked at race relations in Cuba "from a critical and analytical perspective, not only cultural and religious, as they have been traditionally addressed." Esquivel described the general suspicion the artists faced: "This was a theme that art critics in Cuba were wary of at that time, and they still are. Besides, many of the more recognized artists of our generation advised us to abandon the project, as they considered it very risky from a professional point of view. Bringing up these issues raised eyebrows; they accused us of being 'radical blacks,' resentful, and opportunists. They wanted to

avoid airing an issue that seemed to have awakened critical opinions."[34] But at the same time, the exhibitions put the artists on the cultural map and created a certain legitimacy for their work. Ariel Ribeaux's essay on the project was awarded a prestigious prize in a competition held by the First National Biennial of the Theory and Criticism of Contemporary Art and later was published in the journal *Artecubano*.[35] The exhibitions sparked debate on a variety of topics, including the reemergence of racism in the tourist economy, the role of Afro-Cuban culture in generating foreign exchange through a more "dignified" tourism, and the entrusting of cultural promotion to white Cubans, many of whom are ignorant of Afro-Cuban cultural traditions.[36] Queloides both represented and gave rise to a body of art by Afro-Cuban artists who sought to engage with sociopolitical themes of marginality, race, and power.

Elio Rodríguez, one of the prominent artists of Queloides, deals with stereotypes and representations of race in the cultural marketplace of contemporary Cuba. In his series *Las perlas de tu boca* (The pearls of your mouth), shown at the René Portocarrero Silk-Screen Workshop in Havana in 1996, Rodríguez appropriates the iconography of North American movie posters of the 1950s to present contemporary stories. In each of the posters, Rodríguez, a black man, casts himself as the star of the film, making the point that images of blacks were seldom shown. The movie advertisements are sponsored by Macho Enterprise S.A., a fictitious company that Rodríguez created to "comment on the new times we live in, of mixed enterprises, of negotiations, of lies." In one piece in the series, *The Temptation of the Joint Venture* (see Figure 8), Rodríguez depicts the erotic meeting of a black man and a lighter-skinned woman wearing a brightly colored headdress suggestive of a foreigner's idea of the tropics. The desire of black men for mulatta women is framed as a "joint venture," an allusion to the desire of tourists for sexual encounters with Cubans and, as Rodríguez explained, "the coquetry of Cubans with the 'foreigner' at all levels." The joint venture is simultaneously a sexual adventure and a business undertaking: economic negotiations are based in notions of Cuban eroticism and availability. This idea is expressed in another of Rodríguez's pieces, *Tropical*, which depicts a black man flirting with a white tourist (see Figure 9). The revolutionary iconography of the red beret and cigar sported by the black man contrast with the halo of bananas that surrounds his head and his feminine sensuality

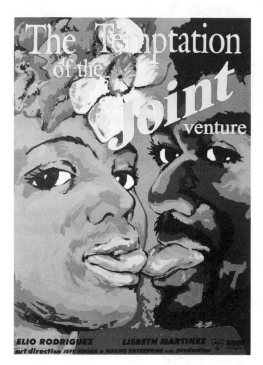

8. Elio Rodríguez, "The Temptation of the Joint Venture," 1996, in the series *Las perlas de tu boca*, René Portocarrero Silk Screen Workshop. REPRODUCED BY PERMISSION OF ELIO RODRÍGUEZ.

as he wraps himself in a white sheet. The caption "I'll wait for you in the dark of the night" and the eerie pair of eyes hidden behind a neon "Tropical" sign underscore the vulnerability of the black man. In his 1998 series of lithographs, *Mulatísimas*, Rodríguez uses nineteenth-century tobacco cases to comment on questions of gender, nation, and tourism today. For Rodríguez, "in the end, the present is no more than a rehashing of the past with new technologies and new strategies, but with the same problems."[37] The modern transactions and negotiations of the special period are determined by the racial practices of the past.

The multimedia artist Roberto Diago presents painting in the form of graffiti. Like rap music, graffiti is an alternative way of writing the history of the city and telling the stories that have been relegated to the margins. For Diago, black history, culture, and voices have been silenced: "Blacks don't have references to our race in the media. When we appear in a soap opera, it's as slaves or servants in white people's houses. In primary education they don't study African stories or speak of the gods that accompanied our slave ancestors who filled this island."[38] In contrast to official national histories, which seek to subsume black identity, Diago's graffiti bring black

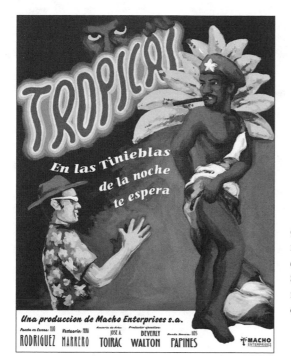

9. Elio Rodríguez, *Tropical*, 1996, in the series *Las perlas de tu boca*. René Portocarrero Silk Screen Workshop.
REPRODUCED BY PERMISSION OF ELIO RODRÍGUEZ.

history to the fore. One graffiti painting produced by Diago in 2002 reads, "Cuba Sí! Fucked. Black 100% My history." Another reads, "My history is your history."[39] Like the shock therapy employed by Manuel Piña, Diago's graffiti demands people's attention and raise the profile of black Cuba in a context where it is hidden and ignored. As Diago said, "It's important for me as a black man and creator to express the reality that official rhetoric doesn't reflect, to show my people that we have our own voice, even though the media doesn't give us space."[40] Diago says he has drawn inspiration from the black artist Jean-Michel Basquiat, less from his artistic techniques than from "his cry as a young black intellectual." In contrast to the "mystical black," Diago wants to show the "social black," "the other part of Cuban life that at times they don't want to show" (quoted in Mateo 2003:24). Like Esquivel, Rodríguez, and Arenas, Diago is concerned with the social conditions of race as lived reality.

After the Queloides exhibition, several of the artists involved began to create performances and exhibitions in public spaces. During the 2000 Bienal, Esquivel created a performance in the Plaza Vieja, the historic center of Havana, called *Acción afirmativa* (Affirmative action). In the perfor-

10. Alexis Esquivel, *Acción afirmativa*. Performance at Plaza Vieja, historical center of Havana, 2000. PHOTO BY LUIS RODRÍGUEZ NOA. REPRODUCED BY PERMISSION OF ALEXIS ESQUIVEL.

mance, shown in Figure 10, Esquivel assumed the position of a street vendor seated next to a large display rack containing only a black doll, which he had bought moments earlier in a tourist market. Esquivel attempted to sell the doll to passers-by for more than fifteen times its value.[41] One observer noted that Esquivel's sales pitch took the form of a pedantic speech about the ideological value of the doll: because it represented black women, who were most oppressed by slavery, it was more valuable than other items for sale in the tourist market (Fusco 2002:139). Another critic noted how Esquivel sought to present his doll as "committed art," parodying the false radicalism invoked to attract foreign buyers and dealers (Medina 2001). Reactions to Esquivel's sales pitch varied: some people wanted to discuss racial problems in Cuba with him and others tried to barter for the doll.[42] Esquivel's performance was a comment on the kinds of "radical" discourses used to attract foreign buyers to the Bienal, of which it was a part, and to the local tourist market.

During the 2003 Bienal, Diago worked with Manuel Mendive and another artist, Choco, on another public event in a *solar* known as La California. As Bettleheim (2005:30) reports, while Mendive did a performance, Choco installed collagraphs in a community room and Diago worked with

children to construct miniature houses. The idea, Diago explained, was that "we all had to get in touch with the artist we have within us. From the kids to the elders." [43] The residents of the solar continued the project after the artists left. As an artist who came from the tenements of a marginal barrio, Diago felt impelled to make his art relevant to his community. Diago has also joined rappers in discussing black history, race, and racism in various workshops and colloquiums in Havana.

The reemergence of art dealing with racial matters from a sociopolitical perspective parallels the rise of rap music as a voice for young Afro-Cubans. However, visual artists were less optimistic about the possibilities for sustaining black voices in the arts, given the political establishment's resistance to their work. Esquivel said that cultural institutions pay lip service to questions of race while postponing any real debate. Religious cosmology and folklore have "won an important commercial space," but those artists who work on the sociopolitical aspects of race relations have had no impact on the art market. The combination of an unresponsive institutional sector and the exclusions of the market have limited the spaces in which black artists can express themselves. According to Esquivel, with the Queloides exhibition a sector of Afro-Cuban artists passed quickly "from being simple to being profound" and they garnered important coverage in major art journals, but the orchestrated silencing of the issues that has since followed "has confirmed a good part of the ideas that the works in the exhibition were proclaiming." [44] Esquivel comes to much the same conclusions as the Grupo Antillano did two decades earlier, that there is very little space in the visual arts for talking about issues of race. A few individual artists have established themselves, but it has been more difficult to sustain a collective voice for addressing issues of race.

The Transnational Dynamics of the Visual Arts

While the period since the late 1990s has seen the reemergence of public performances and critical social commentary on aspects of daily Cuban life in the arts, the gradual integration of Cuban artists into global market structures has produced a distinct network of artists, curators, and exhibitions that circulate between Havana and other overseas art centers. Various scholars and critics argue that this dynamic has made artists a privileged sector, with access to hard currency and foreign travel and with fewer re-

strictions by the state's ideological watchdogs (Power 1999, Block 2001, Hernández-Reguant 2004). But as we have seen, the number of artists who have achieved international success is limited. By necessity, many artists still work in the domestic market and have to negotiate with state institutions. Nevertheless, the transnational dynamics of the visual arts do represent an important change. Even younger artists see greater possibilities in the opening of the international market to Cuban artists. Wilfredo Prieto mentioned that the possibility of receiving scholarships from art schools outside of Cuba is a way of expanding art education for Cubans.[45]

In view of the global market's attraction to exotic locales and traditional cultures, artists have found it useful to retain a base in their country of origin as the source of their work and inspiration. Mosquera (1999:29) compares Cuban visual artists to fishermen: they make their living offshore but always return to port. It is the immersion of artists in a local context that gives them legitimacy in broader markets (Mosquera 1997, Power 1999). Li Cheng and Lynn White (2003:68) relate that since the early 1990s, internationally renowned Chinese artists have increasingly made Shanghai their base. The international recognition of artists and the cultural and financial capital they bring with them may release them from the ideological scrutiny to which domestic artists are subject. But as transnational artists find themselves controlled less by state censorship and more ensconced in what Richard (1996b:263) calls an "international management of 'symbolic capital'" or a global "network of authority," their work increasingly engages with the problems and power of global capitalism. As in the case of Cuban rappers, the participation of visual artists in international networks may provide the means for broader critiques of power and increasingly global solutions.

Beginning in the mid-1990s, as Cuban artists had greater opportunities to travel abroad, their work began to engage less with national concerns and more with universal ideas of modernity and progress, offering critiques of utopian visions shared by socialist and capitalist planners alike. Carlos Garaicoa has produced architectural drawings of old buildings in Havana and photographs of buildings and people in New York and Havana. His piece *Ahora juguemos a desaparecer* (Now let's play at disappearing) consists of a model of a city constructed of candles on a tabletop. When the candles are set alight, they begin to melt: the fate of all utopian constructions (see

11. Carlos Garaicoa, *Ahora juguemos a desaparecer* (I), 2001. Installation of candles on metal table, Arnhem, Netherlands. REPRODUCED BY PERMISSION OF CARLOS GARAICOA.

Figures 11 and 12). Garaicoa began working on this piece during a residency in Arnhem, the Netherlands, in 2001. The work represented the Church of Saint Eusebius, which was heavily damaged during the Second World War and today is a popular tourist site. "The restored church," he said, "seemed to me to be a theater of violence and a metaphor for the fragility of many cities." A second version of the piece included many other cities, drawing on representative buildings such as the cathedral and the Plaza de la Revolución in Havana, the Empire State Building in New York, the Petrona towers in Kuala Lumpur, and the Florence Baptistery. Garaicoa says he intended his second piece to refer to a "global city," which would allow viewers from many countries to reflect on the violence and war visited on their cities and national treasures.[46]

Buildings and objects represent power and domination. In his 1996 piece *Cuando el deseo se parece a nada* (When desire resembles nothing), created while Garaicoa was in residence at Art in General in New York City, he shows a young man standing in front of large buildings that resemble a housing project (see Figure 13). On his arm is a tattoo of the twin towers of the World Trade Center labeled "IN MY SOUL." According to José Ignacio Roca

12. Carlos Garaicoa, *Ahora juguemos a desaparecer* (II), 2001. Installation at Arnhem, Netherlands. REPRODUCED BY PERMISSION OF CARLOS GARAICOA.

(2000:98), the World Trade Center represented modernity, free trade, and commercial power, and the desire for that particular utopian vision is inscribed on the young man's body. The drab buildings behind him testify to his reality. In retrospect we can see in the proud symbols of free-market capitalism the fate of all utopian visions.

Garaicoa envisions new kinds of international cultural alliances as a way of engaging with the problems of global modernity. By revisiting the topic of the war in Angola in his *Memorias íntimas: Marcas* (Intimate mark of memories project), Garaicoa speaks to a historical continuity in Cubans' global concerns and plans, but he is more concerned with the aftermath of the conflict and the meaning of local histories in a larger international framework. In October 1975 the Cuban government had sent troops to support a nationalist movement for independence led by the Popular Movement for the Liberation of Angola (MPLA), supported by the Soviet Union, against an invasion by the troops of South Africa's apartheid regime in alliance with the United States. The invasion transformed what had been a conflict between local Angolan groups into an East–West conflict, decided by foreign troops. Cuban troops played a decisive role in securing victory for the MPLA, but Cuba's official histories have underplayed Cuba's role and

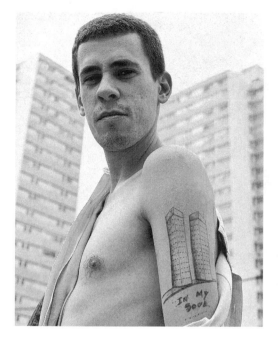

13. Carlos Garaicoa, *Cuando el deseo se parece a nada*, 1996. Art in General, New York.
REPRODUCED BY PERMISSION OF CARLOS GARAICOA.

given greater credit to the MPLA, perhaps to avoid offending the nationalist sensibilities of African governments (Gleijeses 2002:394). After the collapse of the Soviet Union, the Angolan government also distanced itself from Cuba. These factors have contributed to the silence that surrounds Angola in Cuba. As Piero Gleijeses (2002:395) states, "Because their leaders said nothing, the Cuban volunteers who had carried out the missions said nothing. The culture of silence enveloped the island." Garaicoa and other artists have sought to break this silence.

For the first part of the *Memorias íntimas: Marcas*, carried out with an Angolan and a South African artist, Garaicoa traveled in 1997 to the southern Angolan town of Cuito Cuanavale, where the Cubans had declared victory in 1988. Valdés Figueroa (2001:105), one of the participants in the project, relates that the shanties in the town were built of fragments of tanks, shell casings, and ammunition boxes, with "*Ostorokhno*," the Russian word for "caution," stamped on them. Land mines left in the area are responsible for frequent accidents. On the bank of the river Cuito, Garaicoa created a performance piece titled *En las hierbas del verano* (In the summer grass). In what had been one of the primary battlefields of the war, Garaicoa dug holes, exposing himself to the danger of land mines (see Figures 14 and 15). From

14. Carlos Garaicoa, *En las hierbas del verano*, 1997. Performance on the bank of the Cuito River, Angola. Still from a video exhibited at the Centro Cultural Portugués, Luanda, Angola, and the Castle of Good Hope, Cape Town, South Africa. REPRODUCED BY PERMISSION OF CARLOS GARAICOA.

this performance he created an installation that was exhibited in the Centro Cultural Portugués in Luanda, Angola, and at the Castle of Good Hope in Cape Town, South Africa, which houses the regional headquarters of the South African army. The installation consisted of a video of the action displayed next to lines by the poet M. Basho: "It is boring now in the summer grass. The glorious dreams of ancient warriors." The apparent tranquility and majesty of the landscape stands in stark contrast to the reality of the maimings and deaths of local people when the land mines explode. Orlando Hernández wrote a few lines to accompany the installation: "But he knows very well that there is nothing here that will shed any light on the story of this war. No piece with which to solve this sad puzzle of the past. What he is looking for is no longer under the ground. Or it is buried in another place. In many other places." The reasons for the war, the history of the failures and human disasters have been buried along with the land mines.

Garaicoa sought the reasons in other places, and part of the motivation for his journey from Cuba to Angola was to unearth the narratives and personal histories that have been silenced. Upon his return to Cuba, Garaicoa created the second part of his *Memorias intimas: Marcas*, an exhibition called

15. Carlos Garaicoa, *En las hierbas del verano*, 1997. Performance on the bank of the Cuito River, Angola. Still from a video exhibited at the Centro Cultural Portugués, Luanda, Angola, and the Castle of Good Hope, Cape Town, South Africa. REPRODUCED BY PERMISSION OF CARLOS GARAICOA.

Cuatro entrevistas sin . . . (Four interviews without . . .). The pieces were first shown at the Museum of Contemporary Art in Maracay, Venezuela, in 1997 and then at the São Paulo Bienal in 1998; they were also shown several times in Cuba. In 1999 they were displayed at the Salón Nacional de Foto-grafía at the Centro pará el Desarrollo de las Artes Visuales and in 2002 at the Centro Cultural de España in Havana. The exhibition consisted of four stills from a video of Cubans who had fought in Angola (see Figures 16 and 17), accompanied by a few of their disjointed words about their experi-ences in the war from interviews that Garaicoa had conducted with them. The fragmentary quotes and pauses, combined with the silent images on the screen, attest to the silence that surrounds the war and Cuba's part in it. Their words, with no mention of place names or dates, could apply to any twentieth-century war: ". . . that it would be better not even . . . after all, what . . . or if at least we had known . . . or if we had had a . . . but most of us were too young to . . . like a kind of adventure . . . perhaps also because it was about someone else's country . . . with the possibility of dying for something that you had never . . ." The interviews mention the language of victory and martyrdom that bombarded the veterans upon

16. Carlos Garaicoa, *Cuatro cubanos* (I), 1997. Installation of Hi 8 Video transferred to VHS. Museo de Arte Contemporáneo de Maracay, Venezuela. REPRODUCED BY PERMISSION OF CARLOS GARAICOA.

their return to Cuba: "The medals, they can go for all I care . . . together with the speeches, the slogans, the harangues. . . ." The narratives also point to the political leaders' failure to consider the broader implications of the war in Angola. The war was celebrated as a victory of black troops over the white troops of South Africa (Gleijeses 2002:436); it was seen as a crucial victory for Cuba and the Soviet Union in the Cold War; and because Cuba alone had sent troops to support the MPLA, it was used to show that Cuba was not a satellite of the Soviet Union. For Cuban leaders and soldiers, the fact that most Cuban troops were black underscored the support of Cubans for their African brothers.[47] But like other wars, it could also be seen as the marginalized carrying the burden (Bettelheim 2005:44). Garaicoa lets these meanings emerge from the silence that has settled over the issue.

Other Cuban artists have also sought to develop connections with artists and other people across borders. Manuel Piña was a guest of the Hallwalls Contemporary Arts Center in Buffalo, New York, as part of the National Residency program organized by Block in 1997. While there Piña

17. Carlos Garaicoa, *Cuatro cubanos* (II), 1997. Installation of Hi 8 Video transferred to VHS. Museo de Arte Contemporáneo de Maracay, Venezuela. REPRODUCED BY PERMISSION OF CARLOS GARAICOA.

produced a public art project consisting of a series of placards that tell the story of a young Cuban photographer who allows his edited images of nineteenth-century prostitutes to be used in a state campaign to promote tourism (Kellner 1997). The placards were placed in various public spaces, such as a subway station in an African American neighborhood and on a city bus. One placard showed a black woman and a palm tree, with the caption "mix the colors" in English and "mezclar los colores" in Spanish. Piña told me that while in Cuba the work would be understood as applying to sex tourism, in Buffalo it seemed to be about race mixing, a meaning Piña did not intend. In view of the racial segregation that Piña, himself Afro-Cuban, witnessed in Buffalo, he was not surprised that there his work took on racial connotations that it would not have in Cuba.[48] In Buffalo, Piña was made aware of the multiple facets not just of his work but of his identity: he was seen as African American in the black neighborhood where he lived and as a Latino at the Arts Center (Pujol 1997).

Another participant in the National Residency program, Abel Barroso, was invited by Executive Director Larry Baza to the Centro Cultural de la Raza in San Diego. The organization was established to combat the isolation experienced by Chicanos, Mexicans, and indigenous peoples living in

the border region, whose work has generally been marginalized in mainstream art circuits. According to Baza (1997:23), Barroso's trip was intended partly to share experiences and learn: "We wanted to know more about our commonalities and differences as Latinos." In Barroso's *Rush for Freeland*, consisting of four carved horses that are connected to an empty island, the horses represent the exploitative relationship that foreign capital is developing with Cuba. During his time in San Diego Barroso grew tired of being asked how people live in Cuba and of the assumption "that we are old and starving," so he decided to leave the island uncarved and let people draw their own conclusions (Block 1997:24–25).

Artists such as Piña and Barroso find that the insular focus of Cuban art may make it difficult to communicate with non-Cuban audiences, particularly given the positioning of Cuban artists in U.S. art circles. The history of Latino artists in the United States has differed markedly from that of Latin American and Caribbean artists. While curators were championing the global relevance of Latin American and Caribbean art and bringing these artists to the United States for mainstream exhibitions, U.S. Latinos were systematically excluded (Ramírez 1996:32). Consider El Museo del Barrio in East Harlem, founded by Puerto Rican cultural activists in the 1970s. In the mid-1980s, El Museo set out to attract a wider audience by exhibiting the works of Latin American artists, since they had greater appeal for private funders (Dávila 2004:101). El Museo has organized joint exhibitions of Latin American art with New York's Museum of Modern Art (MOMA), as well as several exhibitions by Cuban artists. Now it is the Puerto Rican artists that have a hard time finding a place to exhibit their works, and the decline in Puerto Rican exhibitions became a subject of controversy (Dávila 2004).

Divisions of this kind provide both obstacles and stimuli for Cuban artists working in the United States. On the one hand, Cuban artists are made aware of their privileges as transnational artists. On the other hand, Barroso's experience in San Diego demonstrates that it is also possible to recognize common ground: Barroso shared with the Chicano artists a concern for sociopolitical issues and commentary. He was exposed to a Chicano art center, and the center was able to establish a relationship with an artist that went beyond the restrictions imposed by embargoes and governments (Baza 1997:23).

The ability of some artists to move between Cuba and the United States was certainly important while it lasted, but the administration of President George W. Bush sharply tightened travel restrictions in June 2004. Bush canceled most of the provisions that permitted U.S. citizens to visit Cuba and Cuban artists found it more difficult to obtain visas for travel to the United States. Some artists have found innovative ways of continuing to work from Cuba. When Luis Gómez was denied a visa to attend the opening of his photography exhibition at Art in General in New York City in 2004, Holly Block organized a webcast and had it fed live to the gallery La Casona in Havana on the opening night.[49] Similarly, the curators Barbara Luderowski and Michael Olijnyk had planned a year-long residency program for eleven Cuban artists at the Mattress Factory in 2004–2005, but all the artists were denied visas. The curators went ahead with the show, creating the installations long distance:

> We sent detailed gallery plans and photographs to the artists. They sent us drawings and descriptions for their installations, primarily through email. Materials were identified and samples sent to the artists for approval. Each decision along the way, no matter how small, was discussed with the artist. For instance, Glenda León was sent samples of artificial grass for her piece, Habitat, and confirmed her choice by email. She was also able to see computer simulations of how her work would look in the room and make adjustments to the work. (Luderowski and Olijnyk 2004)

They knew phone and mail would be difficult between the United States and Cuba, so they relied mainly on the Internet to put the exhibition together.[50] The new global connections of visual artists and the Internet have expanded the profile of the Cuban visual arts. Through exhibitions abroad, Web sites, and foreign tours, artists have reached international audiences. But despite these creative initiatives to continue cultural exchanges between Cuba and the United States, since 2004 it has become a lot harder for Cuban artists to maintain their base in Cuba. Several artists are now based in Canada and the United States. As of June 2005, Elsa Mora had moved to Los Angeles, Manuel Piña was teaching at the University of British Columbia in Vancouver, and Tania Bruguera was teaching at the Art Institute in Chicago.

The exhibition, circulation, and consumption of art by transnational artists constitutes a sphere mostly distinct from that of art produced and

exhibited in Cuba. The work of transnational artists does permit the opening up of what George Yúdice (1996:213) refers to as "transnational public spheres of deliberation," in which "actors from different contexts can engage not only in dialogue but also in reciprocal critique." Participation in transnational circuits has given Cuban artists the tools to reflect critically on their own society. Unlike most other cultural producers, transnational visual artists extend their critique of global modernity to the role of the nation-state in facilitating transnational capital. Like Elio Rodríguez, Garaicoa points to the collusion of the Cuban state with foreign companies and multinational corporations. In a piece he wrote to accompany Garaicoa's 2002 exhibition in Italy, Eduardo Luis Rodríguez (2002) contrasts the inner spirituality of urbanites with the grand designs of the planning state as he reflects on the experiences of the microbrigades, the voluntary workers employed by the state throughout the revolutionary period to build large housing projects. The language of glory and progress used to define the works "of key importance for the State" contrasts with the imagery of decay and stagnation: "the dozens of building abortions, half-built, that spread through the city, truncated columns representing a truncated idea, the premature ruins of what never was." The small tenements in the neighborhood where the microbrigade worker lives are contrasted with the new apartment buildings put up by Cuban-foreign joint ventures—"the so-called 'Real Estate'" intended for sale to rich foreigners who have abandoned the white helmets of earlier colonizers for Knicks caps and Ray-Ban sunglasses. Both "Real Estate" and the "State" represent visions of modernity and progress that marginalize the ordinary microbrigade worker, despite his lifelong commitment to working for those ideals.

Transnationalism has provoked and bolstered new kinds of critiques in Cuban visual arts, whether over issues of race, multinational capital, or the nature of modernity, but at the same time it has created a layer of relatively privileged actors who are often limited by the demands of an international art market from building a public art movement in Cuba, in the critical and radical spirit of the 1980s. Although Garaicoa lives in Cuba, he says he has little time to take part in local exhibitions: "An international career has kept me quite busy with various commitments, but this is something I really regret because I like to be close to the Cuban public."[51] Part of the problem is that the international curators are more interested in acquiring

the best works than in enriching the contexts out of which they emerge. Rather than adopt the celebratory tone of much literature on global networks, which sees these networks as beacons for social change and critique in the countries where they originate, I suggest that we remain attentive to the contradictions of transnationalism.

Work in underground spaces and transnational networks in the 1990s has given a critical edge to contemporary visual arts, while there have also been tendencies at work to promote negotiation and incorporation in cultural institutions. That strategy has been due to co-optation by the state and the efforts of some visual artists to seek institutional support as a way of rebuilding artistic movements. Cultural institutions such as the ISA and art teachers mediate between the political leadership, artists, and ordinary Cubans as consumers of art. On the one hand, institutions such as the ISA have become sites of cultural contestation, as visual artists seek to broaden the scope of what is officially recognizable as art and to amplify the scope of the politically permissible. On the other hand, by drawing previously taboo practices such as drag shows and tattoo art into the domain of official cultural institutions, various actors contribute to processes of partial reincorporation.

The ability of some visual artists to work in international circuits of exhibition, production, and dissemination represents a qualitatively different trend from what we find in other art forms such as film and rap music. Visual artists such as Garaicoa have shifted their focus somewhat from the Cuban state to global capitalism, although they also criticize the Cuban state's implication in certain aspects of the international market such as tourism and joint ventures. Moreover, these artists seek to build new public spaces and forms of community that are rooted in global rather than narrowly national landscapes. Garaicoa's piece with Angolan and South African artists is an attempt to build new solidarities and forge cross-national forms of collaboration that signal a new terrain of struggle beyond the realm of the national. Even younger visual artists, who may not have access to the kinds of funding and contacts that would enable them to participate in transnational networks, strengthen their position by applying for foreign scholarships or selling their art to tourists. But given the restrictions placed on foreign travel by the U.S. government, the difficulties artists en-

counter when they seek to work in cultural institutions, and the preoccupation of foreign curators with exhibitions outside of Cuba, it remains to be seen whether transnationalism will turn into a replay of the exodus of the early 1990s or whether it can generate genuinely transnational dialogue and debate.

Conclusion

In 2001 I attended a series of forums on rap music held in Cojimar. From week to week the meetings grew larger and more contentious until the floor space in the small apartment was completely occupied and people were shouting over one another's head. When I returned to Cuba a year later, I learned that the meetings had been closed down by the state, and nothing more was said about them. But concurrent with the closure of these informal meetings were new forums on rap organized by the state-managed Casas de la Cultura. I attended one of these meetings in Central Havana. The audience was much larger than the ones I joined at the informal meetings—there were close to seventy people in the room—and the discussion was more intense and vigorous. It actually seemed as though discussions about race and marginality had become more developed and more radical.

At Cojimar the older Afro-Cubans expressed quite moderate views on race and the young people deferred to them. Here when the older people said that if blacks were held back, it was because they lacked ambition, and that we all ought to recognize our common humanity rather than focus on race, the younger rappers openly challenged them. Marginality was a very real condition that limited people's opportunities, they insisted, and any discussion of race should begin from that point. A series of rappers stood up in front of the group and delivered five- to ten-minute speeches, which met with strong applause and cheering. Sekuo Umoja of Anónimo Consejo gave a particularly rousing address, combining black nationalist sentiment with appeals for rappers to be recognized as an important political voice. It's important to recognize what it means to be black, Sekuo said: it means to be from Africa. If

people of African descent in the United States identify themselves as African American, then people of African descent in Cuba should call themselves Afro-Cuban. Sekuo had harsh words for the government and for the older people who did not challenge its sidelining of racial issues: "If the government wants us to respect José Martí, if they say we are all human, then first they have to respect us." The room exploded with applause, cheers, whistles. Another rapper stood up and argued that rappers should be recognized as communists and revolutionaries. More loud applause. By the end of the session, people were aroused and angry. The political commentary continued during the rap concert that followed.

It is remarkable that despite what was technically the co-optation of the rappers by state institutions, the rappers still pursued their radical politics. We have seen that official cultural institutions have tolerated critical art for several reasons: the changed relationship between state and society in the post-Soviet period, the growing collective power of artists, and the participation of artists and audiences in new modes of incorporation that seek to contain emerging sentiments, counterhegemonic movements, and critical discourses within official frameworks. But we have also seen that the process of incorporating new ideas can change the dominant ideas; artistic communities influence the evolving state as the state shapes the agendas and orientation of artists.

While scholars of Eastern European transitions see the state as a bounded entity existing in opposition to society and poststructuralist scholars tend to dissolve the state into the diverse networks of civil society, we have seen in the Cuban situation that state and society interpenetrate and shape each other, that governance is produced through the agency, actions, and interactions of multiple state and nonstate actors. As filmmakers, underground rappers, public artists, cultural officials, and art teachers sought to highlight their particular agendas vis-à-vis the state, they often collaborated and compromised in ways that bolstered the state's power and produced new alliances.

We have seen how Cuban artists took advantage of a crisis produced by the collapse of the Soviet Union to open up new avenues of negotiation with the state. What do their strategies and travails tell us about the political importance of the arts in contemporary Cuba? What can they tell us about concepts of power, ideology, and hegemony in general?

Art and Politics

Art and popular culture in Cuba generate spaces of public d[]cal discussion that are not distinct from the state or cultural markets. In some cases, art introduces radical and controversial themes into public discourse, as *Fresa y chocolate* deals with homosexuality; as rappers have put racial matters on the agenda; and as shows organized by visual arts students have demonstrated the talents of drag queens. These topics meet resistance by both the political leadership and Cubans generally, who to some degree share a culture of homophobia and racism and are forced to confront their own prejudices. At other times, art can pierce the heart of what the majority of people are feeling, acting as sluice gates for the release of views that not so long ago were discussed only in private and clandestine ways, if they were articulated at all. A film such as *Madagascar* opens the way for acknowledgment of alienation. A rap song about jineterismo or an art installation that represents a dollar store as a museum can give voice and public legitimacy to everyday illicit practices. Art and popular culture have the potential to generate a critical, engaged populace partly because in countries such as Cuba, where discourse is relatively controlled, these forums provide outlets for expression and spaces for confrontation among ordinary citizens.

It is precisely this capacity for touching and engaging ordinary Cubans that makes art an important instrument in the shaping of cultural hegemony. The Cuban state draws on critical art forms as a way of bolstering its power in the crisis created by the collapse of the Soviet Union. The state, far from being the exclusive concentration of power it would like to be, is a constellation of the actions, collaborations, and performances of all the actors who participate in the strategies of incorporation that have emerged since 1991. The precise nature of those articulations varies from one practice to another. Filmmakers, exercising a high degree of self-censorship, try to reconcile critical expression with dominant values, while rappers express an investment in values as demands on the state. Artists and even audiences (consider the viewers of *Madagascar*) participate self-consciously to restore meaning to socialist values and revive transformative visions based on older values.

A particularly resonant idea is that of the nation. The move to redefine Cuban culture and the arts as part of Cuba's historical and national patri-

mony makes culture a crucial site for the reinvigoration of national unity in the face of ideological polarization and economic differentiation. Popular Cuban films such as *Fresa y chocolate* and *La vida es silbar* seek to reconcile citizens and the state under the rubric of a more inclusive and pluralistic nation, suggesting that despite their differences, Cubans can be unified in their patriotism. But in a global order reconfigured by new kinds of transnational flows, this singular, coherent notion of national identity comes under scrutiny. Art forms such as rap music and visual arts, nurtured by dual processes of transnational flows and state sponsorship, introduce more critical conceptions of the nation into public discourse and herald new relationships with the nation-state. Rappers and Afro-Cuban artists appropriate openings presented by the growing commercial interest in Afro-Cuban culture to criticize nationalist discourse, specifically as it excludes blacks and erases cultural difference. By contrast, those visual artists who work in transnational spaces of production and exhibition address global concerns and issues rather than confront the socialist state directly. Whereas underground rap artists continue to demand that the Cuban state recognize the achievements of young blacks and live up to its promises of equality and employment, transnational visual artists question the viability of socialism as a modernist project and expose the movement of the state itself to embrace capitalism.

Transnational flows have introduced a complex and unpredictable force into the dynamic of Cuban cultural politics, which allows for the development of new kinds of public spaces and cross-national solidarities. Various theorists have pointed to these cultural and political possibilities generated by transnational flows, but clearly the nation-state retains a degree of power to reincorporate alternative and countercultural movements, often in collaboration with the very transnational forces that engender these critical movements. Rap musicians are drawn into various strategies by promoters, cultural officials, and institutions to rally young black people under the Cuban flag as the symbol of a rebellious, anticapitalist, and resistant black nation. Particularly in a moment of increasing racial differentiation, the Cuban state bolsters its power among young blacks by associating itself with images of the black nation. Visual artists, especially those exposed to international art markets and the problems of other societies, also build critiques of global capitalism that may coincide with the arguments made

by Cuban political leaders. But as visual artists begin to work in more international spaces, they have less access to and influence over local Cuban audiences.

Nevertheless, popular culture and the arts remain risky as a strategy for reconstructing cultural hegemony. There are moments of disbelief and even cynicism concerning utopian constructions in films such as *Fresa y chocolate* and *La vida es silbar*. Artists themselves do not always seek to collaborate with the state or reconcile their critical perspectives with dominant narratives; at times they propose alternative strategies for social renewal or criticize the state for not living up to their expectations. The political leadership recognizes the potential of critical art to be framed in ways that may not be accommodating to the dominant order. As Verdery (1991:247) has shown, critical public dialogue makes available languages that can be used by forces that want to bring about radical change, not just reform within the system. For this reason, as the state attempts to institutionalize and incorporate critical art, the leadership also keeps it out of the mass media. For instance, *Fresa y chocolate*, despite its popularity in the movie houses, has still not been shown on television. Underground rappers may gather crowds of thousands at state-sponsored festivals, but as Sekuo Umoja of Anónimo Consejo says, "You don't hear Anónimo Consejo or Hermanos de Causa on Cuban radio, they always play Eminem, an obscene American rapper who represents the most violent aspects of that culture" (quoted in Fernández 2003). The exclusion of critical films and music from the mass media is an attempt to control the critical possibilities of art.

But to recognize these possibilities for new and transformative politics is not to say that the arts are associated with dissent or even resistance. I am cautious about speaking of "resistance" in the Cuban context. On the one hand, notions of "rebellion" and "revolution," which may stir the imaginations and energies of citizens elsewhere, have been co-opted by the state in Cuba. Official discourse continually refers to "resistance" to colonialism, U.S. imperialism, and global capitalism. On the other hand, for decades politically influential and wealthy sectors of the Miami exile community have talked about "resistance" to the Cuban government and donated millions of dollars to the Republican Party in return for legislation such as the Helms-Burton Act, which magnified the difficulties faced by ordinary Cubans during the special period by penalizing foreign corporations that

invested in Cuba (Azicri 2000:206). Conservative Cuban American politicians and journalists who are most likely to stand with American conservatives in their condemnation of gangsta rap have opportunistically become the latest champions of Cuban rap, which they see as providing the strongest voice of dissidence against the Cuban state.[1] When established political interests seek to construct "resistance" in different ways, it is important not to lose sight of those interests.

Above all, it would be premature and incorrect to refer to the developing sites of civil society in the arts and in other pockets of Cuban society as forming a movement of cultural dissidence. The human rights movements, reform movements, and cultural movements that were active in Czechoslovakia, Poland, Hungary, and the Soviet Union before the collapse of the Soviet bloc, have no counterparts in Cuba. This lack of dissident activity is partly due to the state's ability to incorporate counterhegemonic movements. It is not only the arts that are being brought into the fold of the dominant order. Adriana Premat (2004) has looked at how the small-scale, self-provisioning urban agricultural sites that emerged in Havana outside the state's purview have been reincorporated into official projects through competitions for the "model garden" and other strategies that rely on identification with official state ideals. Early in 1998 I noticed the flourishing of family-run restaurants and numerous street vendors operating freely in prominent areas. When I returned later, a lot of these little businesses were gone, replaced by the large Pan de Paris chain, which operates in dollars. Activities that flourish outside the state's control are reined in, but the actors themselves generally participate in this accommodation.

Recasting Ideology, Recreating Hegemony

Cuba is a unique case among socialist societies and also among postcolonial regimes. The Cuban revolution was born at a critical moment in the world socialist system: Nikita Khrushchev's campaign to dismantle Stalin's legacy had left the institutionalized politics of Soviet socialism exhausted, and the revitalization of the Marxist tradition now depended on such thinkers as Antonio Gramsci and György Lukács. As Bengelsdorf (1994:66) argues, the success of a small band of guerrillas in ousting a powerful U.S.-backed dictator gave widespread support to "the possibility of a socialism framed around and upon the fullest democratic participation." The Cuban

revolution gained the respect and admiration of important intellectual and literary figures in Europe and Latin America, such as Jean-Paul Sartre, Simone de Beauvoir, and Gabriel García Márquez, and the revolutionary leadership forged links with groups such as the Black Panthers in the United States. For those disillusioned with the failed promises of the Soviet Union, the Cuban revolution offered the nostalgic possibility of a democratic socialism. Although in the course of the revolution many of those fantasies have been demystified, the ideology of the Cuban revolution continues to enjoy a high degree of influence in Cuban society and among subaltern groups in Latin America and elsewhere.

Given the current global dominance of a neoliberal cultural and economic agenda, its focus on individualism and competition, and the growing wealth differentials produced by structural adjustment policies and globalization, Cuba and its alternative code of values have once again begun to provide a reference point for emerging revolutionary and leftist movements in Latin American countries such as Brazil, Argentina, Venezuela, and Bolivia. Across Latin America, Che continues to be the iconic revolutionary hero for radical youth. Social movements in the barrios of Caracas send contingents to Cuba for training in community organizing and social work. A handbook produced by the Landless Laborers movement in Brazil (Movimento dos Trabalhadores Rurais sem Terra, MST) has a section headed "Cuba: A Small Island against Uncle Sam" (Morissawa 2001). Cuba's ability to sustain itself somewhat outside the orbit of U.S. hegemony continues to give it symbolic power as a rebel nation in the revolutionary imagination. The ideals of collectivism, egalitarianism, and solidarity continue to resonate for Cubans in a moment of change and impending transition. Regardless of when and what kind of transition eventually takes place on the island, this symbolic legacy and the worldviews and visions of ordinary Cubans will play large roles in the shaping of a new Cuban society.

But given the uniqueness of the Cuban case, what can it tell us about questions of ideology, hegemony, and state power elsewhere? How can a special case generate a theory that is generalizable? But Castro's is not the only political regime that is breaking with the past. In the global extension of democratic practice in what Samuel Huntington (1991) has called the "third wave of democratization" we can actually see movement toward

greater participation and political dialogue between ruler and ruled in many authoritarian systems.

In countries such as China, Iran, and Mexico, even though long-standing socialist and authoritarian governments continue in place, they have been under pressure to respond to citizens' demands for greater openness. As in Cuba at the start of the special period, several artists fled China after the repression of the Tiananmen Square demonstrations in 1989. More recently Chinese artists have been given much greater latitude. For instance, visual artists report that a sharply critical art show was permitted without state censorship in 2000, and since then the closing of art shows has been quite rare in China.[2] These shifts to greater accommodation of critical art do not amount simply to what some scholars have referred to as a "velvet prison," a situation in which the state gives artists special privileges in exchange for their support (Haratzi 1987, Pickowicz 1995). Rather, the new modes of toleration and incorporation that are visible across a range of societies reflect shifting relationships between state and civil society that have come partly at the initiative of critical citizens. The fallback on a strategy of incorporation points to the vulnerability of centralized states in a moment of crisis.

Political openings in socialist and authoritarian systems may strengthen rather than undermine these systems. Such a development suggests that Huntington may be mistaken in postulating a universal trajectory toward liberal democracy. In general the literature on democratization is imbued with a sense of the superiority of Western models and a failure to see that other political cultures may be in the process of developing mechanisms of democratic participation. One thing that is usually ignored in discussions of transitions to democracy, particularly in respect to socialist societies, is the wide variation in the interpretation of rights. Cuba and China have constantly been challenged on questions of human rights, but Cuban leaders respond that questions of "public health, education, work, housing, and the absence of racial and gender discrimination" should also be recognized as human rights (quoted in Azicri 2000:110). While this response may be a convenient way of distracting attention from issues of political rights, it also points to a failure of several contemporary democratic systems to meet many of these basic needs for large sectors of their populations.

In contrast to the optimism of democratization scholars regarding the spread of liberal democracy, Jean Drèze and Amartya Sen (1995:84) argue

that the transitions in the former Soviet Union and Eastern Europe, with their policies of privatization and cutting back of the state sector, threatened large sections of the population with insecurity by taking away basic welfare provisions. Drèze and Sen recommend "a more positive combination of public-sector reform with expansion of private enterprise," as in China under the market socialist regime. Struggles are being waged between citizens and the state in a variety of postcolonial systems—liberal democratic, socialist, and authoritarian—over the balance between state intervention to ensure basic welfare, the achievement of market competitive economies, and recognition of democratic rights. Perhaps a useful way of conceptualizing the contemporary global transitions is to see them, as Gail Kligman (1990:423) suggests, as "greater or lesser degrees of civil society emerging in public spheres with greater or lesser degrees of autonomy." Moreover, the fact that the public sphere under Cuba's socialist regime and China's market socialist regime have "lesser degrees of autonomy" does not mean that they cannot facilitate vibrant critical discussions of politics that affect the state's exercise of power.

There may also be some ways in which aspects of my theory of artistic public spheres could apply to liberal democracies, especially given the appropriation of minority and counterhegemonic movements by dominant classes worldwide. Michael Hanchard (1994:182) notes that "Brazilian national culture has always translated and transformed Afro-Brazilian cultural practices into national cultural practices, thereby rendering them as commodities in popular culture to be consumed by all." The sponsorship and incorporation of minority cultures, whether by commercial interests or states, is a historical problem that has taken on special urgency given growing inequality as a global phenomena and the need for viable forms of voice and representation to counteract it.

American message rap has a strong black nationalist tone and anticapitalist militancy, but at the same time, rappers appeal to dominant values of American society. For instance, in his song "The Proud," the American rapper Talib Kweli talks about 9/11, and he expresses sympathy for the victims and gratitude to the heroes while criticizing the U.S. government for also killing innocent people abroad and continuing the cycle of violence. Kweli points to the government's exhortations to citizens to go and fight for the flag, but he talks about the absurdity of patriotism in a situation of poverty,

drug addiction, homelessness, and joblessness, particularly in black communities. Kweli encourages people to "face what lies ahead" and "fight for truth and justice." Like Cuban rappers, Kweli draws on the promises of the dominant ideology, of truth and justice, but he demands that in return for the patriotism of black communities ("patriots live in the ghettoes too"), the government must address the problems of marginalized communities. All political regimes attempt to monopolize power, but citizens retain the power to bargain and can use it to shift the grounds of the dominant ideology in ways that privilege their own interests and concerns.

In any political system, hegemony depends on the ability of political blocs to cultivate the support of citizens for the ideological worldviews on which they are based. In a crisis such as the one faced by contemporary Cuba, where dominant values are not taken for granted, active and partial modes of incorporation play a greater role in the functioning of a renewed hegemony. The re-creation of hegemony during a period of crisis is never guaranteed to succeed: new values may be associated with outside political forces; opposition to the state may grow if it does not live up to its promises; the elite themselves may even abandon the hegemonic project. But the continuing hold of aspects of a radical ideological vision over Cuban citizens even in a period of profound crisis and isolation suggests the pervasive power of this vision for ordinary Cubans and the political importance of struggles over culture.

Notes

Introduction

1. I borrow this term from Alexei Yurchak (1997), who uses it in analogy with "late capitalism" to differentiate the period from the late 1960s to the mid-1980s in the Soviet social order from earlier periods of socialism.

2. Many scholars continue to support the post–Cold War declaration of Francis Fukuyama that we have reached the "end of history," despite evidence to the contrary. For instance, Krishnan Kumar (2001:187) argues that "despite some rude noises and scornful denunciations of Fukuyama, it is striking how few of his critics have answered his repeated challenge to them to show what might upset the hegemony of liberal democracy as a worldwide aspiration."

3. The decline in Soviet aid and export income prompted the Cuban state to declare a "special period in time of peace" in September 1990, in an attempt to rebuild the Cuban economy through policies promoting self-sufficiency in food, the reintroduction of wide-scale rationing, the earning of hard currency through tourism, and the reentry of Cuba into a global economy.

4. See, for instance, Krasner 1978; Stepan 1978; Skocpol 1979; Nordlinger 1981, 1987. After the publication of *Bringing the State Back In*, the *American Political Science Review* (APSR) published a debate in which Nordlinger (1988) responded to a critique by Almond (1988) by restating this view of the state as an autonomous and unitary actor.

5. This definition is taken from the exhaustive and influential text by Cohen and Arato (1992), but I refer here to a more general, geographically and theoretically diverse range of work within comparative politics and political theory, including O'Donnell and Schmitter 1986; Przeworski 1991; Linz and Stepan 1996; Keane 1998; Bernhard 1993; Weigle and Butterfield 1992.

6. The political theorist Charles Taylor (1990:41) claims that "civil society is not so much a sphere outside political power; rather it penetrates deeply into this power, fragments and decentralizes it." Drawing on Foucaultian perspectives of governmentality, some edited volumes have also sought to analyze the increasing porousness of the neoliberal state as it expands to incorporate civil society. Among these works are *Cultures of Politics/Politics of Culture: Re-visioning Latin American Social Movements*, edited by Sonia Alvarez, Evelina Dagnino, and Arturo Escobar (1998), and *States of Imagination: Ethnographic Explorations of the Postcolonial State*, edited by Thomas Blom Hansen and Finn Stepputat (2001).

7. See Schmitter 1975, 1979.

8. I refer here to the earlier work of Monsiváis, in articles such as "Notas sobre cultura popular en México" (1978).

9. In a foundational document for the cinema movement in Cuba titled "Una nueva etapa del cine en Cuba" (A new stage in Cuban cinema), Alfredo Guevara (1960:7), director of the newly established Instituto Cubano de Arte y Industria Cinematográficas (ICAIC), stated that the government and all the institutions of art and cinema had a role to play in promoting active debate.

10. The concept of transnational cultural spaces draws from the literature on transnational cultural studies as it has evolved through the journal *Public Culture* and in the work of scholars such as Arjun Appadurai (1996) and Susanne Rudolph (1997).

11. For example, when a respondent to a questionnaire administered after the film *Las profesías de Amanda* (The prophesies of Amanda) was asked which parts he liked best, he answered, "The beginning," and when asked which he liked least, he answered, "The ending." When asked with whom he identified most, he indicated Amanda, the main character. The person who directed the research said that no one actually used the information it yielded and she felt it was a waste of time, but her team carried it out because the leadership required them to do so.

12. I carried out nine months of fieldwork in Cuba, over a period of four years. I began my fieldwork in December 1999 and January 2000. I rented a small apartment in the working-class barrio of Central Havana when I returned for the summer of 2000, funded by a research grant from the Center for Latin American Studies at the University of Chicago. In 2001 I stayed with a middle-class Cuban family in the suburb of Vedado for five months of research funded by the Social Sciences Research Council. I made follow-up research trips in the summer of 2002 and in March 2004.

13. Given the geographic mobility of many Cuban artists, some of these interviews were carried out in New York and Chicago, others via email and telephone.

1. Remaking Conceptual Worlds

1. In October 2004, Castro once again banned the circulation of the U.S. dollar in Cuba. The dollar has been substituted by the convertible peso, which is equivalent to the dollar but has no value outside of Cuba.

2. Quoted in Alberto Pozo, "Preserving and Raising Workers' Morale," *Granma International*, 16 July 2000.

3. An English translation of Raúl Castro's speech is available at www.marxmail.org/raul_castro.htm. My quotations are taken from Katherine Gordy's (2005) more accurate translation.

2. Old Utopias, New Realities

1. Throughout this book, I use the Cuban spelling for African-derived religious names. There is a new standardized spelling for these names in Yoruba, but in

Cuba an older version of the Yoruba spelling is most commonly used. Saints or *santos* are known as *orishas* in standard Yoruba, but they are called *orichas* in Cuba. The name of the oricha spelled Oshun in standard Yoruba is Ochún in Cuba.

2. At the 2001 exchange rate of U.S.$1.00 = 21 pesos. I use this exchange rate for conversions throughout the book.

3. Interview with Grizel González Otaño, Production Unit, ICAIC, August 2001.

4. Ibid.

5. Interview with Luis Alberto García, August 2001.

6. Interview with Gustavo Fernández, Instituto Superior de las Artes (ISA), August 2001.

7. Interview with Daniel Díaz Torres, August 2001.

8. Bernardo Callejas, "Sobre la película *Alicia en el pueblo de Maravillas*," *Trabajadores*, 17 June 1991; Ada Oramas, "Esas 'maravillas' niegan a nuestro pueblo," *Tribuna*, 18 June 1991; Elder Santiesteban, "Alicia en su pantano," *Bohemia*, 21 June 1991.

9. Kelly Anderson, "Cubans Debate Banning of Film That Lampoons Society," *Guardian*, 2 December 1992.

10. *Cine Cubano* 13 (1962): 14–16.

11. Michael Chanan (1985:17) notes that in the 1970s, a successful Cuban film would generally be seen by a million people or more in the first two months of its release. In 1977 *El brigadista* attracted 2 million people during its first six weeks; *Retrato de Teresa* (1979) was seen by 250,000 in two weeks (Chanan 1997:198).

12. Pastor Vega, "Datebook," *San Francisco Chronicle*, 3 February 1980.

13. Interview, July 2000.

14. Such labels as "working class," "professional," and "middle class" in the Cuban context point to distinctions in level of occupational skill and even in cultures and residential arrangements, as in many nonsocialist societies. In Cuba, however, the income differential between working-class and professional occupations is not large, so that a doctor or university professor in Cuba may earn only slightly more than a day laborer. As a result of the economic crisis, these divisions have been widening, although at times the effect is reversed: a taxi driver working in the tourist economy may earn more than a doctor, who is still paid by the state. But the connotations of the terms remain distinct from those in market capitalist societies.

15. I have changed the names of the participants to preserve their privacy.

16. Interview with Abel Prieto, August 2001.

17. Interview with Fernando Pérez, August 2001.

18. Bola de Nieve, or Snowball, was the nickname of Ignacio Villa, a musician who was in fact very black.

19. Interview with Alberto García, August 2001.

20. Interview with Pérez, August 2001.

21. Ibid.

22. Cubans elide the final consonants of most words, so that they pronounce *crisis*, spelled the same in Spanish as in English, very like "Chrissy."

23. Interview with Pérez, August 2001.

24. Ibid.

25. Rolando Pérez Betancourt, "Silbar, pero con aire," *Granma*, 5 December 1998, 6.

26. Toni Piñera, "Fernando Pérez Colecciona . . . Corales," *Granma*, 12 December 1998, 6.

27. In the postrevolutionary period all Cuban citizens had access to state-subsidized concerts, music and dance classes, and other cultural programs.

28. Cuban slang for the United States, used more broadly to refer to all foreign countries.

29. I showed *Madagascar* to audiences at Princeton University and in the Melwood Screening Room in Pittsburgh, and during the discussions people would generally bring up the theme of generational conflict.

30. Jorge Ignacio Pérez, "Deseo cumplido: Fernando Pérez y su último filme," *Granma*, 8 December 1994, 3.

31. A. Plasencia, "Madagascar," *Bohemia*, 17 February 1995.

32. Rolando Pérez Betancourt, "Bertolucci, *Madagascar* y cine cubano" *Granma*, 7 December 1994, 6.

33. Interview with Pérez, August 2001.

34. Ibid.

35. Plasencia, "Madagascar."

36. Interview with Pérez, August 2001.

3. Fear of a Black Nation

1. Hip-hop is based on breakdancing, graffiti writing, DJaying, and rapping. Hip-hop has grown to encompass such other elements as cinema, poetry, and clothing lines. DJaying and graffiti writing did not catch on in Cuba because of the lack of turntables, records, spray cans, and the other resources necessary for these practices, but breakdancing and rapping became popular.

2. "Towards a Mass Solution of the Housing Problem," *Cuba Review* 5, no. 1 (March 1975).

3. Interview with Ariel Fernández, September 2001.

4. By the time this book was finished, Ariel had moved to New York City.

5. Interview with Fernández, September 2001.

6. Interview with Sekuo Umoja, August 2000.

7. Mimi Valdés, "The Big Payback." *Vibe*, 2 February 2002.

8. The Orishas use the standardized Yoruba spelling for their group's name rather than the Cuban *orichas*.

9. Interview with Fernández, September 2001.

10. Tony Pita, "Rap, tiramos la primera piedra," *El Habanero*, 3 August 1999.

11. Jineterismo has evolved from a spontaneous activity into an organized system, divided into established zones; jineteros establish their territory by buying off the police (Elinson 1999:5).

12. According to Carmelo Mesa-Lago (2000:316), the foreign investment law of 1995

authorized free-trade zones and industrial parks, and free-trade zones were sched-
uled to open in the ports of Mariel, Cienfuegos, and Wajay.

13. Interview with Magia, April 2005.

14. Interview with DJ Yary, April 2005.

15. Joaquín Borges-Triana, "Raperas cubanas—una fuerza natural," *Juventud Rebelde*,
5 August 2004, <www.jrebelde.cubaweb.cu/2004/julio–septiembre/ago-5/print/
oreja.htm>.

16. Interview with Norma Guillard, April 2005.

17. "Hip hop no poder," *Estação Hip Hop* 4, no. 25 (2004).

18. Elena Oumano in *Global Hit for Friday*, August 27, 1999.

19. "O governo de Collor foi o da música sertaneja, o de FHC foi da musica rebolante
e o meu governo será o governo do Hip Hop," quoted in "O nosso presidente e o
hip hop," *Estação Hip Hop* 5, no. 26 (2004), 9.

20. Quoted in "Criada comissão interministerial para dialogar com hip hop," *Estação
Hip Hop* 4, no. 25 (2004), 8.

21. Ibid.

22. Interview with Abel Prieto, August 2001.

23. Interview with Mercedes Ferrer, Benny Moré agency, August 2001.

24. Interview with Fernando Jacomino, August 2001.

25. Interview with Fernández, September 2001.

26. Interview with Osmel Francis Turner, September 2001.

27. Interview with Fernández, September 2001.

28. Tony Pita, "Rap, tiramos la primera piedra."

29. Scholars have addressed the contradictory relationship between American black
nationalists and the revolutionary government in Cuba. Carlos Moore (1988) and
Alejandro de la Fuente (2001) point out that Fidel Castro and other leaders sought
to build alliances with the black power movement in the United States, but the
racialized discourse of leaders such as Stokely Carmichael, who spoke of a "white
power structure," was alien to the Cuban political leaders, many of whom them-
selves were "white." Although these tensions have not emerged strongly in the
interactions between African American rappers and the Cuban state, the cul-
tural nationalism of Cuban rappers, developed through participation in cross-
national networks with African American rappers, meets with some official resis-
tance.

30. The House of Umoja is an Afrocentric youth development agency, founded in
1968, which seeks to address problems of violence and crime among young urban
blacks in the United States. *Umoja*, Swahili for "unity," has served as an organiz-
ing principle for the agency.

31. Valdés, "Big Payback."

4. Postwar Reconstructions

1. "Visual arts" refers to painting, sculpture, exhibits, and other forms of "object-
oriented" art. However, the focus in this chapter is on public art, a broader cate-

gory that includes street theater, tattoo art, public installations, and public performances.

2. Interview with Tania Bruguera, May 2005.

3. Interview with René Francisco Rodríguez, July 2002.

4. Ibid.

5. Interview with Bruguera, May 2005.

6. Interview with Sandra Levinson, September 2004.

7. Interview with Manuel González, September 2004.

8. "Crackdown Ends Art Collecting Trips to Cuba" <www.artandantiques.net>, February 2004.

9. Interview with Holly Block, September 2004.

10. Interview of Roberto Diago (grandson of the well-known Cuban painter of that name) by Pedro Pérez Sarduy, September 2003, at <afrocubaweb.com/robertodiago/robertodiago.htm.>.

11. Interview with Rodríguez, July 2002.

12. Interview with Lino Fernández, July 2002.

13. Interview with Rodríguez, July 2002.

14. Ibid.

15. Interview with Ruslan Torres, July 2002.

16. Interview with Rodríguez, July 2002.

17. Interview with Fernández, July 2002.

18. For instance, several prominent gay clubs are featured in the Cuban films *Mariposas en el andamio* (Butterflies on the scaffold, 1996) and *Suite Habana* (Havana suite, 2003).

19. Interview with Fernández, July 2002.

20. Interview with Adrián Soca, July 2002.

21. This incident was related to me in a private conversation.

22. Interview with Torres, July 2002.

23. Ibid.

24. Interview with Lino Fernández, Zenia Couso, Adrián Soca, and Fabian Peña, July 2002.

25. Interview with Gerardo Mosquera, July 2002.

26. Although, as Miguel Angel Centeno (1997:18) reports, Cuba does not have the kind of black market that developed in the Soviet Union in later decades, such as "million-dollar deals with mineral exports to international buyers," the underground economy is still fairly significant and growing. Jorge Pérez-López (1997: 174) quotes estimates from the Institute of Internal Demand which noted that black-market transactions rose from 17 percent of all sales in 1990 to more than 60 percent in 1992.

27. Interview with Wilfredo Prieto, July 2002.

28. Interview with Manuel Piña, July 2002.

29. Ibid.

30. Alexis Esquivel, personal communication, October 2005.

31. Interview with Alexis Esquivel, May 2005.

32. Andrés Petit, "Queloides: Eleven Artists Exhibit Works on Racism at the Centro de Desarrollo de las Artes Visuales in Havana," September 30, 2000, www.afrocuba web.com/artevisuales.htm. One reader of the manuscript questioned whether Andrés Petit is the author's real name or a pseudonym borrowed from the well-known nineteenth-century Cuban religious leader. The coordinators of AfroCubaweb said they could "neither confirm nor deny" that the author is using a pseudonym.

33. Interview with Manuel Arenas, June 2005.

34. Interview with Esquivel, May 2005.

35. Ariel Ribeaux, "Ni músicos ni deportistas: Notas para El libro oscuro," at afrocuba web.com/arielribeaux.htm.

36. Petit, "Queloides."

37. Interview with Elio Rodríguez, May 2005.

38. Interview with Roberto Diago, September 2005.

39. See afrocubaweb.com/robertodiago/robertodiago.htm.

40. Interview with Diago, September 2005.

41. Esquivel, personal communication, October 2005.

42. Ibid.

43. Interview with Diago, September 2005.

44. Interview with Esquivel, May 2005.

45. Interview with Prieto, July 2002.

46. Interview with Garaicoa, October 2004.

47. In a 1976 speech commemorating the victory at the Bay of Pigs (Playa Girón), Castro referred to Angola as "an African Girón" (quoted in Eckstein 2003:187).

48. Interview with Piña, July 2002.

49. Interview with Block, September 2004.

50. Conversation with Barbara Luderowski and Michael Olijnyk, April 2005.

51. Interview with Garaicoa, October 2004.

Conclusion

1. In the late 1990s and early 2000s conservative Miami newspapers published a number of articles about the subversive potential of rap music in Cuba.

2. Jane Perlez, "Casting a Fresh Eye on China with Computer, Not Ink Brush," New York Times, 3 December 2003.

Bibliography

Abu-Lughod, Lila. 1997. "The Interpretation of Culture(s) after Television." *Representations* 59 (Summer): 109–134.

Acanda, Jorge Luis. 1997. "Releyendo a Gramsci: Hegemonía y sociedad civil." *Temas* 10:75–86.

Adorno, Theodor. 1984. *Aesthetic Theory*. Boston: Routledge.

Almond, Gabriel. 1988. "The Return to the State." *American Political Science Review* 82, no. 3: 853–874.

Alvarez, Lupe. 1997. "Accomplice's Probe: Taking the Pulse of 1990s Cuban Art." In *1990s Art from Cuba: A National Residency and Exhibition Program*, 14–19. New York: Art in General and Longwood Arts Project/Bronx Council on the Arts.

Alvarez, Sonia, Evelina Dagnino, and Arturo Escobar, eds. 1998. *Cultures of Politics/Politics of Cultures: Re-visioning Latin American Social Movements*. Boulder: Westview.

Appadurai, Arjun. 1996. *Modernity at Large: Cultural Dimensions of Globalization*. Minneapolis: University of Minnesota Press.

Apter, Andrew. 1999. "IBB=419: Nigerian Democracy and the Politics of Illusion." In *Civil Society and the Political Imagination in Africa: Critical Perspectives*, ed. John L. Comaroff and Jean Comaroff, 267–307. Chicago: University of Chicago Press.

Arato, Andrew. 1981. "Civil Society against the State." *Telos* 47:23–47.

Arenas, Reinaldo. 2000. *Before Night Falls*. New York: Penguin.

Azicri, Max. 2000. *Cuba Today and Tomorrow: Reinventing Socialism*. Gainesville: University Press of Florida.

Baker, Houston. 1991. "Hybridity, the Rap Race, and Pedagogy for the 1990s." In *Technoculture*, ed. Andrew Ross and Constance Penley, 197–209. Minneapolis: University of Minnesota Press.

Baza, Larry. 1997. "Abel Barroso." In *1990s Art from Cuba: A National Residency and Exhibition Program*, 23. New York: Art in General and Longwood Arts Project/Bronx Council on the Arts.

Bejel, Emilio. 2001. *Gay Cuban Nation*. Chicago: University of Chicago Press.

Bengelsdorf, Carollee. 1994. *The Problem of Democracy in Cuba: Between Vision and Reality*. New York: Oxford University Press.

———. 1997. "(Re)Considering Cuban Women in a Time of Troubles." In *Daughters of Caliban: Caribbean Women in the Twentieth Century*, ed. Consuelo Lopez Springfield, 229–255. Bloomington: Indiana University Press.

Benjamin, Jules R. 1990. *The United States and the Origins of the Cuban Revolution: An Empire of Liberty in an Age of National Liberation*. Princeton: Princeton University Press.

Berdahl, Daphne. 1999. *Where the World Ended: Re-unification and Identity in the German Borderland*. Berkeley: University of California Press.

Bernhard, Michael. 1993. "Civil Society and Democratic Transition in East Central Europe." *Political Science Quarterly* 108, no. 2: 307–326.

Bettelheim, Judith. 2005. *AfroCuba: Works on Paper, 1968–2003*. Seattle: University of Washington Press.

Beverley, John. 2001. "The Im/possibility of Politics: Subalternity, Modernity, Hegemony." In *The Latin American Subaltern Studies Reader*, ed. Ileana Rodriguez, 47–63. Durham: Duke University Press.

Bhabha, Homi. 1990. "Introduction." In *Nation and Narration*, ed. Homi Bhabha, 1–7. New York: Routledge.

Bickford, Susan. 1996. *The Dissonance of Democracy: Listening, Conflict, and Citizenship*. Ithaca: Cornell University Press.

Blake, Casey N. 2002. "Public Art and the Civic Imagination in Late Twentieth-Century America." *Newsletter* no. 22, 53–55. Washington: Center for Advanced Studies in the Visual Arts, National Gallery of Art.

Block, Holly. 1997. "Interview with Abel Barroso." In *1990s Art from Cuba: A National Residency and Exhibition Program*, 23–25. New York: Art in General and Longwood Arts Project/Bronx Council on the Arts.

———. 2001. "Introduction: Remembering Why." In *Art Cuba: The New Generation*, ed. Holly Block, 7–12. New York: Harry N. Abrams.

———. 2004. "Galleries." In *Time Out Havana and the Best of Cuba*. London: Time Out.

Block, Holly, and Betti-Sue Hertz. 1997. "Acknowledgments." In *1990s Art from Cuba: A National Residency and Exhibition Program*, 4–5. New York: Art in General and Longwood Arts Project/Bronx Council on the Arts.

Borges-Triana, Joaquín. 2004. "La fabrik: Obreros de la construcción y embajadores de la creación." *Movimiento, La Revista Cubana de Hip Hop* 2:5–9.

Bourdieu, Pierre. 1984. *Distinction: A Social Critique of the Judgement of Taste*. Trans. Richard Nice. Cambridge: Harvard University Press.

Bunck, Julie Marie. 1994. *Fidel Castro and the Quest for a Revolutionary Culture in Cuba*. University Park: Pennsylvania State University Press.

Burawoy, Michael, and János Lukács. 1992. *The Radiant Past: Ideology and Reality in Hungary's Road to Capitalism*. Chicago: University of Chicago Press.

Burton, Julianne. 1997. "Film and Revolution in Cuba: The First Twenty-five Years." In *New Latin American Cinema*, ed. Michael Martin, 2:123–142. Detroit: Wayne State University Press.

Calhoun, Craig. 1992. "Introduction: Habermas and the Public Sphere." In *Habermas and the Public Sphere*, ed. Craig Calhoun, 1–50. Cambridge: MIT Press.

———. 1993. "Civil Society and the Public Sphere." *Public Culture* 5:267–280.

Camnitzer, Luis. 1994. *New Art of Cuba*. Austin: University of Texas Press.

Campbell, Albert. 1995. "Una introducción a la economía cubana: Sus objectivos, estrategias y desempeño." *Temas* 2:36–48.

Cassel, Valerie. 1997. "Tania Bruguera." In *1990s Art from Cuba: A National Residency and*

Exhibition Program, 27. New York: Art in General and Longwood Arts Project/Bronx Council on the Arts.

Castro, Fidel. 1961. *Palabras a los intelectuales*. Havana: National Cultural Council.

———. 1966. "The Revolution within the Revolution." In *Women and the Cuban Revolution*, ed. Elizabeth Stone, 48–54. New York: Pathfinder.

Centeno, Miguel Angel. 1997. "Cuba's Search for Alternatives." In *Toward a New Cuba? Legacies of a Revolution*, ed. Miguel Angel Centeno and Mauricio Font, 9–24. Boulder: Lynne Rienner.

Chanan, Michael. 1985. *The Cuban Image*. London: British Film Institute.

———. 1997. "The Economic Condition of Cinema in Latin America." In *New Latin American Cinema*, ed. Michael Martin, 1:185–200. Detroit: Wayne State University Press.

———. 2002. "We Are Losing All Our Values: An Interview with Tomás Gutiérrez Alea." *boundary 2* 29, no. 3: 47–54.

———. 2004. *Cuban Cinema*. Minneapolis: University of Minnesota Press.

Chatterjee, Partha. 1990. "A Response to Taylor's 'Modes of Civil Society.'" *Public Culture* 3, no. 1: 119–132.

Cheng, Li, and Lynn White. 2003. "Dialogue with the West: A Political Message from Avant-Garde Artists in Shanghai." *Critical Asian Studies* 35, no. 1: 59–98.

Cohen, Jean, and Andrew Arato. 1992. *Civil Society and Political Theory*. Cambridge: MIT Press.

Comaroff, Jean, and John L. Comaroff. 1991. *Of Revelation and Revolution: Christianity, Colonialism, and Consciousness in South Africa*, Vol. 1. Chicago: University of Chicago Press.

———. 1997. "Postcolonial Politics and Discourses of Democracy in Southern Africa: An Anthropological Reflection on African Political Modernities." *Journal of Anthropological Research* 53, no. 2: 123–146.

Comaroff, John L., and Jean Comaroff. 1999. "Introduction." In their *Civil Society and the Political Imagination in Africa: Critical Perspectives*, 1–43. Chicago: University of Chicago Press.

Combahee River Collective. 1997. "A Black Feminist Statement." In *The Second Wave: A Reader in Feminist Theory*, ed. Linda Nicholson, 63–70. New York: Routledge.

Cooper, Carolyn. 1995. *Noises in the Blood: Orality, Gender, and the "Vulgar" Body of Jamaican Popular Culture*. Durham: Duke University Press.

Corbett, Ben. 2002. *This Is Cuba: An Outlaw Culture Survives*. Cambridge, Mass.: Westview.

Crehan, Kate. 2002. *Gramsci, Culture, and Anthropology*. Berkeley: University of California Press.

Cross, Brian. 1993. *It's Not About a Salary . . . : Rap, Race, and Resistance in Los Angeles*. New York: Verso.

Cruz-Malavé, Arnaldo. 1998. "Lecciones de cubanía: Identidad nacional y errancia sexual en Senel Paz, Martí y Lezama Lima." *Cuban Studies* 29:129–154.

Dávila, Arlene. 2004. *Barrio Dreams: Puerto Ricans, Latinos, and the Neoliberal City*. Berkeley: University of California Press.

De la Fuente, Alejandro. 1998. "Recreating Racism: Race and Discrimination in Cuba's 'Special Period.'" Cuba Briefing Paper no. 18, Center for Latin American Studies, Georgetown University.

———. 2001. *A Nation for All: Race, Inequality, and Politics in Twentieth-Century Cuba*. Chapel Hill: University of North Carolina Press.

Diawara, Manthia. 1998. *In Search of Africa*. Cambridge: Harvard University Press.

Díaz, Désirée. 2000a. "Memorias a la deriva: El tema de la emigración en el cine cubano de la década de los noventa." MA thesis, University of Havana.

———. 2000b. "El síndrome de Ulises: El viaje en el cine cubano de los noventa." *LaGaceta de Cuba* 6:37–40.

Díaz Pérez, Clara. 1994. *Sobre la guitarra, la voz: Una historia de la nueva trova cubana*. Havana: Letras Cubanas.

Díaz Torres, Daniel. 1991. "Sobre el riesgo del arte." *Cine Cubano* 135:23–25.

Dilla, Haroldo. 1999. "Sociedad Civil en los 90: El debate cubano." *Temas* 16–17:155–175.

———. 2002. "Cuba: The Changing Scenarios of Governability." *boundary 2* 29, no. 3: 55–76.

———. 2005. "Larval Actors, Uncertain Scenarios, and Cryptic Scripts: Where Is Cuban Society Headed?" In *Changes in Cuban Society since the Nineties*, ed. Joseph Tulchin et al., 35–50. Woodrow Wilson International Center for Scholars.

D'Lugo, Martin. 1993. "Transparent Women: Gender and Nation in Cuban Cinema." In *Mediating Two Worlds: Cinematic Encounters in the Americas*, ed. John King, Ana López, and Manuel Alvarado. London: British Film Institute.

———. 2001. "Otros usos, otros públicos: El caso de *Fresa y chocolate*." *Temas* 27:53–62.

Drèze, Jean, and Amartya Sen. 1995. "India and China." In their *India: Economic Development and Social Opportunity*, 57–68. New York: Oxford University Press.

Eckstein, Susan. 2003. *Back from the Future: Cuba under Castro*. 2nd ed. New York: Routledge.

Elinson, Hannah. 1999. "Cuba's *Jineteros*: Youth Culture and Revolutionary Ideology." Cuba Briefing Series Papers no. 20, Center for Latin American Studies, Georgetown University.

Evans, Peter B., Dietrich Rueschemeyer, and Theda Skocpol, eds. 1985. *Bringing the State Back In*. New York: Cambridge University Press.

Fadraga Tudela, Lillebit. 2000. "De la memoria y otros aires comunes: Censura, religión y ruptura en la plástica cubana de los noventa." BA thesis, University of Havana.

Fagen, Richard R. 1969. *The Transformation of Political Culture in Cuba*. Stanford: Stanford University Press.

Fernandes, Sujatha. 2005. "Transnationalism and Feminist Activism in Cuba: The Case of Magín." *Politics and Gender* 1, no. 3: 431–452.

Fernández, Ariel. 2000a. "¿Poesía urbana? o La nueva trova de los noventa." *Caimán Barbudo* 296:4–14.

———. 2000b. "Orishas: El aché a través del hip-hop." *Caimán Barbudo* 296:6–9.

———. 2002. "SBS ¿timba con rap?: El hip hop de la polémica." *Revista Salsa Cubana* 5, no. 17: 43–45.

———. 2003. "Identidades y interiores de ciertos consejos anónimos." *Movimiento, La Revista Cubana de Hip Hop* 1:5–10.

Fernández Robaina, Tomás. 1998. "Marcus Garvey in Cuba: Urrutia, Cubans, and Black Nationalism." In *Between Race and Empire: African-Americans and Cubans before the Cuban Revolution*, ed. Lisa Brock and Digna Castañeda Fuertes, 120–128. Philadelphia: Temple University Press.

Ferrer, Ada. 1999. *Insurgent Cuba: Race, Nation, and Revolution, 1868–1898*. Chapel Hill: University of North Carolina Press.

Fornet, Ambrosio. 2001. "Apuntes para la historia del cine cubano de ficción: La producción del ICAIC (1959–1989)." *Temas* 27:4–16.

Foucault, Michel. 1991. "Governmentality." In *The Foucault Effect: Studies in Governmentality*, ed. Graham Burchell, Colin Gordon, and Peter Miller, 87–104. Chicago: University of Chicago Press.

Fowler, Víctor. 1996. "Identidad, diferencia, resistencia: A propósito de *Madagascar* y *Reina y rey*." *La Gaceta de Cuba* 3, no. 34: 22–26.

Fraser, Nancy. 1992. "Rethinking the Public Sphere: A Contribution to the Critique of Actually Existing Democracy." In *Habermas and the Public Sphere*, ed. Craig Calhoun, 109–142. Cambridge: MIT Press.

Fusco, Coco. 2002. *The Bodies That Were Not Ours and Other Writings*. New York: Routledge.

Gal, Susan, and Kligman, Gail. 2000. *Reproducing Gender: Politics, Publics, and Everyday Life after Socialism*. Princeton: Princeton University Press.

Gamson, William A. 1992. *Talking Politics*. Cambridge: Cambridge University Press.

García Canclini, Néstor. 1995. *Hybrid Cultures: Strategies for Leaving and Entering Modernity*. Trans. Christopher L. Chippiari and Silvia L. López. Minneapolis: University of Minnesota Press.

———. 2001. *Consumers and Citizens: Globalization and Multicultural Conflicts*. Trans. George Yúdice. Minneapolis: University of Minnesota Press.

Gates, Henry L., Jr. 1988. *The Signifying Monkey: A Theory of African American Literary Criticism*. New York: Oxford University Press.

Geertz, Clifford. 1973. *The Interpretation of Cultures: Selected Essays*. New York: Basic Books.

Gilroy, Paul. 1987. *There Ain't No Black in the Union Jack*. London: Hutchinson.

———. 1993. *Small Acts: Thoughts on the Politics of Black Cultures*. London: Serpent's Tail.

———. 1996. "One Nation under a Groove: The Cultural Politics of 'Race' and Racism in Britain." In *Becoming National: A Reader*, ed. Geoff Eley and Ronald Grigor Suny, 352–370. New York: Oxford University Press.

Giral, Sergio. 1994. "Images and Icons." In *AfroCuba: An Anthology of Cuban Writing on Race, Politics and Culture*, ed. Pedro Perez Sarduy and Jean Stubbs, 264–272. Melbourne: Ocean Press.

Giuliano, Maurizio. 1998. *El caso CEA: Intelectuales e inquisitores en Cuba: ¿Perestroika en la isla?* Miami: Ediciones Universal.

Gleijeses, Piero. 2002. *Conflicting Missions: Havana, Washington, and Africa, 1959–1976*. Chapel Hill: University of North Carolina Press.

González Gutiérrez, Alfredo. 1997. "Economía y sociedad: Los retos del modelo económico." *Temas* 11: 4–29.

Gordy, Katherine. 2005. "The Theory and Practice of Ideology: Navigating the Principles of Cuban Socialism." PhD dissertation, Cornell University.

Gosse, Van. 1998. "The African-American Press Greets the Cuban Revolution." In *Between Race and Empire: African-Americans and Cubans before the Cuban Revolution*, ed. Lisa Brock and Digna Castañeda Fuertes, 266–280. Philadelphia: Temple University Press.

Gott, Richard. 2004. *Cuba: A New History.* New Haven: Yale University Press.

Gramsci, Antonio. 1971. *Selections from the Prison Notebooks.* New York: International Publishers.

Guevara, Alfredo. 1960. "Una nueva etapa del cine en Cuba." *Cine Cubano* 3:7.

Habermas, Jürgen. 1989. *The Structural Transformation of the Public Sphere: An Inquiry into a Category of Bourgeois Society*, trans. Thomas Burger with the assistance of Frederick Lawrence. Cambridge: MIT Press.

———. 1996. *Between Facts and Norms: Contributions to a Discourse Theory of Law and Democracy*, trans. William Rehg. Cambridge: MIT Press.

Hall, Stuart. 1985. *The Hard Road to Renewal: Thatcherism and the Crisis of the Left.* New York: Verso.

———. 1988. "The Toad in the Garden: Thatcherism among the Theorists." In *Marxism and the Interpretation of Culture*, ed. Cary Nelson and Lawrence Grossberg, 35–57. Urbana: University of Illinois Press.

Hanchard, Michael. 1994. "Black Cinderella? Race and the Public Sphere in Brazil." *Public Culture* 7:165–185.

Hansen, Thomas Blom, and Finn Stepputat, eds. 2001. *States of Imagination: Ethnographic Explorations of the Postcolonial State.* Durham: Duke University Press.

Haraszti, Miklós. 1987. *The Velvet Prison: Artists under State Socialism.* New York: Noonday Press.

Hebdige, Dick. 1979. *Subculture: The Meaning of Style.* New York: Methuen.

Henken, Ted. 2002. "Condemned to Informality: Cuba's Experiments with Self-Employment during the Special Period (The Case of the Bed and Breakfasts)." *Cuban Studies* 32:1–29.

Hernández, Orlando. 2001. "The Pleasure of Reference." In *Art Cuba: The New Generation*, ed. Holly Block, 25–31. New York: Harry N. Abrams.

———. 2005. "The Importance of Being Local." In *Alberto Casado: Todo clandestino, todo popular*, 16–27. Exhibition catalogue. New York: Art in General.

Hernández, Rafael. 1999. *Mirar a Cuba: Ensayos sobre cultura y sociedad civil.* Havana: Letras Cubanas.

Hernández-Reguant, Ariana. 2002. "Radio Taino and the Globalization of the Cuban Culture Industries." PhD dissertation, University of Chicago.

———. 2004. "Copyrighting Che: Art and Authorship under Cuban Late Socialism." *Public Culture* 16, no. 1: 1–29.

Hinton, William. 1966. *Fanshen: A Documentary of Revolution in a Chinese Village.* New York: Monthly Review Press.

Hopenhayn, Martin. 2001. *No Apocalypse, No Integration: Modernism and Postmodernism in Latin America*. Durham: Duke University Press.

Humphrey, Caroline. 2002. *The Unmaking of Soviet Life: Everyday Economies after Socialism*. Ithaca: Cornell University Press.

Huntington, Samuel. 1991. *The Third Wave: Democratization in the Late Twentieth Century*. Norman: University of Oklahoma Press.

Joffe, Margaux. 2005. "Reshaping the Revolution through Rhyme: A Literary Analysis of Cuban Hip-Hop in the 'Special Period.'" Working Paper no. 3, Andrew W. Mellon Undergraduate Paper Series in Latin American and Caribbean Studies, Duke University Center for Latin American and Caribbean Studies.

Kaige, Chen. 1990. "Breaking the Circle: The Cinema and Cultural Change in China." *Cineaste* 17, no. 3: 28–31.

Kapcia, Antoni. 2000. *Cuba: Island of Dreams*. New York: Berg.

Keane, John. 1998. *Civil Society: Old Images, New Visions*. Stanford: Stanford University Press.

Kelley, Robin. 1997. *Yo' Mama's Disfunktional! Fighting the Culture Wars in Urban America*. Boston: Beacon.

Kellner, Sara. 1997. "Manuel Piña." In *1990s Art from Cuba: A National Residency and Exhibition Program*, 39. New York: Art in General and Longwood Arts Project/Bronx Council on the Arts.

Kligman, Gail. 1990. "Reclaiming the Public: A Reflection on Creating Civil Society in Romania." *East European Politics and Society* 4, no. 3: 393–427.

Kohli, Atul, and Vivienne Shue. 1994. "State Power and Social Forces: On Political Contention and Accommodation in the Third World." In *State Power and Social Forces: Domination and Transformation*, ed. Atul Kohli and Vivienne Shue, 293–326. Cambridge: Cambridge University Press.

Kornai, János. 1980. *Economics of Shortage*. Amsterdam: North-Holland.

Krasner, Stephen. 1978. *Defending the National Interest: Raw Materials Investments and U.S. Foreign Policy*. Princeton: Princeton University Press.

Kumar, Krishnan. 2001. *1989 Revolutionary Ideas and Ideals*. Minneapolis: University of Minnesota Press.

Kutzinski, Vera. 1994. *Sugar's Secrets: Race and the Erotics of Cuban Nationalism*. Charlottesville: University Press of Virginia.

Lancaster, Roger. 1992. *Life Is Hard: Machismo, Danger, and the Intimacy of Power in Nicaragua*. Berkeley: University of California Press.

Landes, Joan. 1988. *Women and the Public Sphere in the Age of the French Revolution*. Ithaca: Cornell University Press.

Levinson, Sandra. 1989. "Talking About Cuban Culture: A Reporter's Notebook." In *The Cuba Reader: The Making of a Revolutionary Society*, ed. Philip Brenner et al. New York: Grove Press.

Lewis, Oscar, Ruth Lewis, and Susan Rigdon. 1977a. *Four Men*. Vol. 1 of *Living the Revolution: An Oral History of Contemporary Cuba*. Urbana: University of Illinois Press.

———. 1977b. *Four Women*. Vol. 2 of *Living the Revolution: An Oral History of Contemporary Cuba*. Urbana: University of Illinois Press.

————. 1978. *Four Neighbors*. Vol. 3 of *Living the Revolution: An Oral History of Contemporary Cuba*. Urbana: University of Illinois Press.

Limia, Miguel. 1999. "Sociedad civil en los 90: El debate cubano." *Temas* 16–17:155–175.

Linz, Juan J., and Alfred Stepan. 1996. *Problems of Democratic Transition and Consolidation: Southern Europe, South America, and Post-Communist Europe*. Baltimore: Johns Hopkins University Press.

López Vigil, María. 1998. "Cuban Women's History–Jottings and Voices." *Envío* 17 (208): 27–43.

Lowe, Lisa, and David Lloyd. 1997. "Introduction." In *The Politics of Culture in the Shadow of Capital*, ed. Lisa Lowe and David Lloyd, 1–32. Durham: Duke University Press.

Luderowski, Barbara, and Michael Olijnyk. 2004. *New Installations, Artists in Residence: Cuba, October 3, 2004–April 24, 2005*. Exhibition catalogue. New York: Mattress Factory.

Lumsden, Ian. 1996. *Machos, Maricones, and Gays: Cuba and Homosexuality*. Philadelphia: Temple University Press.

Machado Rodríguez, Darío. 1998. "La ideología de la revolución cubana a la luz del *Manifiesto Comunista*." *Cuba Socialista* 11:56–64.

Mallon, Florencia. 1994. "Reflections on the Ruins: Everyday Forms of State Formation in Nineteenth-Century Mexico." In *Everyday Forms of State Formation: Revolution and the Negotiation of Rule in Modern Mexico*, ed. Gilbert M. Joseph and Daniel Nugent, 69–106. Durham: Duke University Press.

Mankekar, Purnima. 1993. "National Texts and Gendered Lives: An Ethnography of Television Viewers in a North Indian City." *American Ethnologist* 20, no. 3: 543–563.

Martín-Barbero, J. 1993. *Communication, Culture and Hegemony: From the Media to Mediations*. Trans. Elizabeth Fox and Robert A. White. Newberry Park, Calif.: Sage.

Mateo, David. 2003. "No todos los negros tomamos café: Conversación con Roberto Diago." *La Gaceta de Cuba* (mayo–junio): 22–26.

Mbembe, Achille. 1992. "The Banality of Power and the Aesthetics of Vulgarity in the Postcolony." *Public Culture* 4, no. 2: 1–30.

Medin, Tzvi. 1990. *Cuba: The Shaping of Revolutionary Consciousness*. Boulder: Lynne Rienner.

Medina, Cuauhtémoc. 2001. "Una isla cada vez más isla." *Reforma*, 3 January.

Mercer, Kobena. 1990. "Black Hair/Style Politics." In *Out There: Marginalization and Contemporary Cultures*, ed. Russell Ferguson, Martha Gever, Trinh T. Minh-ha, and Cornel West, 247–264. Cambridge: MIT Press.

Mesa-Lago, Carmelo, et al. 2000. *Market, Socialist, and Mixed Economies: Comparative Policy and Performance: Chile, Cuba, and Costa Rica*. Baltimore: Johns Hopkins University Press.

Miller, Ivor. 2000. "A Secret Society Goes Public: The Relationship between Abakuá and Cuban Popular Culture." *African Studies Review* 43, no. 1: 161–188.

Mitchell, Timothy. 1991. "The Limits of the State: Beyond Statist Approaches and Their Critics." *American Political Science Review* 85, no. 1: 77–96.

————. 1999. "Society, Economy, and the State Effect." In State/Culture: State-Formation after the Cultural Turn, ed. George Steinmetz, 76–97. Ithaca: Cornell University Press.

Mitchell, Tony. 2001. "Introduction: Another Root–Hip-Hop Outside the USA." In Global Noise: Rap and Hip-Hop Outside the USA, ed. Tony Mitchell, 1–38. Middletown Conn.: Wesleyan University Press.

Molina Cintra, Matilde, and Rosa Rodríguez Lauzurique. 1998. "Juventud y valores: ¿Crisis, desorientación, cambio?" Temas 15:65–73.

Monsiváis, Carlos. 1978. "Notas sobre cultura popular en México." Latin American Perspectives 5, no. 1: 98–118.

Monzón Paz, Lissette, and Darys J. Vázquez Aguiar. 2001. "The Art Market on the Fringes of Ideology and Reality." Artecubano: Revista de Artes Visuales 3:63–69.

Moore, Carlos. 1988. Castro, the Blacks, and Africa. Los Angeles: Center for Afro-American Studies.

Moore, Robin. 1997. Nationalizing Blackness: Afrocubanismo and Artistic Revolution in Havana, 1920–1940. Pittsburgh: University of Pittsburgh Press.

Morissawa, Mitsue. 2001. A história da luta pela terra e o MST. São Paulo: Espressão Popular.

Mosquera, Gerardo. 1997. El arte latinoamericano deja de serlo. Madrid: Arco Latino.

————. 1999. "The Infinite Island: Introduction to New Cuban Art." In Contemporary Art from Cuba: Irony and Survival on the Utopian Island, ed. Marilyn A. Zeitlin, 23–31. New York: Arizona State University Art Museum/Delano Greenidge Editions.

————. 2001. "New Cuban Art Y2K." In Art Cuba: The New Generation, ed. Holly Block, 13–15. New York: Harry N. Abrams.

Navarro, Wendy. 2000. "Transfiguraciones elásticas: Tránsito y disidencia en el arte público contemporáneo." Artecubano: Revista de Artes Visuales 2:46–56.

Neocleous, Mark. 1996. Administering Civil Society: Towards a Theory of State Power. New York: Macmillan.

Nordlinger, Eric. 1981. On the Autonomy of the Democratic State. Cambridge: Harvard University Press.

————. 1987. "Taking the State Seriously." In Understanding Political Development, ed. Myron Weiner and Samuel Huntington, 353–390. Boston: Little, Brown.

————. 1988. "The Return to the State: Critiques." American Political Science Review 82, no. 3: 875–901.

Nugent, David. 1997. Modernity at the Edge of Empire: State, Individual, and the Nation in the Northern Peruvian Andes, 1885–1935. Stanford: Stanford University Press.

O'Donnell, Guillermo, and Philippe C. Schmitter. 1986. Transitions from Authoritarian Rule: Tentative Conclusions about Uncertain Democracies. Baltimore: Johns Hopkins University Press.

O'Neill, Shane. 1997. Impartiality in Context: Grounding Justice in a Pluralist World. Albany: State University of New York Press.

Ong, Aihwa. 1999. Flexible Citizenship: The Cultural Logics of Transnationality. Durham: Duke University Press.

Pacini Hernandez, Deborah, and Reebee Garofalo. 1999. "Hip Hop in Havana: Rap,

Race and National Identity in Contemporary Cuba." *Journal of Popular Music Studies* 11–12: 18–47.

Padrón Nodarse, Frank. 1994. "La realidad en el cine cubano de los noventa: Las eternas luchas del espejo y la imágen." *Dicine* 57:19–23.

Paley, Julia. 2001. *Marketing Democracy: Power and Social Movements in Post-Dictatorship Chile.* Berkeley: University of California Press.

Paranaguá, Paulo Antonio. 1997. "Cuban Cinema's Political Challenges." In *New Latin American Cinema*, ed. Michael Martin, 2:167–190. Detroit: Wayne State University Press.

Pardue, Derek. 2004. "Writing in the Margins: Brazilian Hip-Hop as an Educational Project." *Anthropology and Education Quarterly* 35, no. 4: 411–432.

Pérez, Louis A., Jr. 1999. *On Becoming Cuban: Identity, Nationality, and Culture.* Chapel Hill: University of North Carolina Press.

Pérez-López, Jorge F. 1997. "Cuba's Second Economy and the Market Transition." In *Toward a New Cuba? Legacies of a Revolution*, ed. Miguel Angel Centeno and Mauricio Font, 171–186. Boulder: Lynne Rienner.

Pérez-Stable, Marifeli. 1993. *The Cuban Revolution: Origins, Course, and Legacy.* New York: Oxford University Press.

Perry, Imani. 1995. "It's My Thang and I'll Swing It the Way That I Feel!: Sexuality and Black Women Rappers." In *Gender, Race, and Class in Media: A Text-Reader*, ed. Gail Dines and Jean Humez, 524–530. Thousand Oaks, Calif.: Sage.

———. 2002. "Who(se) Am I? The Identity and Image of Women in Hip-Hop." In *Gender, Race, and Class in Media: A Text-Reader*, ed. Gail Dines and Jean Humez, 2nd ed., 136–148. Thousand Oaks, Calif.: Sage.

Pickowicz, Paul. 1995. "Velvet Prisons and the Political Economy of Chinese Filmmaking." In *Urban Spaces in Contemporary China: The Potential for Autonomy and Community in Post-Mao China*, ed. Deborah S. Davis, Richard Kraus, Barry Naughton, and Elisabeth Perry, 193–220. New York: Cambridge University Press.

Pough, Gwendolyn. 2002. "Love Feminism but Where's My Hip Hop? Shaping a Black Feminist Identity." In *Colonize This! Young Women of Color on Today's Feminism*, ed. Daisy Hernández and Bushra Rehman, 85–95. New York: Seal Press.

———. 2003. "Do the Ladies Run This . . . ?: Some Thoughts on Hip-Hop Feminism." In *Catching a Wave: Reclaiming Feminism for the Twenty-first Century*, ed. Rory Dicker and Alison Piepmeier, 232–243. Boston: Northeastern University Press.

Power, Kevin. 1999. "Cuba: One Story after Another." In *While Cuba Waits: Art from the Nineties*, ed. Kevin Power, 22–65. New York: Smart Art Press.

Premat, Adriana. 2004. "Private Plots, State Power, and the Modeling of Havana's Urban Gardens." Paper presented at "Cuba Today: Continuity and Change since the 'Período Especial,'" Bildner Center for Western Hemispheric Studies, CUNY Graduate Center.

Press, Andrea L., and Elizabeth R. Cole. 1999. *Speaking of Abortion: Television and Authority in the Lives of Women.* Chicago: University of Chicago Press.

Prieto, Abel. 1996. "¿Oficialismo o herejía? Entrevista a Abel Prieto." *Revolución y Cultura* 1.

Przeworski, Adam. 1991. *Democracy and the Market: Political and Economic Reforms in Eastern Europe and Latin America*. New York: Cambridge University Press.

Pujol, Ernesto. 1997. "Interview with Manuel Piña." In *1990s Art from Cuba: A National Residency and Exhibition Program*, 40–43. New York: Art in General and Longwood Arts Project/Bronx Council on the Arts.

Quiroga, José. 1997. "Homosexualities in the Tropic of Revolution." In *Sex and Sexuality in Latin America*, ed. Daniel Balderston and Donna Guy, 133–154. New York: New York University Press.

Ramírez, Mari Carmen. 1996. "Brokering Identities: Art Curators and the Politics of Cultural Representation." In *Thinking about Exhibitions*, ed. Reesa Greenberg, Bruce Ferguson, and Sandy Nairne, 21–38. New York: Routledge.

Ramos Cruz, Guillermina. 2000. "Grupo Antillano and the Marginalization of Black Artists." In *Afro-Cuban Voices: On Race and Identity in Contemporary Cuba*, ed. Pedro Pérez Sarduy and Jean Stubbs, 147–177. Gainesville: University Press of Florida.

Richard, Nelly. 1996a. "Chile, Women, and Dissidence." In *Beyond the Fantastic: Contemporary Art Criticism from Latin America*, ed. Gerardo Mosquera, 137–144. Cambridge: MIT Press.

———. 1996b. "Postmodern Decentredness and Cultural Periphery: The Disalignments and Realignments of Cultural Power." In *Beyond the Fantastic: Contemporary Art Criticism from Latin America*, ed. Gerardo Mosquera, 260–269. Cambridge: MIT Press.

Ritter, Archibald. 1998. "Entrepreneurship, Microenterprise, and Public Policy in Cuba: Promotion, Containment, or Asphyxiation?" *Journal of Interamerican Studies and World Affairs* 40, no. 2: 63–94.

Robinson, Eugene. 2004. *Last Dance in Havana*. New York: Free Press.

Roca, José Ignacio. 2000. "Ruins; Utopia." In *Carlos Garaicoa: La Ruina; La Utopia*, ed. José Ignacio Roca, 96–99. Bogotá: Biblioteca Luis Angel Arango.

Rodríguez, Eduardo Luis. 2002. "El microbrigadista." In *Carlos Garaicoa, Continuity of Somebody's Architecture*. Italy: Gli Orli.

Rodríguez, Ileana. 1996. *Women, Guerillas, and Love: Understanding the War in Central America*. Minneapolis: University of Minnesota Press.

Rolando, Gloria. 2000. "Africa, the Caribbean, and Afro-America in Cuban Film." In *Afro-Cuban Voices: On Race and Identity in Contemporary Cuba*, ed. Pedro Pérez Sarduy and Jean Stubbs, 129–139. Gainesville: University Press of Florida.

Rosales, Rocio. 2004. "Loose Women in a Confining State: Liberating Ideology and Economic Constraints in Cuba." Paper, Department of Sociology, Princeton University.

Rose, Nikolas, and Peter Miller. 1992. "Political Power beyond the State: Problematics of Government." *British Journal of Sociology* 43, no. 2: 173–205.

Rose, Tricia. 1994. *Black Noise: Rap Music and Black Culture in Contemporary America*. Hanover, N.H.: Wesleyan University Press.

Roseberry, William. 1994a. "Hegemony and the Language of Contention." In *Everyday Forms of State Formation: Revolution and the Negotiation of Rule in Modern Mexico*, ed. Gilbert M. Joseph and Daniel Nugent, 355–366. Durham: Duke University Press.

————. 1994b. *Anthropologies and Histories: Essays in Culture, History, and Political Economy.* New Brunswick: Rutgers University Press.

Rosendahl, Mona. 1997. *Inside the Revolution: Everyday Life in Socialist Cuba.* Ithaca: Cornell University Press.

Rubin, Gayle. 1975. "The Traffic in Women: Notes on the 'Political Economy' of Sex." In *Toward an Anthropology of Women,* ed. Rayna R. Reiter, 157–210. New York: Monthly Review Press.

Rudolph, Susanne. 1997. "Introduction: Religion, States, and Transnational Civil Society." In *Transnational Religion and Fading States,* ed. Susanne Rudolph and James Piscatori, 1–26. Boulder: Westview.

Ryan, Mary. 1992. "Gender and Public Access: Women's Politics in Nineteenth-Century America." In *Habermas and the Public Sphere,* ed. Craig Calhoun, 259–288. Cambridge: MIT Press.

Saldaña-Portillo, María Josefina. 2003. *The Revolutionary Imagination in the Americas and the Age of Development.* Durham: Duke University Press.

Santí, Enrico Mario. 1998. "*Fresa y chocolate:* The Rhetoric of Cuban Reconciliation." In *Modern Language Notes* 2. Baltimore: Johns Hopkins University Press.

Sayer, Derek. 1994. "Everyday Forms of State Formation: Some Dissident Remarks on 'Hegemony.'" In *Everyday Forms of State Formation: Revolution and the Negotiation of Rule in Modern Mexico,* ed. Gilbert M. Joseph and Daniel Nugent, 367–378. Durham: Duke University Press.

Schmitter, Philippe. 1975. *Corporatism and Public Policy in Authoritarian Portugal.* Beverly Hills, Calif.: Sage.

————. 1979. "Still the Century of Corporatism?" In *Trends toward Corporatist Intermediation,* ed. Philippe C. Schmitter and Gerhard Lehmbruch, 7–52. Beverly Hills, Calif.: Sage.

Scott, James. 1990. *Domination and the Arts of Resistance: Hidden Transcripts.* New Haven: Yale University Press.

Shaw, Deborah. 2003. *Contemporary Cinema of Latin America: Ten Key Films.* New York: Continuum Press.

Shue, Vivienne. 1994. "State Power and Social Organization in China." In *State Power and Social Forces: Domination and Transformation,* ed. Atul Kohli and Vivienne Shue, 65–88. New York: Cambridge University Press.

Skocpol, Theda. 1979. *States and Social Revolutions: A Comparative Analysis of France, Russia, and China.* New York: Cambridge University Press.

Smith, Lois, and Alfred Padula. 1996. *Sex and Revolution: Women in Socialist Cuba.* New York: Oxford University Press.

Smith, Paul Julian. 1994. "The Language of Strawberry." *Sight and Sound* 4, no. 12: 30–33.

————. 1996. "*Fresa y chocolate* (Strawberry and Chocolate): Cinema as Guided Tour." In *Vision Machines: Cinema, Literature and Sexuality in Spain and Cuba, 1983–93,* 81–100. New York: Verso.

Soles, Diane. 2000. "The Cuban Film Industry: Between a Rock and a Hard Place."

In *Cuban Transitions at the Millennium*, ed. Eloise Linger and John Cotman, 123–135. Largo, Md.: International Development Options.

Stallybrass, Peter, and Allon White. 1986. *The Politics and Poetics of Transgression*. London: Methuen.

Stepan, Alfred. 1978. *State and Society: Peru in Comparative Perspective*. Princeton: Princeton University Press.

Suárez Salazar, Luis. 2000. *El Siglo XXI: Posibilidades y desafíos para la revolución cubana*. Havana: Ciencias Sociales.

Taussig, Michael. 1997. *The Magic of the State*. New York: Routledge.

Taylor, Charles. 1990. "Modes of Civil Society." *Public Culture* 3, no. 1: 95–118.

Tonel, Antonio Eligio. 1998. "A Tree from Many Shores: Cuban Art in Movement." *Art Journal* 57, no. 4: 62–73.

Ulysse, Gina. 1999. "Uptown Ladies and Downtown Women: Female Representations of Class and Color in Jamaica." In *Representations of Blackness and the Performance of Identities*, ed. Jean Muteba Rahier, 147–172. Westport, Conn.: Bergin & Garvey.

Urla, Jacqueline. 1997. "Outlaw Language: Creating Alternative Public Spheres in Basque Free Radio." In *The Politics of Culture in the Shadow of Capital*, ed. Lisa Lowe and David Lloyd, 280–300. Durham: Duke University Press.

Valdés, Nelson P. 1997. "El estado y la transición en el socialismo: Creando nuevos espacios en Cuba." *Temas* 9:101–111.

Valdés Figueroa, Eugenio. 2000. "Solitude Laid Bare in the Garden of the Madhouse." In *Tonel: Lessons of Solitude*, 25–41. Exhibition Catalogue. Vancouver: Canada Council for the Arts.

———. 2001. "Trajectories of a Rumor: Cuban Art in the Postwar Period." In *Art Cuba: The New Generation*, ed. Holly Block, 17–25. New York: Harry N. Abrams.

Valdés Gutiérrez, Gilberto. 1996. "La alternativa socialista: Reforma y estrategia de orden." *Temas* 6.

Véliz, María Victoria. 2001. "Cuba TatuArte: La memoria." *ArteCubano: Revista de Artes Visuales* 2:70–77.

Verdery, Katherine. 1991. *National Ideology under Socialism: Identity and Cultural Politics in Ceauşescu's Romania*. Berkeley: University of California Press.

———. 1996. *What Was Socialism and What Comes Next?* Princeton: Princeton University Press.

Vilariño Ruiz, Evelio. 1998. *Cuba: Socialist Economic Reform and Modernization*. Havana: José Martí.

Wade, Peter. 1993 *Blackness and Race Mixture: The Dynamics of Racial Identity in Colombia*. Baltimore: Johns Hopkins University Press.

Wang Hui. 1998. "Contemporary Chinese Thought and the Question of Modernity." *Social Text* 55 (16), no. 2: 9–44.

Wanner, Catherine. 1998. *Burden of Dreams: History and Identity in Post-Soviet Ukraine*. University Park: Pennsylvania State University Press.

Warnke, Georgia. 1995. "Discourse Ethics and Feminist Dilemmas of Difference." In *Feminists Read Habermas: Gendering the Subject of Discourse*, ed. Johanna Meehan, 247–262. New York: Routledge.

Wedeen, Lisa. 1999. *Ambiguities of Domination: Politics, Rhetoric, and Symbols in Contemporary Syria*. Chicago: University of Chicago Press.

Weigle, Marcia, and Jim Butterfield. 1992. "Civil Society in Reforming Communist Regimes: The Logic of Emergence." *Comparative Politics* 25, no. 1: 1–23.

West, Cornel. 1990. "The New Cultural Politics of Difference." In *Out There: Marginalization and Contemporary Cultures*, ed. Russell Ferguson, Martha Gever, Trinh T. Minh-ha, and Cornel West, 19–38. Cambridge: MIT Press.

West-Duran, Alan. 2004. "Rap's Diasporic Dialogues: Cuba's Redefinition of Blackness." *Journal of Popular Music Studies* 16, no. 1: 4–39.

Whitfield, Esther. 2002. "Dirty Autobiography: The Body Impolitic of *Trilogía sucia de la Habana*." *Revista de Estudios Hispánicos* 36, no. 2: 329–351.

Williams, Raymond. 1977. *Marxism and Literature*. New York: Oxford University Press.

Wilson, Fiona. 2001. "In the Name of the State? Schools and Teachers in an Andean Province." In *States of Imagination: Ethnographic Explorations of the Postcolonial State*, ed. Thomas Blom Hansen and Finn Stepputat, 313–344. Durham: Duke University Press.

Yglesias, José. 1968. *In the Fist of the Revolution: Life in a Cuban Country Town*. New York: Pantheon Books.

Yúdice, George. 1996. "Transnational Cultural Brokering of Art." In *Beyond the Fantastic: Contemporary Art Criticism from Latin America*, ed. Gerardo Mosquera, 196–217. Cambridge: MIT Press.

———. 2003. *The Expediency of Culture: Uses of Culture in the Global Era*. Durham: Duke University Press.

Yurchak, Alexei. 1997. "The Cynical Reason of Late Socialism: Power, Pretense, and the Anekdot." *Public Culture* 3:161–188.

Žižek, Slavoj. 1989. *The Sublime Object of Ideology*. New York: Verso.

———. 1993. *Tarrying with Negative: Kant, Hegel, and the Critique of Ideology*. Durham: Duke University Press.

Zurbano, Roberto. 2004. "¡El Rap Cubano!: Discursos hambrientos de realidad (siete notas de viaje sobre el hip-hop cubano en los diez años del festival de rap de la Habana)." *Boletín de Música Cubana Alternativa* 1.

Index

Sujatha Fernandes is an assistant professor of sociology at Queens College, City University of New York.

Library of Congress Cataloging-in-Publication Data
Fernandes, Sujatha.
Cuba represent! : Cuban arts, state power, and the making of new revolutionary cultures / Sujatha Fernandes.
p. cm.
Includes bibliographical references and index.
ISBN-13: 978-0-8223-3859-8 (cloth : alk. paper)
ISBN-10: 0-8223-3859-9 (cloth : alk. paper)
ISBN-13: 978-0-8223-3891-8 (pbk. : alk. paper)
ISBN-10: 0-8223-3891-2 (pbk. : alk. paper)
1. Arts—Political aspects—Cuba. 2. Arts, Cuban—20th century. 3. Socialism and the arts—Cuba—History—20th century. I. Title.
NX180.P64F47 2006
700.1′0309729109049—dc22 2006012765